Contemporary Art Therapy with Adolescents

of related interest

Medical Art Therapy with Children
Edited by Cathy Malchiodi
ISBN 1 85302 677 8 pb
ISBN 1 85302 676 X hb

Medical Art Therapy with Adults
Edited by Cathy Malchiodi
ISBN 1 85302 279 4 pb
ISBN 1 85302 678 6 hb

Creativity and the Dissociative Patient
Puppets, Narrative and Art in the Treatment
of Survivors of Childhood Trauma
Lani Alaine Gerity
ISBN 1 85302 722 7

Active Analytic Group Therapy for Adolescents
John Evans
ISBN 1 85302 616 6 pb
ISBN 1 85302 615 8 hb

Group Work with Children and Adolescents
A Handbook
Edited by Kedar Nath Dwivedi
ISBN 1 85302 157 1

Raising Responsible Teenagers
Bob Myers
ISBN 1 85302 429 5

Parenting Teenagers
Bob Myers
ISBN 1 85302 366 3

How We Feel
An Insight into the Emotional World of Teenagers
Edited by Jacki Gordon and Gillian Grant
ISBN 1 85302 439 2

Making a Leap – Theatre for Empowerment
A Practical Handbook for Creative Drama Work with Young People
Anna Herrmann and Sara Clifford
ISBN 1 85302 632 8

Contemporary Art Therapy with Adolescents

Shirley Riley

Forewords by Gerald D. Oster and Cathy A. Malchiodi

Jessica Kingsley Publishers
London and Philadelphia

The Appendix is reprinted with permission from the American Art Therapy Association, Inc. It was originally published in *Art Therapy: Journal of the American Art Therapy Association, 14* (1) 1997.

First published in the United Kingdom in 1999 by
Jessica Kingsley Publishers Ltd,
116 Pentonville Road,
London N1 9JB, England
and
325 Chestnut Street,
Philadelphia, PA 19106, USA.

www.jkp.com

Second impression

Copyright © 1999 Shirley Riley

Library of Congress Cataloging-in-Publication Data
Art therapy with adolescents / Shirley Riley.
p. cm.
Includes bibliographical references and index.
ISBN 1 85302 636 0 (hbk. : alk. paper). -- ISBN 1 85302 637 9 (pbk. : alk. paper)
1. Art therapy for teenagers. 2. Child psychotherapy. I. Title.
RJ505.A7R55 1999
616.89'1656'0835--dc21
98-45881
CIP

British Library Cataloguing in Publication Data
Contemporary art therapy with adolescents
1.Art therapy for teenagers
I.Title
616.8'91656'0835

ISBN 1 85302 636 0 hb
ISBN 1 85302 637 9 pb

Printed and Bound in Great Britain by
Athenaeum Press, Gateshead, Tyne and Wear

Contents

ACKNOWLEDGEMENTS 6

FOREWORD 7
Gerald D. Oster

FOREWORD 11
Cathy A. Malchiodi

INTRODUCTION 17

1. Integrating Developmental Theories with Art Expressions 27

2. Adolescent Group Treatment 66

3. Adolescence Depression, and the Impact of Societal Issues 115

4. Severely Damaged Adolescents
in Residential and Therapeutic School Settings 153

5. Adolescents and Their Families 193

6. How Therapists Get Tangled Up in Adolescent Treatment 218

7. Short-Term, Solution Focused, Art Therapy Treatment 237

APPENDIX: SOCIAL CONSTRUCTIONISM:
THE NARRATIVE APPROACH AND CLINICAL ART THERAPY 257

REFERENCES 267

FURTHER READING 274

SUBJECT INDEX 277

AUTHOR INDEX 284

Acknowledgements

There are many people and influences that have had impact on this journey of discussing adolescent treatment, but one person took the entire trip with me and held my hand all the way: my husband. He taught me computereez, proofread every chapter, praised my books, and lived with me through my 'crises'. I needed all his help many times and I am enormously grateful.

My second powerful influence is my friend and admired colleague, Cathy Malchiodi. She originally pushed me to publish my work, has continued to be a constant inspiration, and helped me laugh at human foibles, all through this latest adventure.

I most gratefully thank Gerry Oster for his illuminating foreword. I leaned on his expertise through reading his books, long before I started my own. Jessica Kingsley has been wonderfully supportive and reassuring in every aspect of the publication and she calmed my inner adolescent when I regressed into self-doubt.

Jean Noble read and edited, Aimee Loth and Roberta Lengua contributed their valuable experiences, Robert Saldana worked many hours on the photographs of the client's artwork, and Rita Coufal listened to me when I needed an ear, to each of them I give my appreciation.

Lastly I thank my sons for being fine men and choosing wonderful wives. Together they have produced such excellent children that my faith in the next generation gave me balance when the youths I encountered daily seemed in such a hopeless state. Without all of you this book would not have come into existence.

Foreword

Gerald D. Oster

Adolescence is a very confusing time, even for the most well-adjusted teenagers. It is a time for excitement and adventure, yet is fraught with countless pitfalls. These short, but ever so critical, years produce conflicting demands from peers, school, parents and society. There are also rapid internal changes occurring as the developing teenage body emerges into adulthood. Add to the mix the potential of family conflict, variable moods and longer periods of depression, and possible learning problems, and you have a volatile concoction that is bound to give rise to at least minor explosions. One day up, the next day down may be the norm. For the adolescent who is struggling and for those caregivers and caretakers attempting to provide nurturance, this instability may be just too much and professional intervention may be required.

Through my own clinical work with adolescents, I have had the opportunity to interact with a diversity of problems and populations. I have been confronted with sad and sullen teens, as well as highly defiant ones. I have sat with teenagers from all walks of life – youths from the inner city, children in government officials, and adolescents witnessing their families perish in wars. With each of these teens, I have admired their resilience and their ability to express their pain and their anger, both in verbal and non-verbal ways.

Through drawings and other media, teenagers have the opportunity to use a different, yet natural vehicle of communication that can become a catalyst for change. Artwork becomes a format that can increase discussion and enhance the possibilities for insight. It helps break the ice when faced with teenagers who are anticipating yet another adult attempting to interrogate their private lives. By using alternative, non-verbal techniques, clinicians can assist traumatized youngsters

reveal inner thoughts or secrets that they would otherwise have difficulty revealing. Drawings and other artwork can become personal and unique statements that words alone cannot otherwise identify. These graphic images also create permanent records that do indeed speak 'thousands' of words. And these creative expressions become a bridge from within to help close the gap between themselves and the clinicians who are trying to find a way to enter and understand their world.

Mental health professionals from all disciplines naturally want to enhance their understanding of adolescent behavior. Drawings and other related artwork allow for interpretations at a deeper level through visual and graphic representation. Offering teenagers the opportunity to communicate through non-verbal means is a strategy that should be part of every clinician's repertoire because of its versatility and impact on the therapeutic process. Directing teenagers in artwork provides a modality through which both the client and therapist witness emotions, events, and ideas not easily or accurately expressed through words alone. By understanding the process and the product more clearly, clinicians can help their teens clients to quickly communicate relevant issues and problems, thus expediting assessment and treatment.

Therapists face many difficult situations, especially with troubled teenagers, or families in crises. Enhancing self-expression through artwork has the potential to convey in very dramatic ways the complexities of these painful emotions and unspoken problems. In order to effectively use artwork in teenagers in different settings, therapists must gain the skills necessary to help them understand their clients' expressions, implore assessment strategies that can enlighten them toward a workable diagnosis, and add creative procedures that make sense to them and to their clients in order to help overcome therapeutic resistance and emotional hurdles.

In this book, Shirley Riley draws upon her many productive clinical experiences and teachings to share creative approaches that work to engage troubled adolescents. In understandable prose, she is able to integrate theory with practical suggestions, to explain how she connects with teenagers who may be resistant or provocative. She is able to offer many possibilities that can work in various settings and she provides

many case illustrations that show how the process unfolds. With clarity and conviction, she presents why artwork can be so valuable in determining diagnoses and treatment direction.

This book will greatly enhance your understanding of the teenage years and how therapists using creative media can intervene efficiently and effectively in this process. It will provide the reader with added skills, insights, and directions that can assist both the beginner and more experienced clinician amplify their work. A comprehensive range of timely issues are discussed that only a caring and sensitive therapist such as Shirley Riley can provide. This book will undoubtedly become a valued resource that many clinicians will have on their bookshelves in order to access its stimulating and creative ideas.

Gerald D. Oster, Ph.D.
Clinical Associate Professor
University of Maryland Medical School

Foreword

Cathy A. Malchiodi

When I first read this book, I was immediately reminded of my first work as a therapist with adolescents almost twenty years ago when I was still somewhat of an adolescent myself. I vividly remembered all my struggles, and as Riley describes in this book, my entanglements. Luckily, most of the adolescents I encountered had support from parents or extended family. Art expression served as a potent way for them to communicate conflicting emotions and confusing questions of identity, to tap their natural creative potentials to problem solve, to restore and repair the self, and to forge a meaningful therapeutic connection with me through their images.

Most therapists working with adolescents are not quite as fortunate as I was to work with young people who had relatively supportive parents and families; they generally may see adolescents who come from impoverished families, crime-ridden environments, or violent neighborhoods. Recently, I have returned to working with adolescents and am confronted with a caseload of teens troubled by broken homes, family violence, and the impact of gangs, crime, and drugs in their neighborhoods. The adolescents with whom I work are homeless, receiving art therapy and other services through a drop-in center in an urban setting. All of these adolescents live on the streets, some choosing to leave home and family and others neglected or abandoned by parents or caretakers. They invariably reflect the predominate issues of today's youth – drug abuse, gangs, crime, sexuality, and social problems.

Many of the earlier writings on adolescent development and treatment that I found useful during my first experiences with young people are no longer practical in addressing the problems I see before me each week. Luckily, Shirley Riley has synthesized her vast clinical

experiences with adolescents into a wonderfully pragmatic, insightful, and realistic text which addresses contemporary adolescence and today's priorities in adolescent treatment. While other authors have described the use of art therapy with adolescents, Riley goes beyond classic and often outdated developmental and psychological theories about adolescence and takes a refreshing look at adolescent therapy within a contemporary context. The significance of societal, cultural, and familial is emphasized along with the importance of narrative approaches, post-modern thought, and short-term, solution-focused treatment. Riley also infuses a variety of salient clinical issues such as distancing, reflecting, and timing in adolescent therapy, addressing and respecting metaphorical communication, and understanding the therapist's countertransference or 'entanglements' that inevitably arise when working with adolescents. Additionally, the reader is treated to lively case descriptions and practical clinical applications of art therapy in adolescent group treatment, adolescents and family therapy, inpatient and outpatient populations, residential programming, school settings, and a wide range of individual treatment situations.

Art expression is a rich window to the world of our clients, but with adolescents it sometimes may be the only window available to us. I find, like Riley, that working with adolescents involves identifying and understanding the cultural differences between adults and young people. In this sense, all therapeutic work with adolescents is multicultural. We sip our morning tea, answer our e-mail, think about contributing to a retirement fund, and attend professional development seminars to enhance our skills; they watch TV, worry about rock concert tickets, and think about body piercing. Other adolescents have more serious cultural concerns such as pressures to take drugs, whether or not to engage in sexual activity, or survival in neighborhoods fraught with violence or gang activity. Many of the adolescents I work with identify themselves with internalized cultural images such as 'gutter punks', 'street rats', or 'coke heads', or have created names for themselves such as 'Bones', 'Terminator', or 'Cutter', indicative of their self-concepts and world views.

As a therapist and an adult outside of the teenage culture, I can only hope to begin to connect with these adolescents if, as Riley notes, I can

see treatment through multiple lenses: regional, urban and/or suburban, socio-economic, race, ethnicity, and culture. Rather than clinging to the notion that adolescence is a series of predictable tasks, it is more helpful to take a post-modern stance which honors context and personal perspectives in addition to developmental issues. Art expression is one of the few ways that a therapist can begin to recognize these cultural differences and utilize the multiple lenses available for understanding. It is one of the few means through which many adolescents feel comfortable sharing the impact of culture and society, gender and family.

The contents of this book and observations by its author are refreshingly realistic, reflecting both the successes and failures inherent to adolescent therapy. Adolescents are undeniably unpredictable, no matter what their life circumstances or background, and therapists, no matter how skilled, are consistently confronted by unexpected or unanticipated responses and behavior. In reading the cases described by the author, those who work with adolescents will be confronted by their own experiences with adolescent treatment and the difficulties of art therapy with this population. I was reminded of a recent encounter I had with a fourteen-year-old boy in my practice for the first time last month. During our initial session he asked me about my sexual activity with my husband, demonstrated his ability to burp and create other gastrointestinal noises, attempted to rummage through a file cabinet, and then asked me if I could drive him to a local ski resort at the weekend. While some teenagers may give the therapist the silent treatment, others, like my young client, may test interpersonal boundaries and ultimately the therapist's patience.

When confronted with unpredictable behaviors that can frustrate even the most skilled therapist, we often wonder if it is possible to build a relationship with the troubled adolescent before us. Certainly, as demonstrated throughout the pages of this book, art is an amazingly effective and potent way to begin the process of creating a meaningful bond between the therapist and adolescent client. However, what Riley emphasizes is that it takes more than simply offering art expression to establish a relationship and eventually initiate change and growth. Respecting adolescent clients as experts, recognizing cultural, societal,

and economic backgrounds, and responding to their unique world views form the basis for Riley's approach to intervention. These are necessary components to successful treatment and the development of rapport and by using art therapy as the vehicle, the therapist is able to establish a lasting relationship necessary to successful adolescent therapy.

Lastly, Riley's book is not about diagnosis and assessment *per se*, but is about developing a positive and productive therapeutic structure for exploration, change and growth with adolescent clients. Descriptions of strategies in this text do not correspond to specific diagnoses; rather the therapist takes a creative approach dependent on the pace of the relationship, interactions between therapist and client, and personal needs of the adolescent client rather than a diagnosed pathology. First and foremost, the adolescent's view of self and the world and unique life experiences as expressed through art and image dictate what the therapist must do in order to be of service.

Most importantly, however, this book finally brings adolescent art therapy into the post-modern world where brief, solution-focused treatment is a must. Riley skillfully and cogently demonstrates the importance of contemporary theories of therapeutic intervention and adolescent development, taking the reader through numerous case examples which integrate contemporary theory with actual clinical practice. The richness of this book is enhanced by the variety of settings and adolescent populations presented, offering both the beginning and advanced therapist methodology, strategies, and advice which will enhance their clinical skills and expertise in work with a variety of adolescent populations.

It has been wisely observed that 'therapy with adolescent often requires a departure from traditional talk therapy' (Sommers-Flanagan and Sommers-Flanagan, 1997). Effective work with adolescents requires the creativity and flexibility of therapists and the usual approaches to intervention and treatment may not always fit. Hardy (1996) concurs, summarizing therapy with adolescents as follows: 'Therapy has to be about creating, and then holding, a connection' (p.55). As an art therapist I can't think of a better way to describe the power of art therapy as a modality with adolescents and I can't think of

a more accurate way to describe what Riley conveys in this book. Adolescence is a period of the life cycle dedicated to creating and adolescents are busy with the tasks of shaping identity, experimenting with relationships, and formulating ideas, beliefs, and world views. It is also a time of enhanced creativity, making art expression a natural and effective way to establish a connection with adolescents. Engaging their interests and talent for creativity is one way of few ways to reach this population and overcome the resistance to traditional therapy common to adolescents in general. Art therapy, as Riley persuasively demonstrates, is unquestionably an effective means of engaging this difficult population and of establishing and maintaining a connection which is therapeutically meaningful and productive.

Cathy A. Malchiodi, MA, ATR, LPAT, LPCC
Director, Institute for the Arts and Health, Salt Lake City

Introduction

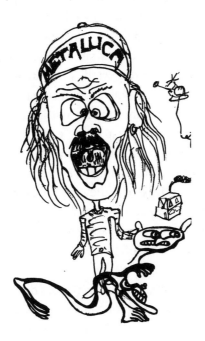

Figure 0.1 16-year-old adolescent male, self-portrait

This book on adolescent art therapy treatment looks at the difficulties of adolescence through a contemporary lens. The text will bring the reader into the real world of clinical practice. It is directed to meet the needs of the practicing clinician and the educator preparing students to face the challenge of adolescent treatment. The following chapters record my clinical experiences, my reflections on adolescent treatment; and how I integrate art theory and practice with post-modern approaches to therapy. I speak to therapists, who, like myself, are interested in a pragmatic and theoretical re-evaluation of the merits of art therapy as a successful therapeutic intervention.

The reflections and practical experiences that are offered throughout the text will demonstrate how, where, and why certain clinical art therapy tasks were selected to accomplish therapeutic goals.

My philosophy embraces the notion that uncertainty and flexibility are positive traits for the 'adolescent' therapist. These traits are seen as an extension of a social constructionist belief system. By that I mean that the adolescent client is viewed in the context of his/her environment and included in the co-construction of the treatment goals. The teenager is encouraged to illustrate his/her perceptions through art tasks, and their narrative is respected. The results are positive.

Uncertainty should apply when attempting to predict the patterns of adolescence; some youths are moving with ease through these years, some are caught in a fatal trap that leads to despair. Who is the adolescent we talk about, and what are his/her concerns? Adolescence is not the same from month to month. This creative, inventive segment of our population is in flux, and they capitalize on their fluidity. They move in a manner of weeks from one ideology to the next, from one form of self-expression to a contrasting form. We scarcely can keep their vocabulary straight, and we often are incapable of understanding their belief systems.

Because a high percentage of clinical cases deal with the problematic adolescent, there is a necessity for a book that will address the practical and challenging needs of art therapists in the 'trenches' with the teenagers. In my opinion, authors who address the adolescent's problems solely from a theoretical base, do not appreciate that there is no single theory that suffices. Many of the workable approaches with this age group come from experience and the ability to take a larger view of theory and bring it into the here and now of treatment. The art product is often interesting and conveys a message of meaning, but the process of arriving successfully to the point of making art, has often been neglected. The manner in which the therapeutic process must be individualized, and the belief system of the therapist, is of primary importance with an adolescent population.

When talking about adolescence we should make it clear in what context we are placing the youths and which segment of this population we are addressing. Are we discussing all of Western society's teenagers (rich, poor, educated, deprived), or the small segment of adolescents that pass through the doors of a mental health facility? Are we seeing the teens in an outpatient, inpatient, or day treatment center? Does the

therapist like working with this population, or is s/he forced by circumstances to take a job that requires providing adolescent treatment?

I bring forth these concerns because I believe that a clinically directed text has a tendency to use the term 'adolescence' in a manner that might be construed to mean most young people of the ages between ten and twenty years. The fact is, a text about therapy is focused only on the limited percentage of teenagers that have not been able to weather the storms of adolescence. These youths have experienced complex stressors that have diverted them from the normal developmental progression. Our task, as therapists, is to do our best to confirm their inner strengths and search for outside support systems. The goal of therapy is to find ways that will assist them to compensate for their distress. Not an easy task considering the complexities of society in the twenty-first century.

A lens on development

When I started to see teenagers through a lens that separated puberty from adolescence it helped me to establish a therapeutic relationship. By that I mean I recognized that there is a difference between physical growth and psychological maturation. Physical growth starts when the biological key turns on, and continues until the hormones and genetic patterns call a stop. Sexual drives, body changes, cognitive potential, all proceed at the individual pace of each child. No two teenagers are on precisely the same path of maturation. I no longer evaluate the teen chronologically, I consider him or her developmentally.

Ideally the psychological growth is supposed to maturate in a synchronous fashion with the physical growth. In many cases, this does not happen. These are the young people we see in our practices. The two aspects of adolescence are 'out of kilter'. We see great, tall boys, needing a shave, who relate to the world like ten-year-olds. We see buxom girls, fully matured physically, with the conceptual skills of pre-adolescents. We also see the baby-faced teen, who as yet has no secondary sex changes, who is miserable because s/he has not started the maturation of puberty. Their sophisticated intellectual abilities and psychological

insights are not appreciated. Add the complexities of the family life, the socio-economic deprivations, the pressures of the peer group, and the chaos of the school system, and you have the adolescent client.

The purpose of this text

Bearing in mind the complicated challenges that these youths present to the clinician, as well as their natural reluctance to communicate on an intimate basis with *any* adult, how can therapy help? My goal is to share some of the successes I have had and reveal some of the failures. I offer utilitarian approaches to working in the real world with families and their adolescent children; clients who are not in therapy to 'grow more aware', but to solve real, everyday problems and get on with their lives. The problems sometimes are too much for therapy, and we have to turn to the social system for support. However, if the therapist sees the client through the lens of a 'development skewed by circumstances', and not as a pathological symptom, even small interventions can help. Solution-focused therapy takes advantage of small alterations to instigate greater changes.

Clinicians in the field who are struggling to help teens bridge the gap between adolescence and adulthood in these difficult times, can apply some of the suggestions in this text. Through their own creative experimentation, therapists will be able to modify and build upon the work I have done. Many of our most resistant youths are being counseled by the least experienced therapists. Neophytes are forced to work where the jobs are, they need practical ideas structured to address the problems that they see daily. The more experienced clinician, who chooses the adolescent field by choice as I have, will resonate with some of the case examples and recall his/her own success and difficulties with this fascinating period of human development.

Art therapy

Art therapy is not an exclusive modality; it offers many positive opportunities for a wide variety of clients and therapists. It is a great way to get past the initial wall that surrounds the troubled teenager, and a

fine therapeutic tool to encourage the story the youth would like to tell. Adolescents want to let others know how 'screwed up' they find the world, but they do not trust enough to use words. They can more comfortably employ the silent form of communication through images. As long as they are not pressed to talk, paradoxically, they will. The art form is safe and under their control.

This book was written to be useful for art therapists and clinicians from allied fields. I believe that professionals of all helping disciplines often find some of their clients create graphic expressions. Whether or not the therapist deliberately encourages artwork, the teen will often make drawings and scribbles in the session. Some marks cry out to be acknowledged, others are defenses to avoid talking. It seems obvious to me that to pretend that this tool of communication belongs to one discipline exclusively, makes little sense. When the therapeutic qualities, inherent in creative expression, surface and become a challenge to the therapist, the advice and support of a trained art therapist can be utilized. Just as I have benefited from the psychological theories of verbal therapists, I hope our friends in allied professions will benefit from learning about art therapy. Art therapy synthesizes verbal and non-verbal communication.

Therapists often are shy about labeling themselves as creative. I challenge that notion. Doing therapy is creative and, at best, artistic. Creative therapists can use art therapy to make visible the clients problems. The client 'sees' his/her problem and has an opportunity to solve it creatively. Art therapy, in my opinion, is a co-constructed fusion of theory, process, therapeutic relationship, and the client's self-interpreted illustrations of their difficulties.

Assessment: structured and on-going

This text will not focus on assessment protocols, they are useful and may be researched by the reader if they have the need to evaluate the client (Buck, 1948; Burns and Kaufman, 1970; DiLeo, 1973; Kellogg, 1970; Malchiodi, 1990; Oster and Gould, 1987; Silver, 1989). The assessment that I prefer is an on-going comparison of the artwork that the client offers from session to session. The individual symbolic meaning

narrated by the adolescent, enriches and personalizes the evaluation. Adolescents are suspicious of pre-planned drawing 'tests'. They are unwilling to be analyzed and will go to extremes to avoid exposure. I would much prefer to involve the teenagers in their own appraisal processes than to try and fit their art into a preconceived schema. It is not too difficult to judge the onset of trauma, when images change from organized to disorganized structure. However, knowledge of the assessments available in art therapy and projective tests used by psychologists, is recommended. There are patterns that dominant in many cases, and can be useful triggers to alert the therapist. The danger, in my opinion, is to have the formula interfere with the ability of the therapist to look at each client art piece as unique. I believe that we each invent our reality, and if I impose my reality or an assessment device on the client's reality, then I am interfering with therapy.

Perspectives and history

When I think back almost two decades ago on the adolescent boys and girls that I worked with in an outpatient clinic in southern California, I believe that the problems were less intense. There were fathers in jail, poverty, drugs, gangs, and sexual promiscuity, but the drive-by shootings, threat of HIV-AIDs, and the surge of minority ethnic conflicts were much less violent. The greatest change that I observe is the high percentage of adolescents who are suffering from pre-natal substance abuse and subsequent neglectful parental care. These learning disabled, hyperactive children make up a large percentage of the clinical cases, particularly at ages eleven through thirteen. Because these early adolescents do not have responsible parents (in most cases) they suffer from shifting placements and dubious foster care. This is a tremendous challenge for the clinician who is dedicated to helping this age group.

Some of the art therapy activities, discussed in the following chapters, are helpful in keeping the teen focused and provides a vehicle for expressing their frustration and depression. If the art therapist chooses to share his/her skills and educate other professionals in the use of art, s/he has offered a unique service. I do not feel that art therapy is threatened when other mental health workers employ graphic images

in therapy. Training in art therapy is specialized and goes beyond the occasional use of artwork to engage an adolescent. There is a difference, and it does not need defending. I hope the examples I have provided will clarify that difference and encourage therapists involved in providing adolescent treatment.

An overview of the following chapters

It may appear rather unorthodox to suggest to readers that they turn to the Appendix before becoming engaged with the main body of the text. I recommend this to those not familiar with social constructionist/ narrative thoughts about conducting therapy. In addition, it is helpful to recognize that these theories are altered when utilized in conjunction with imagery and the incorporation of art making. They are further modified by the person who integrates these belief systems into their own method/construction of approaching therapy; in this case the author of this text. Therefore, I suggest that in order to understand the basic philosophical stance that is taken throughout this narrative of adolescent treatment, it is best to read the last chapter first!

Chapter 1 takes the reader into the specialized environment and attitudes that surround the art of creating a therapeutic relationship with an adolescent. The more recent thoughts about development, and the impact that bears on treatment with this age group are reviewed. A variety of therapeutic issues and how the theories are integrated into expressive therapy are discussed. The importance of seeing the adolescent in the context of their living conditions and past and present traumas is emphasized. Some of the important issues in adolescent treatment, such as confidentiality, power and control, non-pathologizing belief system, and the impact of gender concerns are introduced in this first chapter.

The second chapter focuses on adolescent group treatment. Group is the therapy that is most commonly offered to teenagers; in part because they prefer to be with their peers, and in part because it is financially productive for the agency. The progression of a group from its inception through forming a cohesive whole, is discussed. Art therapy tasks that further group process are developed. Examples of successful and

unsuccessful group interventions are offered, as well as the clinical rationale for the outcome. How to set up a group as well as keeping it vital, is also examined. The art therapy tasks that are described in this chapter on group can also be utilized in individual work if the therapy requires it.

Chapter 3 examines the rising prevalence of depressed, acting-out adolescents. The rationale that depression is the major, underlying cause for adolescent malfunctioning is discussed. Many illustrations help the reader to learn how the adolescent displays his or her depression in the art, even when they are unable to verbalize the pain within. Why the act of externalizing depression is helpful to the teen, and how to encourage this activity through art expressions, is a major focus of Chapter 3. Suicide, self-mutilation, and deliberate risk taking is also looked at.

Chapter 4 offers a unique opportunity to enter into a dialogue between the author and two art therapists practicing with a similar adolescent population but in different settings. The discussion illuminates how the context, the environment, and the agency expectations, color the therapy offered the teenager. Each methodology succeeds, but the approach differs radically. With Aimee Loth we learn how she integrates a time-limited frame into the therapeutic scheme and satisfies the goals of therapy. Her art therapy interventions are inventive and synchronized with a narrative philosophy of treatment. Many of her clients are labeled 'severely emotionally disturbed' and are served in a public school which specializes in keeping these teenagers from dropping out of school. Roberta Lengua conducts her art therapy in a residential setting, with adolescents who have been placed for a variety of reasons. Many are depressed, display conduct disorders, and come from dysfunctional homes. Her art therapy department offers an opportunity for these disturbed youngsters to find a haven in the art. She is not required to limit her treatment to a time frame, and this modifies the art therapy approach.

The outcome of evaluating these two dialogues offers the reader an opportunity to appreciate that *where* the therapy is offered, the *context* and *process* of the therapy, decides whether it will be art psychotherapy or art as creative therapy. The arguments pro and con concerning these two ways of offering art therapy are put to rest by the clear

demonstration that a good therapist is led by the needs of the client, not by an ideological belief system.

Chapter 5 uses the chaos theory as the departure point to explore how the onset of adolescence disrupts the family system. Families, introduced to the chaos theory of change, can benefit from the knowledge that adolescent discontinuous growth patterns are not unusual, are in fact helpful. Education can normalize the impact of the adolescent developmental phase. The variety of 'families' that qualify for this nomenclature is taken into consideration, with a focus on the single parent family. Several case examples help the reader imagine how the art is essential in the process of illustrating the differing views that family members have of the 'problem'.

Chapter 6 reviews the major ways that therapists get tangled up in the adolescent clients' world. Many of our own unresolved difficulties stem from this period of our life, and the adolescent client is a master at stimulating these dormant stressors. Personal challenges that the author has struggled with are referred to, as well as the conflicts that other therapists have shared about their entanglements. This chapter will resonate with any therapist who has to deal with the teenagers of today's society.

Chapter 7 leads the reader through the exciting opportunity of appreciating how art therapy and brief-term therapy can be complementary. The mental health world is demanding short-term treatment from many mental health workers. It is therefore a comfort to see that this is not a deprivation, not poor therapy, but instead, an excellent way to give the client service. In particular, an adolescent client is not willing to commit to long-term treatment if s/he can help it. Rather than unfinished long-term therapy, this chapter provides ideas how to make the solution-focused, narrative approach highly functional.

As I wrote this book I gained pleasure from the memories that came flooding back through the many years of working with this group of youngsters. I have always been drawn to the adolescent youths, and find getting to know them fascinating. If some of this pleasure and excitement has surfaced in my writing I will be satisfied. There are many paths to success in all forms of therapy, this has been my path; I hope the reader will find our walk together profitable.

Integrating Developmental Theories with Art Expressions

I ain't Mental.

(Spoken by countless teenagers as they came to the mental health clinic)

There would be therapists dancing in the street if there was one sure theoretical approach that would lead to successful treatment with adolescents. The reality is; there is no one 'right' way to help adolescents with their problems. No single theory can be the complete answer since each adolescent presents a unique combination of difficulties, each adolescent group is different, and concepts that seemed valid last year are invalid this year. It is time to re-evaluate the myth of 'adolescent treatment' and create a workable mix of theory and experience to serve the youthful clients we treat. Giving up formulae does not mean giving up an educated base which informs adolescent treatment; it does mean that uncertainty and exploration are necessarily components of an exciting challenge (Anderson and Goolishian, 1988). How to integrate classic and post-modern adolescent treatment is a subject that I intend to explore with the reader.

This chapter will set forth the concepts of adolescent development and the manner in which I believe art therapy treatment can successfully serve the needs of this age group. Helping adolescent boys and girls through the 'rite of passage' of the teen years is challenging and exciting. Much depends on a personal empathy and interest in teenagers, a segment of our population that constitutes a large percentage of clinical services and the attention of society in general. Given a positive outlook on this age group, a sense of humor, and some creative

therapeutic tools, the therapist can find pleasure and satisfaction in working with the adolescent client.

The adolescent of the millennium

Adolescence still exists, but the 'adolescent' youth, as he or she has been described in developmental texts, has become invisible. Instead, we have young people propelled into unsuitable, semi-adult behavior before they have reached appropriate maturation; unprepared youths who choose to escape the pain and stress of entering into the adult world by drug use or other destructive behaviors. The myth of adolescence implies that this age group is irresponsible. The dominant story is that adolescent youths will not contribute to family or society. However, we should not forget that between these extremes of behaviors are some adolescent boys and girls who are defying the stereotype which society has created around the ages of eleven to twenty. These healthy 'misfits' are progressing through their teen years with relative ease and without seeking alienation from family or society. Paradoxically, often their lack of rebellion results in making them social outsiders with their peer group, a rejection which can lead to depression. At the opposite end of the scale, youths who seek a life style of high conflict often turn to acting out, alienation from family, and/or suicidal behaviors. The radical adolescent image that is projected by society and confirmed by the teen peer group and the media, becomes a self-fulfilling prophesy. A created reality has made adolescence a period of life that is often feared and ridiculed by adults. Therapists contribute to this negative image since the adolescents they see in treatment are drawn from the group of teens that are troubled, and they study clinical literature which focuses on these problem situations.

A therapist cannot treat an adolescent successfully unless the influences of social norms and economic pressures are seriously examined. Adolescent treatment must be seen through multiple lenses; regional, urban and suburban, poverty and wealth, culture and ethnicity. External stressors in the child's environment translates into internal belief systems. Furthermore, each adolescent brings their own difficulties to treatment. No two youths develop at the same rate, either

physically, intellectually or emotionally. The current thought about adolescent development supports the notion that the guidelines to development can no longer be applied rigidly, as they have been in the past (Leveton, 1984; Fishman, 1988; Rutter and Rutter, 1993; Bloch, 1995; Blau and Gullotta, 1996).

Wylie (1998) offers a description of the teen years:

> The common miracle that defines childhood and adolescent develop-ment is its constant change; there is no period of life when human beings are so malleable, so protean in their own unfolding possibilities. There is also no time in life when human beings are so utterly in thrall to their own emotions, so completely in need of guidance, nurture, the steadying hand of someone who knows better what the world can offer, for good or ill. Children who are denied the deep embrace of loving and lovingly *demanding* adults – real grown-ups, not over-age wanna-be teens – during their young lives do not necessarily turn into human monsters (in fact, miraculously, most of them do not), but the worse the circumstances, the greater the danger. (p.37)

Developmental process: traditional and post-modern

In spite of my hesitation to present the notion of a predictable progression of adolescent tasks, as suggested by some of the earlier observers of adolescent evolution (Blos, 1962; Erikson, 1968; Malmquist, 1978), there are some basic changes which must be achieved before adulthood. It is helpful when working with adolescents to keep these constructs in mind, and to add some of the more modern theories which broaden the scope of developmental evolution (Bloch, 1995; Fishman, 1988; Mirkin and Koman, 1985).

There are two processes of growth during adolescence; puberty (physical maturation), and adolescence (psychological maturation). The rapidity of physical growth varies with each child and depends on genetic inheritance, dietary nourishment, and general health of the individual. Ethnic groups also show some recognizable growth patterns, and sexual development appears to be more or less rapid depending on genetic factors. The refined research regarding these factors are beyond my expertise, however working with teens for two

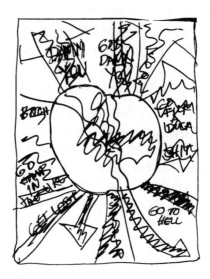

Figure 1.1a First expression of anger at adults

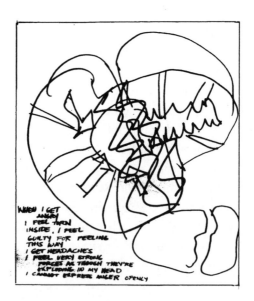

Figure 1.1b Second expression, anger with explanation. 'When I get angry – I feel torn inside, I feel guilty for feeling this way. I get headaches, I feel very strong forces, as though they're exploding in my head. I cannot express anger openly' (16-year-old)

decades has given me some guidelines which I incorporate when planning a treatment plan.

In spite of subsequent work on adolescent developmental patterns, it is helpful to list the stages of development that Blos recorded in his germinal book, *On Adolescence* (1962). Many of his criteria still hold true, some of the psycho/sexual concepts are outdated, but the search for identity as the key issue remains constant. When using these concepts as a reference, it is helpful to bear in mind that the form, shape, meaning of the adolescent identity has recently gone through a major shift. The identity sought for in the 1960s is not the identity favored in today's adolescent world.

Blos (1962, pp.12–14) believed that adolescence maturation occurs ideally in seven major areas; not necessarily in sequential order or chronological progression.

1 The adolescent moves from concrete to abstract thinking.

2 Judgement and logical thinking are developed.

3 Social skills, empathy, altruistic and sexualized feelings become stable.

4 Self-image has become firm enough to withstand criticism and stress.

5 A sense of individual identity incorporates successfully a variety of internal and external roles.

6 Comfort with a changed body image frees the youth from obsessing about appearances.

7 A sense of self strong enough to continue to mature with reduced outside assurance.

These stages are useful for the therapist to bear in mind as they consider long range goals for treatment. However, it is not helpful to intellectualize these processes and neglect how the socio-economic-cultural circumstances make the achievement of these goals difficult, even hazardous, for many teenagers.

Strand (1997) proposes a vastly different form of gauging the nature and development of the structures that guide development. He sees five levels of development that mark this progression. 'Each successive order

of consciousness represents a new position of meaning-making equilibrium, capable of organizing more aspects of possible experience than the previous order' (p.327). He finds the adolescents developing at the third level of meaning-making. 'This stage is referred to as *cross-categorical* thought, which signals the emergence of the capacity for abstraction and self-reflection, the development of values, and participation in mutual relationships. Egocentric management of one's own desires gives way to concern about the feelings and impressions of others' (p.330). Looking at adolescent development from a 'developmental-constructivism' viewpoint is significantly different from the psycho-sexual approach and one I believe will add substantially to successful adolescent treatment.

Rutter and Rutter (1993) take a broad perspective of the developmental process. They believe that:

> there can no longer be a single theory which constitutes a final explanation of maturation; most theories pay lip service to the role of genetic factors; biological maturation; and the relevance of brain pathology. Rarely an attempt is made to provide any form of integration. In addition Freudians, Piagetians, and Ericsonians seem to ignore the social life of children. Psychosexual and operational changes have given way to a focus on attachments, on the way relationships influence others, on the development of social understanding, and on the way children make inferences about another person's thoughts and beliefs. As a consequence of these neglects there has grown a need to create new concepts and a fresh approach. (p.3)

The incorporation of earlier observations of adolescent development with contemporary theories give today's clinician a workable and realistic foundation for their approach to adolescent treatment. I believe that therapists should offer treatment that incorporates a knowledge of developmental stress points with an expressive mode of communication. Treatment that allows the adolescent to show where s/he is on their own personal scale of development.

Figure 1.2 Setting goals: 'Stop screwing around. Stop fighting. Stop flaming up. Stop bugging people. Eat right. Go to school'

Environmental stressors and attention to context

Every person projects, in their artwork and their verbal communication, information that reflects their social, cultural, and familial context. Environmental influences emerge in a client's artwork. Their concerns are embedded and expressed in the context of their world. Normally, the inner-city child selects images which reflect their daily life and traumas, or the dreams they have of a better world. For example, many of these children spend most of their time after school inside their homes; not because their parents are abusive or over-protective, but because it's not safe on the streets. This situational stress may compound the reasons why the adolescent has been referred to the clinic. The teenager raised in a rural environment with comparable emotional problems, may convey a similar message but with dissimilar forms. Forced physical restriction to the home may not be their experience, perhaps they have to endure other limitations that are just as confining. Images may project the same distress, however they differ in form when

created by kids from dissimilar environments. Therapists have misinterpreted the art when the client's living conditions have been ignored. The key lies in looking for similarities and differences simultaneously. All art therapy expressions must be regarded in the context of the art maker's world.

Poverty is endemic in many parts of the world and is equally debilitating no matter where the youngster suffers. Economic hardship cannot be disregarded when evaluating an adolescent's traumatic situation. However, how the deprivation is experienced by the teen can vary tremendously. Poverty has a universal language of hopelessness, but the harm it inflicts is a matter of degree dependent on the personality structure and the support system for the individual. Some resilient adolescents combat poverty and are survivors, others are overwhelmed with deprivation and internalize it. These less resilient youths find ways to fill their lives with alternative means of stimulation; drugs, gangs and crime to combat the disillusion they feel with society. The countless factors that influence the child to make their choices are studied by sociologists and mental help workers, studies that are beyond the scope of this text.

What therapists have to be acutely aware of, is that surrounding circumstances impact the youth, and the youth impacts their environment. We, as art therapists, cannot feel secure that the image is understood until it has been explained fully in the context of how the client experienced his/her difficulties.

Issues of gender and culture

A therapist must wear different lenses when treating adolescent boys and girls. Male and female concerns are very much influenced by the cultural belief system in which they are lived. There are no absolute cultural guidelines. The therapist must do his/her own personal research depending on who they are seeing, where they are seeing them, and what specific external concerns are impacting the therapy. I live in a multi-cultured city. The Hispanic population is numerically about the same as the Caucasian. But who are these Hispanics? Who are the Caucasians? The Spanish speaking persons come from many

countries and white skin does not represent a homogeneous group. Where do the other persons of color fit? We have Middle Easterners, Asians, Blacks, and bi-racial citizens in all parts of the city. How children reflect these complicated demographics, interact and develop, is one of the most challenging issues of our time.

In my opinion, the only sensible and practical way to approach this enigma, is to see each person in therapy as a member of an unfamiliar culture. Indeed, we all are strangers to one another. If we are genuinely curious and question with sensitivity, we can be open to the experience of the 'other'. We must ask our clients to teach us about their culture and correct us when we make wrong assumptions. How each culture perceives the time of life that we have named adolescence differs greatly. A teenager may be expected in his/her culture to conduct him or herself quite differently from the general modes of behavior in Western society.

Theories that hold to a sequential pattern of adolescent development are most challenged when looking at therapy from the stance of gender and gender defined roles. Adolescent youths exert a powerful influence in society. They create the male/female image of tomorrow. A major difficulty lies in the confusion that the adolescent feels over the very roles that they are determined to modify. Since they are not clear about the distinctive traits and duties of men and women they will not be very perceptive when they strive to explain their views. Collage is useful when attempting to understand gender defined roles through the eyes of the youth in treatment. The client can cut, mix images, juxtapose shapes, and symbolically experiment with concepts that are vague. Drawing over or around the collage can add to the individuality of the art expression. If the adolescent is provided with flexible media, s/he can clarify what s/he is sure about and what s/he is not. However, if the magazine pictures are all taken from *Cosmopolitan*, the art will not be representative. It is the art therapist's responsibility to buy or beg magazines that have illustrations which show persons of various cultures and color, a broad variety of ordinary people. *Vogue* will not do. Plasticine and marking pens come in a variety of skin tones. Art therapy must have the tools to facilitate reaching goals, not add to frustration. Many youths today are verbalizing equality for gender defined roles, but in fact are living according to the old double standard. The attitude

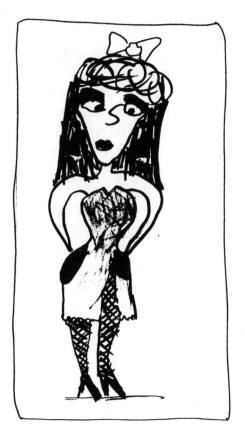

Figure 1.3 Today's teen girl in yesterday's image

of their ethnic group has much to do with this paradox. How the teen is influenced by the family's belief system is a major concern. The adolescent may protest that he (or she) no longer believes in those 'old fashioned' ideas, but, in spite of the 'American dream' of equality, the girls are still taking a subservient stance and the men a macho role. Look at the gang model; the structured, double standard roles are alive and well. Although it may be dystonic to his or her belief system, the therapist must resist imposing his/her own convictions about gender defined roles on their clients.

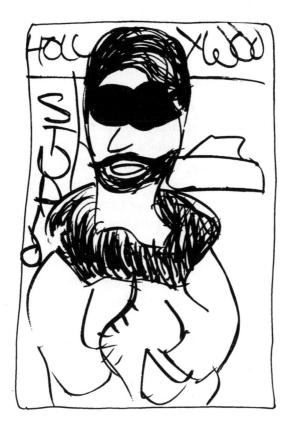

Figure 1.4 The Hollywood 'Macho' dream

Adolescent creativity

One of the sorely neglected, but dominant traits of adolescence is their creativity (Malmquist, 1978). Teenagers are willing to draw and create art as freely as they resist talking to an adult. How to engage this talent for creativity and channel it into therapy, is the skill of the trained art therapist. The author takes issue with the notion that structured pre-designed assessment and art directives can be relied upon to achieve therapeutic goals. Assessment is useful, but therapy is an opportunity to provide a creative outlet for conflictual material, an outlet designed to help the adolescent therapeutically. The following examples of

interventions, vignettes and narratives will illustrate how the adolescent's individualized creativity leads the therapist to a more successful conclusion of treatment.

Art therapy with adolescents

From the time I first studied adolescent development and clinical art therapy I was aware that the theory and the modality seemed to mirror each other. For example, the adolescent enters into the most creative time of their lives: art therapy is based on the notion that when creativity is introduced into problem solving, the art can provide fresh viewpoints and excitement. When thinking of adolescent creativity the traditional attachment to aesthetics must be broadened to include imagination and behavior. As an example of creativity, consider this common use of inventiveness: a teenager can invent more ways to avoid doing something they dislike then any adult can imagine. Tapping into the adolescent's creativity is not difficult if the art therapist suggests expressive tasks in a manner which shows respect for their way of reinventing meaning and involves subject matter that is of interest to the teen.

Continuing with the metaphor of the mirror; another dominant trait of adolescence is the desire to develop an individual personality. They prefer to create a personalized image of themselves, internally and externally, without discussing the process with adults. This desire is reflected in the art therapy process, where the method of creating is thoughtful, individualized, and non-verbal. An image becomes tangible in an art product. However, the process which transpired within the youth creating the image, and the subsequent choice of verbalizing, is voluntary.

For every person, adult or adolescent, who makes a choice to produce a specific image, the selective mental process which is activated is extremely complicated. The mind must scan all memories stored in relation to the subject which is the focal point of the planned art expression; the client then decides which memory to retrieve, and determines why it is significant; finally, how to render the memory with media and discuss its significance. Many possibilities are reviewed, one

is selected. All this is done in seconds. In addition, the image stimulates metaphorical conversation which enriches the possibilities of communication.

The visual image informs the adolescent on two levels. First, an art product manifests the cognitively selected overt meaning of the trauma. Second, the art is a conduit for material which may unexpectedly surface through the representation. Visual images can slip by the barrier of ordinary defenses and provide information that has been inaccessible to the client. In spite of how complicated this process sounds, it is something that is possible for everyone, and can be accessed (without consciousness) when desired.

Freedom and singularity are characteristics of the adolescent process and the art therapy process. An art expression is always 'original' since it is created by an individual. If the drawing is a 'copy' it is still a personal effort and displays some peculiar characteristics. Even stick figures are dissimilar, since they are drawn with a different stroke from a different hand. There are no restrictions to creativity and no 'right way' to make an art therapy drawing. If the expression conveys the client's meaning it is 'right'. The client is always free to change the 'rules' and reinterpret the directive.

Finally, the quality of art therapy that is most appealing to the adolescent is that the art is non-threatening. If the therapeutic product comes from your own hand, and no one knows what it means until you tell, then how can it be threatening? That is not to say that often the art reveals material that the art maker had no intention of representing. However, this unintended revelation can be kept private or shared with the therapist at the will of the client.

The early alliance

It is essential and difficult to provide a non-confrontive, flexible form of therapy to the reluctant teenager who resents being in therapy. Imagery, as it is used in art therapy, is often the key to making an early alliance which is so essential in adolescent treatment. Art therapy must be offered in a manner that comfortably fits the adolescent; the teenager is wise about interpretations and projective tests. They will look with

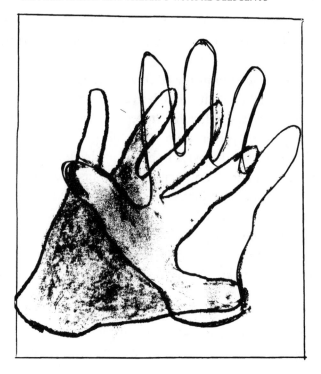

Figure 1.5 Tracing of adolescent's hand, therapist's hand. Concretizing the relationship

suspicion on art tasks unless the therapist understands how to engage them in the process and utilize the product. A false move of interpretation or an imposition of the therapist's agenda on the relationship, will null the opportunity to join with the young client. Every relationship with an adolescent is in jeopardy in the early stages.

Malchiodi (1997) addresses the need to establish a relationship quickly with a client. Although she was referring to abused children, the skittish adolescent is no different: 'the therapist must always remember that there is not much time to establish a relationship. In order to make any progress with a child, a rapport must be established quickly during the opening stages of intervention. A natural, nonthreatening approach that immediately conveys concern and respect is advisable' (p.36).

The form and shape of the therapy must conform to the adolescent world view. It is hopeless to attempt to approach the teen client with psychological techniques created for adults. In fact, the only workable

therapeutic technique is for the therapist to enjoy working with this age group, be interested in their opinions, and be open to learning a fresh way of looking at society and behaviors. If the therapist attempts to inflict his/her belief systems on an adolescent, they will be gravely disappointed. If they are willing to listen to the teen view and exchange opinions, the adolescent is often tolerant and forthcoming in a dialogue.

Identity and identifying adolescent codes

Personality traits and behaviors, generally experienced during this period, are also essential factors that the clinician and parents must expect to encounter. The adolescent is in search of an identity first and foremost, and his/her search is conducted in a manner expressive of the youth's personality. I have often said that the reason kids of this age stand in front of the mirror for an extraordinarily long time, is that they hope by peering at their reflection they will become acquainted with the stranger that is reflected back! Focusing on themselves exclusively is

Three self-portraits by girl with esteem problems and identity confusion

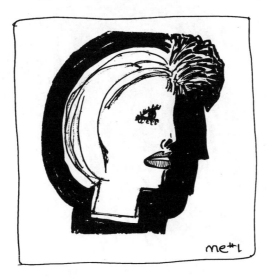

Figure 1.6a 'Me'#1

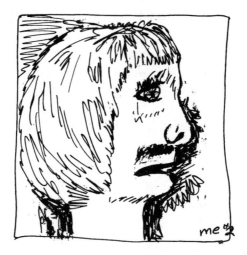

Figure 1.6b 'Me'#2

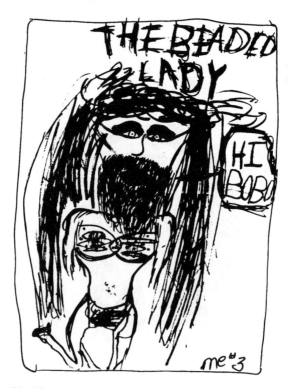

Figure 1.6c 'Me'#3

one of the mechanisms that fosters this search for identity. It is irritating for adults to deal with the extreme narcissism of this age, but it is less difficult if it is understood as a process toward adulthood and not a fall into pathology. The sense of self is so fragile that conforming to peer group dress codes, musical choices, vocabulary, and hair styles, are all attempts to find some reassurance and identity. In a personal survey I have interviewed about twenty youths in their adolescence, asking the question 'What are teenagers most concerned about?' Almost without exception they replied, 'How they look'. The 'look', the dress, the jeans, the shoes, all identifies the clique to which the teen belongs. Without a peer group from whom the teenager can find support, they feel lost. Rejection by peers is the greatest threat. If therapists do not understand that these values are primary in the minds of their clients, they will be ignoring basic facts of adolescence.

It seems strange to an adult who is not part of the adolescent world, that parents often sacrifice essentials to buy their son a pair of expensive athletic shoes. To the outsider the shoes do not appear to be any different than a less expensive pair, but the label *is* the child. I had a thirteen-year-old boy in therapy at the clinic, who carried his expensive athletic shoes with him in his back-pack. If he wore them he might be beaten and robbed by the local gang, but just to own them gave him status in his eyes.

Metaphorical communication

Finding a metaphorical idiom is at the heart of intimate clinical understanding and personalized dialogue.[1] Sims and Whynot (1997) explore the use of metaphor as a technique for recognizing and learning to employ a neglected linguistic resource. The metaphor is an aid to elaborating and making sense of the narrative. They suggest that 'we postpone "making sense" and take time to explore the imagery being used and expand the range of association from which meaning will arise. In the narrative mode, meaning is not a destination. It is a process.

[1] Metaphor: use of a word denoting one kind of idea in place of another to suggest a likeness between them. *Franklin Dictionary*, Merriam Webster, 1987.

The goal of our inquiry is not to arrive at knowledge but to cultivate understanding' (p.343).

Adolescents are constantly using their own individualized metaphors. They would much prefer to find their way in this mode, than to be confounded by adult grammatical rules. Metaphor is another aspect of their creativity applied to communication. This preference serves the art therapist in providing individualized treatment. Art therapy has always sought and utilized metaphorical communication inherent in the art product. Art makes it easier to enter into the range of associations that are embedded in the image. This is done by validating the image, staying with the imagery, rather than assuming knowledge of the meaning. Adolescent clients are comfortable talking through the metaphor. Their creativity embraces this artistic variation on mundane communication and they enjoy elaborating a narrative through an allegory.

Resistance to revealing the content of the drawing should be expected from the adolescent, and, generally speaking, is appropriate. Resistance should be reinterpreted as appropriate withholding of private revelations. That is the rationale behind the use of metaphor, a way to circumvent disclosure and still have a meaningful dialogue. Most adolescent clients have had so many unfortunate and disappointing interactions with adults they have every right to be cautious about trust. The youth that reveals his/her secrets immediately is less appropriate than the reluctant sharer (Rinsley, 1980, p.7).

Distancing, trust, and timing

The early alliance between therapist and adolescent should be built on inquiries that are 'once removed'. An adolescent will cooperate when you ask, 'If you were reporting on your age group, what is the major issue most kids would be worried about? Illustrate this concern for me, to help me understand'. The therapist is asking about a broad issue where the client can act as an 'expert', and inform the therapist. S/he can deny that the subject under discussion has any personal significance. Exploring a topic by relating it to the art, not the client, reinforces the comfort of distance. An art therapist has the option of

keeping his/her eyes on the drawing, and thus gracefully avoiding direct eye contact, which is often discomforting to the teen. If the therapist asks questions about personal matters early in the relationship the adolescent will be ill at ease and probably not respond. If general questions are proposed, the youth can reveal him/herself 'behind' the guise of the 'other'.

This way of working is in contrast to the more structured art therapy approach which has a pre-determined protocol set for establishing a therapeutic relationship. Having a progression of 'directives' provides comfort for the therapist, it does not necessarily fit the adolescent client in treatment. I believe that assessment procedures should be separated from the art therapy relationship. The teenager flees from confrontation, and is suspicious of any form of adult-driven directive.

For example, a girl in middle school made a 'scale of importance' drawing. She felt that for most adolescents clothes and musical choices were a number one concern. She drew this most prominently on the page. Being 'smart' and going with 'smart kids' was her second choice; friends that you can trust followed. Only at my suggestion did family get on the list at all. I inquired if family meant a lot to her and her friends, she replied, 'not really'. This child was from an intact and supportive family, and I believe that her relative disregard of the family was not only age appropriate, but demonstrated her assurance that they would be there when called upon. It would have been a mistake to judge her values and introduce some notion of pathology based on some theoretical evaluation.

In many cases, the less sturdy the family relationship, the more frequently distorted family images are shown. For example, the family may be scattered all over the page with no interaction demonstrated; important members may be left out; or actual physical confrontations may be pictured. This often reflects the anxiety the child feels about permanence and security, or other family dysfunctions. An exception to this observation is the child that is totally abandoned. S/he may never cooperate with creating a family drawing because it is too painful to face the complete loss. All these variables invalidate a set interpretation of adolescent drawings.

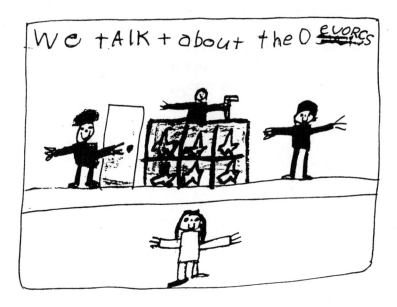

Figure 1.7 12-year-old projects a 'divorce' day at court

Through the form of creating 'once removed' illustrations, and talking about 'other kids', it often becomes clear that the 'other' and the client are one. Even this interpretation should not be made with a feeling of certainty. This age group is very wise and s/he may be talking about concepts and abstractions rather than being self-revealing. Time will confirm the individual reality of the client. When there is a greater understanding of the youth in treatment the time will come for problem solving. Through illustrating concerns and stories with many alternative outcomes, a preferred conclusion can be created. If the adolescents *can* picture an alternative, then it stands to reason that they have a concept of success that can be activated and reinforced. Without a vision of change a positive therapeutic outcome is a very difficult challenge.

Being 'right or wrong' should not be an over-riding concern in the therapy of adolescents. Following a narrative form of therapy, the most important concern is the discourse. What the story contains is what the client is willing to let another person know about his or her self. By

continuing this form of 'story telling' dialogue the child will begin to feel safe as s/he teaches the therapist about issues of adolescence.

Handling proscribed therapy

I want to emphasize that there is a tremendous difference between adolescent youths who have had some stability in their lives and those who have not. Cobb (1996) examines the tremendous impact that loss or thwarted attachment from primary caretakers has on adolescent development. The losses experienced in childhood remain operative in adolescence. When the youth becomes overly anxious and has no attachment figure to turn to, the distress is heightened since they are reluctant to signal for help (p.62). There are also great differences between compliant adolescents who have been educated to accept the concept of therapy as a help, and those forced into therapy more as a punishment by courts or societal institutions. The youth who *has* to be in therapy will most probably see it as a point of honor not to be forth-coming. The youth who has been in therapy since s/he was a youngster, because either the parents or the system has attempted to have a series of therapists substitute for family, are also extraordinarily guarded and resistant.

It is perfectly reasonable that during the period when a child is forming an identity, when they are searching for role models and consistency, they will be strongly defended against opening up to a stranger (therapist), an adult with whom they neither want, nor feel, any sense of continuance. Acknowledging this reality, and asking the youth for some direction for the relationship is the most hopeful approach. I often turn to the pleasure of making art and temporarily leave the immediate goal of therapy behind. I verbalize, 'let's put the notion of therapy aside, and just do some drawing'. When the youth can save face, and give himself or herself permission to enjoy the act of creating, the therapeutic process will introduce itself in due time.

The severely damaged adolescent who is fearful of therapy can find pleasure in moving colors about and making their own graffiti. If the therapist stays in the role of interested observer and helper, and admires the art product (particularly the effort made), the onus is removed from

upport of the reluctant client by moving from 'therapy' to art skills, models a non-intrusive adult who is accepting and genda. If authorities demand verification and records of certain oral changes, and confirmation of attendance, the therapist can sh.. with the client their dilemma of providing this information. If the adolescent is included in co-creating a treatment plan, they feel you are working on their behalf. As a co-creator they can find solutions to some of the most puzzling systemic situations and demands, if they are offered the opportunity.

Polarity drawings

Providing art materials without an explicit agenda is one way of providing therapy that is acceptable to the adolescent population. Under these circumstances the client makes free drawings and comes up with the subject for discussion by him/herself. However, for most adolescents in treatment there is less need to be so entirely unstructured. My own approach is to offer an opportunity for the kids to do 'polarity' drawings. That is my terminology for an art expression that looks at both sides of an issue. For example; 'How do your parents punish you? How do you punish your parents?' Youngsters do punish their parents in a variety of ways. There is usually a lively discussion of how loud music and deaf responses, etc., can drive the parents up the wall. Following this provocative subject, I will usually ask, 'How would you handle this problem if you were the parent?' The corrective drawings (my terminology) challenge the adolescent and when the roles are reversed they offer more rational problem solving than most of us expect.

An example of making a 'correction' on a drawing is to ask the youth to take a color that is identified as the 'corrective' color, and redraw on the original artwork changes that would reduce the problem. If making marks is not enough the toxic image can be cut away, or cut up and reassembled, each action designed to find a more functional outcome to the difficulty first presented.

Why is this 'polarity' approach successful? The adolescent is ambivalent about most issues because this is the time to question both

Figure 1.8 Free drawing 'I am a target' (16-year-old boy – red and black pens)

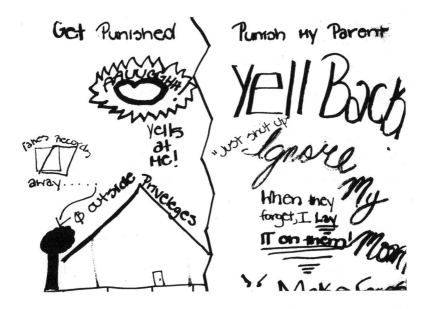

Figure 1.9 'How do you get punished? How do you punish parents?'
(14-year-old boy)

sides of a topic and form individual values. It is a time when thinking logically is a new skill, and they delight in this new power and carry it to extremes. The attempt to separate from the parents, while still keeping a connection, challenges them to review the parents' belief system and retain or reject parts of parental behavior. Looking at the opposing sides of issues through the art expression, encourages the adolescent to do what s/he is doing constantly, but in a concrete form where the plus and minuses are easier to evaluate.

Knowing the developmental framework of adolescence provides the art therapist with tools to suggest subject matter for artwork. Without a point of reference from which to speculate and instigate a dialogue, the therapist has less chance to succeed. I find it useful to talk to the teen about 'other clients' who are conflicted about the 'justice of the world', or the 'appropriateness of the educational system', (couched in their language). Puzzling with the teen often leads to an art piece that expresses his or her view of society. Adolescents have great pleasure in their new skills at logical thinking, and that mixed with a feeling of grandeur gives them the right (in their eyes) to revamp the world. In some cases I have been impressed with how inventive and fair minded their suggestions are.

Adolescents are intolerant of facades and social behavior that they consider phony. Another polarity drawing is one based on 'How do others want you to act, how do you want to be?' A variation on that is 'How do others see you? How do you see yourself?' This directive allows the youth to stay in his/her dominant narcissistic stance and project criticism of the adults, while metaphorically symbolizing his/her 'true' self. This same drawing done at progressive stages of development becomes a record of the growth of identity and the tolerance of others.

Confidentiality of the artwork

Breaking confidentiality is the greatest crime a therapist can make with a teen teenager. Art should never be shown to other family members, peers, or staff, without full knowledge and permission from the art maker (Malchiodi, 1990). Whether accidentally or with good

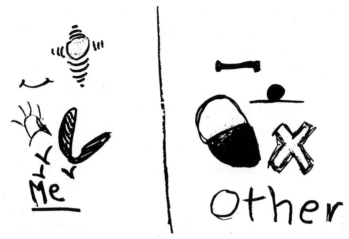

Figure 1.10 'How I see myself. How others see me. "Me" a butterfly, a bouncey ball, smiling, watching. "Other" no smiles, a lead weight, black shell, crossed out' (13-year-old girl)

intentions, for whatever reason, if the art goes out of the room and into the hands of anyone else the therapy is finished. Adolescents are unforgiving if betrayed. Therefore, therapists must guard the artwork vigilantly. If there is a situation that arises where the art indicates that the child is at risk, the youth must be a part of the process of showing the art or reporting on its content. If a parent is called, the adolescent must be in the room to hear the conversation. If an appointment must be made, changed, or questioned, the telephone call should be directly to the client, not the parent. The therapists will be trusted if they demonstrate trust.

Art therapy messages

An exception to keeping the art in the room, was created to solve a therapeutic impasse. Two brothers living in a residential setting refused to talk to their parents. To find a way to let their voices be heard in the family session and still not force them to talk, the art therapist had them draw messages to the parents in their individual therapy. Drawings that expressed their wishes and feelings. The artwork went to the family sessions rather than the brothers. Messages were sometimes sent to the

ay of collage expressions and sometimes by drawings. The
ion through the 'neutral' media of the art therapy
ve the parents time to consider the content. The boys were
k about the session from the family therapist until enough
established to have the sons and parents meet together.
When silence in the family session constitutes a major problem, the art
can be constructed to be the adolescent's voice.

In other cases, art messages to persons who have caused the
adolescent emotional pain may never actually be sent. If clients have the
opportunity to externalize and concretize their statement of un-
happiness, it is often a great relief. This same technique of the
art-created message can address the unfinished business a youth has
with persons who have vanished from their lives. Grandparents or
parents who have died, mothers or fathers that have deserted the family,
can all be the recipients of the message that was left unsaid in the past.
The art gives the youth a safe place to mourn and express his/her
repressed feelings.

The issue of control

For any age group the art therapy expression is a personal projection of
the feelings, concerns, and thought processes of the art maker. For the
adolescent an additional attraction is found by exercising their control
and power. *In art for therapy they learn to freely project their concerns, secure in
the knowledge that they need only share verbally what they choose.* I have said
earlier, and it seems worth repeating; it is crucial for the adolescent to
feel that they have control over their relationship in therapy. The art
means what they say it means. There are times when I have been sure
that I was being tested, and when the drawing had little to do with the
verbal discussion. This seemed less important than the fact that I was
worthy of being tested. On occasion, the content that manifested itself
in the image seemed to blatantly contradict the words that I heard.
However, when I allowed myself to get beyond my own 'visual
knowing' and move into the drawing as the client described it, I often
was rewarded with valuable information.

Drawing as communication

As I describe the encounters with clients of this age, I have used the term 'drawing' repeatedly. This is not accidental. In my experience in an outpatient clinic, adolescents prefer to draw. They favor black markers, red is second choice. The drawings may be stereotypic; gang symbols and teenage logos may take the place of spontaneous images. Again, this is the need to conform to the peer standards, to keep the adult at a distance, and make their mark of identity. Collage is also acceptable to this age group since they are often perfectionists and highly critical. It is seen as a way to make art that does not reveal their low opinion of their artistic capabilities. Adolescents can be very inventive in their use of magazine pictures. They often cut away parts of several pictures and reassemble them to make some startling images. If teens are aware of the second level meanings present in these collage pictures they do not necessarily share their insight, but hope the message gets across to the therapist. As the therapeutic relationship grows the adolescent will expect the therapist to 'get' their revelation and understand the meaning. When these expectations have become clear between the child and the therapist there is a great deal more latitude for speculations and cautious interpretation. As the system of communication is strengthened, the therapy becomes less mysterious.

Missing the message in the art

A girl was in treatment with me for a rather long period of time. We started when she was twelve and our contact continued inconsistently until she was in her late teens. 'Annie' was a troubled girl who ran away from home and acted out with drugs, but made most of her appointments faithfully even if she was on the streets. She repeatedly drew walls with ladders leaning against them. Annie identified the wall as her problem that she had to scale, and the ladder as the therapy. I inquired about the hidden side of the wall, what time frame was needed to scale the wall, and every other supportive and interested speculation I could imagine. The walls kept appearing and I was fairly sure I had a notion of what they meant, but I was reluctant to make an interpretation before her decision to disclose. In due time she identified the wall as her

vith her gender identity. She was very forthcoming in her
.it to me that she thought I would never 'get it'. In her mind she
nould have known that wall equaled 'coming out' and have
ssed it openly. Perhaps I should have. I was concerned that I
w.. .ld be ahead of her with an interpretation, she was hoping I had the
ability to read her mind and say the words she wanted to say.

A major area of treatment that must concern therapists, is supporting
the gay and lesbian adolescents as they make very serious decisions
concerning 'coming out'. Depending on the family context this choice
is a major turning point in a young person's life which is already more or
less painful. If the family is punitive it is a traumatic event. In all cases
there are identity issues, both personal and societal that must be
examined. The support systems for the gay community have recently
expanded, but prejudice and religious pressures are still dominant. It is
essential that art therapists become informed of the literature recently
published, and inform themselves of the community services which can
aid the youth find a supportive environment. The strength of using art
therapy is that the image can serve as a first step toward telling the story
non-verbally; the story of gender identification. The case mentioned
above is an example of a girl working out her decisions in the art and
conveying the message without words. When she felt more secure she
could tie words to representation.

Talking in numbers

During adolescence the ascent from year to year marks significant
changes. There are differences between being twelve and thirteen, there
are changed expectations of a fifteen-year-old versus a sixteen-year-old.
How the child defines these changes and their expectations that
surround the transitions differ radically in every case and are influenced
by many factors, such as, family, economic, and cultural conditions. By
taking advantage of the concept that each year of adolescence is a
metaphor for behaviors, sexuality, and individuation, I have learned to
talk numbers. Numbers are neutral, they are non-perjorative.

By 'talking numbers', I allow teenagers to make their own
interpretation of the question of growth and change. The content of the

Figure 1.11 Middle school girl looks to the future: over the bridge to graduation. A behavior change

response to a 'numbers' question, fits the youth's interpretation of the question. For example, I will ask a girl of thirteen; 'What expectations will the guys have of you when you become fourteen? How did that differ from twelve?' This question implies an examination of the growth of sexuality and social pressures. It could also lead to a personalized interpretation that has to do more with physical maturation, responsibilities, etc. To another child I could ask; 'Show me what age your parents see you as? How old do you see yourself?' 'How will this image change when you are __ years older?' 'If they treat you like ten, how can you convince them that you are thirteen?' None of these questions ask specific questions, but all of them open the door to a variety of responses that are shaped by the needs of the client. I also emphasize change by inventing reality. 'How old are you?' 'Sixteen.' 'Did you know that sixteen is the perfect age to accomplish the changes that you want?' (Whatever age is proposed is the 'perfect' age.) This invented reality invites the youth to supply an alternate outcome to a negative script (Watzlawick, 1984). I have offered the concept of a

turning point, which I believe is a critical tool for anyone in therapy. Talking numbers moves the dialogue to a different plane, and by its neutral, non-judgemental language, allows the adolescent to communicate easily. If I have added a little magic to the therapeutic prescription, I am guilty.

Many teenagers have a clear understanding of the dilemmas of their lives, they lack the vocabulary to project their ideas. A parentified child doesn't know that expression, but they do know how to draw an old lady of fifty, a self-image that represents their inappropriate responsibilities. Often this image is followed by a drawing of a child of five, which depicts how their parent treats them. Imagery makes it all clear; to the child, to the therapist.

I had a thirteen-year-old parentified boy in group, where his main goal (which was conceptualized and supported by the group) was to be thirteen! Every time he began to justify why he had to be responsible for his mother, the group got on his case and yelled 'thirteen!' He understood that goal perfectly and was able to report how 'old' he had been during the week between group meetings.

Language

Language can be a barrier to understanding. We all hear a word in the context in which we were taught its meaning, as time passes the word cumulates further significance. There is no pure meaning to any word, since it not only has a unique intellectual significance, it also has a singular visual image activated by the vocalization. *The advantage of the shared image in art therapy is one of the greatest values that can be credited to this modality.* The tangible communication of the problem allows both client and therapist to focus on an art product that is before them. The mystery and miscommunication embedded in languaging is greatly reduced. I offer one example. If I were to say 'father', would anyone of us visualize the same person with all the emotional significance attached to that person/word? Would it not be more clear if I created a picture of my father, through collage or simple drawing, that embodied the essence of that man? I could then point out his character and his role in my life. My concept of father would become not only visible to another person, but

where, when, and how, that word 'father' came to mean a certain set of values to me.

The challenge of communication is described by the social constructionist theorists as ideas, concepts, and memories arising from social interchange and mediated through language. The therapeutic process is a system where the dialogue leads to a creation of a new narrative. The alternative story allows for change and hope to become a turning point for the client (Gergen, 1991; Hoffman, 1990). For adolescent treatment this approach allows the therapist to enter into a dialogue with the client in a manner that is positive and instills hope. Changing the outcome of a story does not seem daunting to a teen, whereas making 'major changes in behavior' sounds overwhelming. A narrative begs for visual illustration, therefore the art is syntonic with the theory (Riley and Malchiodi, 1994).

Language is often a smoke screen behind which the adolescent can hide from adults. By inventing new words with specialized meanings, and changing that vocabulary from month to month, the outsider is effectively excluded. This clever, creative device succeeds in creating confusion. To avoid being caught up in a losing game of 'guess what this means', reinforces the practicality of utilizing visual communication, the choice of art therapy for teenagers. Taking this concept a step further toward making the language specific and understandable, a task could be invented to deal with this predicament. The therapist could ask the adolescent to help make a dictionary of images that represent the unfamiliar words. Adolescents sometimes enjoy teaching an 'innocent' adult what it's all about.

Media

As a general rule, adolescent clients prefer the same limited group of media to be available each session. Like children in a changing world, they like the stability of their chosen tools. The art therapy room should have a basket of broad tipped felt pens, a basket of oil pastels, a basket of collage pictures (cut out) and accompanied by a glue stick and scissors, on the table at every meeting. Paper is best provided by a roll of white butcher paper, which allows the paper to be torn the size that fits the art

Figure 1.12 Damaged youth, with his self-created 'twin' (Alter-ego)

image. Standard size paper does not make allowances for the needs of the client. One young man took the roll of paper, made an image of himself at the top, and then rolled the paper from the therapy room down the hall to indicate how far he wanted to be away from his mother.

None of the materials should be 'precious'. Casual containers, a casual attitude about the choice of media and the manner of representation, helps to reduce anxiety about an artistic product. However, when the well done piece is created it is a delight to marvel over!

In addition to the favorite broad tipped felt pen; plasticine (oiled clay) is also acceptable to the adolescent. At first, the boys take satisfaction in using the clay to create large penises to shock the therapist. Past that phase, the youths can demonstrate the family system with lumps of clay (more or less articulated) representing the members. They then are often willing to have the plasticine figures have a

dialogue. Many secrets can be shared in this manner, and the form of the communication system is heard in the role-play. The three-dimensional aspect of clay simulates movement and narrative. This technique resembles play therapy, with the advantage that the object is created by the player. When dealing with anger there is satisfaction is squishing the clay flat if it represents a person that the kid would like to eliminate. Contrary to being satisfied with lumps, many teenagers, not only the girls, are able to render well articulated small sculptures.

Art therapists should share that they do not believe they can 'read' the art or that they are convinced there is a reliable rationale proving that colors stand for certain emotions. Be willing to share your reactions to the youth's art, *after* it has been discussed from the adolescent's view. Communicating your reactions to the art maker gives the artwork respect. In addition, it provides an opportunity to reframe and gives positive connotation to the therapeutic transaction.

Let the hands do the talking

I had an older teen return for a follow-up visit rather unexpectedly. She sat with me and played with the clay and talked about social things and

Figure 1.13 The adolescent 'get away'

made insignificant chatter. While she was talking her hands were busy. In due time we both looked at the table where her little yellow bird rested, who had an egg in her tummy, rather like a kangaroo carrying a baby in a pouch. We both sat there quietly while the sculpture sent its message. She had a hard time telling me she was pregnant, so her hands did it for her.

In a family therapy situation the non-verbal adolescent boy of thirteen, kept me informed of the family's progress by drawing a surfer. This surfer started out in jeopardy, about to be inundated by a huge wave. At each session he handed me a drawing with the same theme. As the 'surfer' began to master the waves, the family showed their mastery over their difficulties. In the final session the surfer was shown doing a complicated turn and landing on his board safely. I relied on his visual reporting (Riley and Malchiodi, 1994).

Adding kinesthetic opportunities to therapy

Too often the kinesthetic sense is neglected when we think about engaging the whole person in the creative process of change. However, it is an important part of how we experience the world. If clients are engaged physically, such as in drawing or sculpting, they are reinforcing the thought process. Hand and arm movements used in making art, seem to stimulate a person to form verbal connections and anchors the image in memory. For the reluctant adolescent client I advise having some balls of variously colored plasticine in a basket on the therapy table. I have found that it is almost irresistible. Once the fingers begin to knead and play with the clay, the mouth seems magically to start to move. With clients of any age, I regularly encourage them to let go of any pre-formed notion of what or how they should do an art therapy expression. My way of explaining an avenue to spontaneity is to urge them to 'let their fingers do the thinking'. Fingers prove to have brains too. They can create without inhibitions hindering them!

Art therapy journaling

Adolescent boys and girls who have some artistic talent are often disappointed if they feel they are being pushed to draw only as a response to some question from the therapist. In these cases, encouragement for their ability and praise for their products is the best tool for therapy. Making (or buying) a plain paper journal and educating the adolescent about drawing techniques, if they request it, and demonstrating the notion of keeping an art therapy journal is helpful. A journal can become an exciting exploration for the teen, talented or not. It is a time that many youngsters keep diaries and are very secretive about the contents. The art therapy journal becomes a complement to their diary and provides expression when words are inadequate.

The journal is used to visually reflect situations that arise on a daily basis. It is not confined only to reactions to trauma, but is used to record thought and responses through artwork. Patterns and personal color codes will emerge over time and become a valuable tool for the artist. In addition the art therapy session is extended by many hours by utilizing the journal an adjunctive therapeutic session. Talented youngsters may be less self-revealing in their art since they will be looking at the product more intensely than engaging in the process. However, the art will assume its own power of communication in due time.

I find it difficult not to get caught up in the fantasy that it is my responsibility to see that a talented teen receives art lessons. I have to remind myself; be encouraging, support him or her in continuing to make art after therapy is over, give the adolescent information about community programs, and remain within the parameter of my role as therapist.

Illustrations of male and female roles

I highly recommend that the adolescent be asked to illustrate the roles of men and those of women with collage pictures. I suggest collage because the subject matter of role identification is multi-faceted and difficult to draw. Even writing the explanatory words on the collage piece may be troublesome; for example, if the parent is not fluent in English it may not be spoken at home. The adolescent may feel that

Figure 1.14 'When I am 18 the girls will be lining up to come to my place'
(14-year-old boy)

English is not their first language even if, for example, they were born in the USA. Using collage or drawing provides a universal language. The printed picture can be revealing without words (Landgarten, 1993).

For example; if a girl makes a collage of mothers, babies, and intact families; the *process* of moving into that collage with the client *is* the therapy. The images may reflect love, attachment, rape, abortion, incest, dreams of the future, or countless other situations beyond imagination; the content is a mystery. Until we explore with the adolescent what these girls and babies in the collage are feeling, saying, thinking, dreaming, etc., we have no real appreciation of the content. Exploring and staying with the process helps the therapist see the collage as an extension of the girl's thoughts. A collage may be dealing with serious issues, or it may be just a projection of what her family expects of her. A

sustained lingering look at the image with the youth is a way to broaden the field of inquiry. Do not neglect the opportunity to move away from the vertical story line and transition into a horizontal walk into associations that inform the therapy. *Listen to the narrative that illuminates the image. Stay with the image, it illuminates the narrative.*

Gender-defined individuation

Girls seek their identity by first acknowledging and reflecting the female role models in their life and seeking respect from the primary male model. They then struggle with the dual task of staying in connection with a woman (mother), and at the same time individuating. Their goal is to stay attached and separate simultaneously. Boys identify with their male role model (father-figure), reject the feminine and work toward separating from their mother. Their task is gender defined and easier to clarify. This simplified version of a complicated process is stated to make the point that therapy models written by men about men's way of individuating do not fit a girl's needs. Therefore when the girl stays connected with her mother she is not necessarily enmeshed, she is solving her needs in a woman's way (Gilligan, *et al.* 1991). Because we are so accustomed to thinking of separation as a major task of adolescence, it is hard not to misjudge the teenage girl's expressive statements, verbal and non-verbal.

In some societies if the girl moves away (individuates) in a manner that is not sanctioned by her culture, she may feel shunned and lonely (Riley, 1997). It is important to look for these conflicts in the artwork. Young women are growing up in the United States with American values of independence taken for granted, but they may be surrounded at home with the older traditional values of dependency. These young women are in a difficult position. Providing a pictorial arena where she can experiment with a blending of these roles, or make her own choice, is easier, more safely done, if the conflict is viewed through an image.

Substance abuse and violence

Be prepared for a flowering of marijuana leaves in the teenager's drawings. Substance abuse is part of the adolescent culture today. The youth may not be 'using', but assuredly many of his or her friends are, at least, experimenting with drugs. Violence is a part of the culture, if the child has not witnessed violence directly, he or she has certainly experienced it in the media and in the schools. These two issues are worthy of in-depth study and specialized treatment which cannot be covered in this chapter.

The art therapist can be of the greatest service by assessing the adolescent's involvement with drugs and shield them from violence by reporting to protective services. In the assessment process it is important to evaluate whether the art expressions are indicators of serious risks, or if the teenager is indulging in experimentation and testing the therapist's tolerance.

Both these serious situations should, in my opinion, be handled with the family. Addicted youths should be in a rehabilitation program, and violence should be confronted with the parents and reported if not controlled. How to use art therapy in these circumstances depends on the program of the rehab center; and how to engage the family will be addressed in Chapter 5.

Summary

Adolescence is a complicated period of our lives; providing therapy for this age group is equally complicated. There are ways to simplify treatment and bring understanding to the travails of this age group. The first is to look at the external world of the adolescent and appreciate the pressures and significant stressors that he or she has experienced. View the child as a survivor who is attempting the difficult rite of passage from childhood to adulthood. The choice of a positive philosophy, which permeates the sessions, will convince the adolescent that the therapist is not searching for pathology. Attention to the immediate stressors of society which surround the maturing adolescent will make therapy contemporary and will not impose standards of out-moded theories. Second, careful listening to the adolescent's narrative of their

development will provide historical knowledge from their viewpoint. It is less important to search for the 'truth', than understand how teenagers see themselves and their world. Other realities can emerge later.

To become familiar with the teen client's world view the therapist needs more than words. S/he requires a complete picture. That picture can be accessed through the use of the art therapy modality. Using simple media, refraining from interpretation, and demonstrating genuine interest and curiosity, offers the youth a vehicle for non-threatening communication. Art used in therapy can meet the adolescents' needs for control, narcissistic expression, creativity, exaggerated logic, and experimentation directed toward appropriate individuation. The defensive language invented by adolescents is bypassed through the prose of imagery.

There are many paths to the goal of helping teenagers surmount the challenges of the years ten to twenty. However, none of these paths are available unless the therapist lets the youth be the guide. Therapy that doesn't seem like therapy because it is artwork; communication that transcends ordinary words by imagery and through metaphor; and a relationship with an adult that is not experienced as controlling; is a description of success with teen clients. Rather than inventing a way to modify adult treatment to fit the adolescent, I suggest that we give the teenager what s/he wants, in the form they find acceptable. The answer is: art and therapy creatively combined to reach a satisfactory outcome for the youth who is struggling to make sense of a world of conflicts.

Adolescent Group Treatment

All the men in our family go to jail. Do yours?

(Family traditions discussed in adolescent group)

Figure 2.1 Unstructured 'sign-in' wall mural, 8' x 5" – adolescent group, 9 months' duration

Adolescent group therapy has traditionally been offered as a solution which will counteract the negative attitude this age group has toward individual or family therapy. Group therapy takes advantage of one of the developmental needs of adolescence, peer grouping. At this age confiding in friends takes the place of communicating with parents. This concept seemed to be 'natural' for adolescent treatment, one that was reinforced by success in many clinics. In the past the adolescents

were interested in art therapy groups because they were less threatening and kept their hands busy while they talked about their difficulties. However, recently teen groups have become a questionable success in many therapeutic settings. Group was not well attended, and the youths appeared to be reluctant to share any issues that were of a serious nature.

The falling off of attendance, at the very time that mental health looks to group therapy as an economical solution to treatment, stimulated my curiosity. I questioned the continued validity of traditional group therapy treatment with adolescents. Does group art therapy remain the therapy of choice with this age group? Has the pace of life and the reduced attention to the aesthetics of living negated the efficiency of a therapy that encourages a creative approach to learning? My reflections and explorations of these and other issues comprise the body of this chapter.

Some of the questions I asked myself were: has group become less effective as a forum for peer support? Have escalating pressures of the socio/economic environment and violence in the home caused a dramatic change in the developmental tasks of the youth? Is early exposure to sexualized experiences so common that sex is no longer an issue to be explored in group? Have family values buckled because there is a loss of structure and tradition? Have youths given up on searching for a firm foundation from which they can try their new maturity? Are these stressful changes the ones that clinicians recognize when conducting the teen groups? Do therapists turn away from the conflictual and problematic issues of ethnic tensions and the pressure from shifting cultural demographics? The following exploration of adolescent groups will address these issues.

Treatment issues: pragmatic and clinical

The complexity of difficulties the adolescent brings to therapy is truly extraordinary. The therapist begins to feel that there are no successful adolescents, and no support system adequate to help the teen through this time of change. We tend to forget the fact that mental health treatment today is continuously narrowed down to those clients in the 'greatest risk' category. Crisis intervention is more common than

on-going therapy. Preventative therapy has become a memory in community mental health and hospital treatment. State funded and insurance sponsored therapy clearly demand a severe, dysfunctional diagnosis for the client to qualify for therapy and payment. These services, usually, fund only short-term or projected outcome treatment. In many therapeutic settings group treatment is preferred since it serves a 'number' of clients simultaneously. The question remains, does it serve the client well?

In spite of changing times and variations in the speed of maturation of our children, there are many fundamentals of clinical art therapy that remain a valid and effective tool for working with adolescents. Art psychotherapy has typically provided unique and creative opportunities for group work with adolescents. Exploring the developmental stages of adolescence through the opportunities that a creative modality offers, fits in a manner that reduces the adolescent's resistance to therapy.

The traditional belief concerning the major task of adolescent development is for the youth to individuate and successfully complete the process of separation from the family of origin (Blos, 1962). The more contemporary thought concerning individuation is that it is best accomplished by moving away from the family while simultaneously staying connected (Bloch, 1995). In their struggle to find the proper distance from their family that will allow for both connection and autonomy, the teenager turns to his peer group for advice and support. Unfortunately, the peer group is just as confused as the individual and the advice is often unproductive. In spite of this dilemma the adolescent is more inclined to accept treatment in a group with his/her peers than work in individual treatment. The stigma of being 'mental' is diluted if other kids are in the same boat. In addition, to be offered an art group that provides a chance to do something other than talk, seems less formidable than to be forced to *talk* about problems with an adult.

How art therapy can best serve the adolescent has been referred to in the previous chapter, at the risk of being repetitive the advantages listed below are particularly important when offering group treatment to teenagers. This modality is uniquely responsive to the anxieties of the teenager. It offers a form of therapy that: (1) gives them control over

their expressions, the young clients reveal in the art product only what they wish to reveal, visually or verbally; (2) they find using media provides an outlet for their creativity; (3) this provides a pleasure component; and (4) utilizes the personal and age-group metaphors and symbols; the adolescent believes that his/her control over verbalization effectively keeps the adult (therapist) from making intrusive interpretations.

By rejecting 'talk' therapy and the concomitant request to expose 'feelings', the adolescents experience autonomy (control) and this comfortably feeds into their narcissistic stance. Since group leaders are not invested in establishing a 'parental' power position, they rarely need to probe. The young clients are provided with opportunities to create expressive products that address issues of ambivalence and are of immediate concern in their world. In their own art they find a new view of their dilemmas.

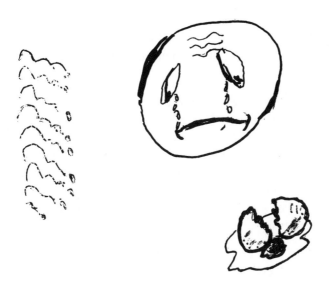

Figure 2.2 How does it feel to lose a friend? 'Like a broken egg – it can't be fixed' (14-year-old girl)

Group treatment versus individual treatment

Group treatment is often preferred since it reflects the adolescent's desire to utilize a peer group as a replacement for parental influence and structure (Linesch, 1988; Berkovitz, 1972). In some circumstances this preference for a peer group may become a menace for the parents. Fear of 'the group' can become a reality if parental influence is so inadequate that the adolescent's loyalty is transferred to a gang, crew or clique. This attraction to potentially destructive relationships has increasingly become the focal point of adult anxieties concerning adolescent development and behaviors. The narcissistic stance of adolescence stimulates an unrealistic fantasy in the youth that they will be protected from the realities of gang warfare, crime, and drug involvement. For good reason the parent may see any group as a threat. The goal of a therapeutic group is to provide an alternative to violence and project more productive, suitable challenges that might appeal to the adolescent's sense of omnipotence and idealism.

Rethinking theory and practice

It is necessary that clinicians construct a theoretical approach for today's adolescent society. Gergen (1991) believes that the differences we experience demand change.

> The language and vocabulary of our theories are all based on continuing and changing social practice. These languages and vocabularies actually constitute the dilemma and, in narrative constellations, are the peoples and human systems that may be possible in our various psychological worlds. These different selves, these different human systems require a different therapy for very different kinds of human problems. Our theories generate very different therapists who see very different people for very different reasons. (p.10)

If we are going to provide different therapies because our adolescent population is now developing in a very different world, we must think differently about the ways we provide treatment. Post-modern theories that encourage narration and provide the opportunity to illustrate these narratives seems to be the best solution to an integrated approach to adolescent treatment. A non-judgemental vocabulary combined with a

non-pathologizing theory, one that encourages alternative solutions to difficulties, fits the adolescent's desires and does not evoke resistance. (White and Epston, 1990; Bloch, 1995).

Art therapists find working with this age group one of constant surprises, and do not experience major difficulties when they accept a flexible philosophy. The teenager who is in trouble finds many ways to screen his/her vulnerability, they are filled with ideas and protestations. There is little chance for boredom and repetition. The many modes and moods of adolescence keep the therapist alert, and their art is amazing.

Focal issues that impact group treatment

The following issues are some of the subjects that are difficult for adolescents to discuss; their accelerated physical maturation, their fractured family situations, the violence in adolescent society, their drug and alcohol involvement, and their early sexual experiences. Not because they find them so unsettling to discuss, rather, it would not be 'cool' to admit that these major stressors are a problem. The chances of the teen opening up to a discussion around these situations are much higher in a group setting, where they can find relief by sharing with peers.

To the adult it often appears that the members of group have experienced the entire gamut of adolescent challenges by the time they first add 'teen' to their chronological age. That is not to say they have resolved the developmental difficulties. Their exposure to sex, violence, drugs, and temptations of every sort, as well as domineering and aggressive peer group pressures, has compressed their development into a time warp that allows for little, if any, integration or resolution of adolescent tasks.

It still comes as a shock to find many fifteen-year-old kids who announce they are in the 'recovery phase' of substance abuse. They are old hands at playing the destructive drug game and are struggling with the consequences. Adolescents in recovery are only a small percentage of the countless other young people who are still using drugs (Cox, 1990). These observations are not a surprise to anyone who watches TV

or interfaces with families with adolescent children, either socially or professionally.

Challenges and dilemmas

The primary challenge for the adolescent is the breakdown of the family. It is hard, if not impossible, to rebel against family values when the family itself is fractured. Healthy 'rebellion', which is the function of the adolescent's questioning of the previous generation's standards, is an essential task of adolescent development. When the family is in a state of upheaval and flux there is no firm boundary against which the adolescent can mutiny. They cannot test their values because adult values are not defended by overwhelmed or distant parental figures. Middle-class and lower income families are beset with monumental insecurities; families are often headed by a single parent and functioning in economic chaos. The children cannot test the rules of the home if the only sensible rule is 'survive at any price'. Sons and daughters of families more financially fortunate are also at risk – attempting to deal with divorce, two parent incomes that keep both mother and father fully engaged outside the home, and conflicting ethical values in a troubled world. These issues burden the adolescent, but they are too complicated for them to address verbally or conceptualize.

The second challenge is exploring the gender designated rules of their family and culture. The youths cannot examine their gender defined roles by measuring their values against the beliefs of their same sex parent, if mother is too exhausted from working two jobs to do much mothering. If the father is overworked and rarely at home, he is not available. The father may not be there at all; killings, jail, and divorce remove the man from the home in a high percentage of cases that present at a clinic.

The traditionally mysterious questions around sexuality and romance, commitment and loyalty, are de-mystified in elementary school, if not before. The teacher/parent who shows the child how to love or live a 'good life' often comes over the TV screen or the Internet. This electronic relationship is limited to half hour or one hour time

spans with time out for commercials. Role models are disposable and interchangeable and on the whole manufactured and inauthentic (Goldner, *et al.* 1990, p.343).

Example

This example of how a thirteen-year-old girl client attempted to deal with a perplexing topic, demonstrates the social attitude of a group of adolescents around sexual issues. She chose to use the adolescent art therapy group to help her make the decision 'when should I lose my virginity?' The group had previously become comfortable discussing sex by representing their tension and anxiety around this subject through art projects. When she brought this question to the group they kept their eyes on their drawings and avoided eye contact. The drawings they made were poor reproductions of sexy rock group album logos, which appeared to avoid the issue that she brought to the group. To this group the state of virginity was not a particularly desired or precious status to preserve, a dispassionate discussion evolved around social acceptance and gender roles. Some superficial boasting from some members about their sexual prowess was another distracting contribution. The type of person with whom she would have her first sexual encounter was less important than weighing her subsequent change of social status and the advantages or disadvantages that would accompany this passage.

My struggle to introduce questions of vulnerability, risk, opportunity for physical harm or disease was my own issue. I wrongly worked too hard to encourage the group to discuss the emotional component of sexual coupling, but as one might expect, I was only moderately successful. I should have taken a clue from their artwork which represented stars of hard rock music. These personalities, perhaps, were metaphors for sexualized idols that do not have to take responsibility. I could have entered into the 'rock' metaphor they offered and found a way to illuminate the points of concern in a method palatable to them. I do not regret bringing up the issues of physical danger and medical jeopardy, that is part of my concept of responsibility. I do regret that I

was not able to find the language of these adolescents to convey my apprehensions.

The group drawings that followed the rock star representations demonstrated their concept of male/female roles. The imagery, which grew out of her dialogue about intercourse, should have been a flag to me. The drawings showed that they held a common perception of gender-defined roles, ones that were traditional and biased. The females were represented as sex objects, over-developed and without a purpose other than be a 'girlfriend'. There appeared to have been little or no feminine conscience raising in this group. If the girl had sex, she was responsible. If she did not have sex she was shunned, if she did, she was degraded. They offered no solution to this dilemma, possibly because 60 per cent of the group members were of first generation families, where the old world standards of gender discriminated roles and beliefs were verbalized but not necessarily practiced. In reaction to peer group pressure to be promiscuous, some girls boasted about their virginity, but often faltered in their resolve to delay sexual experimentation. At another time in a similar group, I recall my question; 'Is it important for the woman to have an orgasm as well as the man?' was met by blank looks and disbelief that women did or indeed could be orgasmic. Babies yes, pleasure no.

Another consideration that should have influenced me was the group's perception of sex. Sex information on 'how to' and 'where to' is so clearly explicated on TV and in teenage gossip, that my attempts to help the group member explore her decision were not productive. What might have been a discussion about values some years ago, became a non-issue in this group.

The 'therapy' that was successful was that she chose group to be her audience and her sounding board. Her drawings of; being at a crossroads, coloring big question marks that represented her dilemma, speculating on choices by drawing them, picturing a baby and other images, gave her time to contemplate her decision. The comfort she derived from her non-verbal conversation, in the presence of her peers, was significant. The problem was projected in the art, which provided her the opportunity to observe her actions. She was validated through the process of questioning her decision within the safety of her therapy

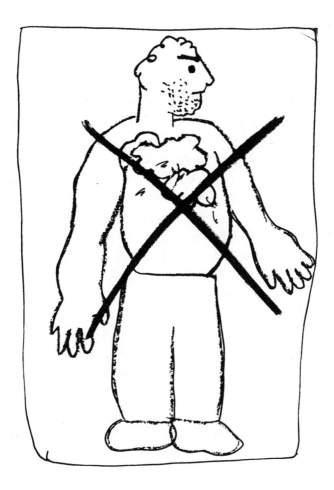

*Figure 2.3 'I am tough on the outside – but I want to stop hurting on the inside'
(16-year-old boy)*

group. The pressure she would have experienced if she had dared to discuss this with her 'real' group of friends or with her parents was eliminated. Self-reflection, with even the minimal support and alternate solutions offered by the group and the adult therapist, gave this girl the chance to feel that this was a decision worth taking time to decide. By using the art as her arena for experimentation she made a choice and was not judged in the process.

Goals for adolescent group treatment

The first concern in adolescent group is the establishment of trust. For today's group this is a major issue that cannot be emphasized enough. Consider, the adolescent may have had to cross over gang lines just to visit the clinic. Is death or a beating worth chancing just to get to therapy? When the youth does find a way to get to the clinic, and if it is group treatment, why would he/she risk saying anything that may evoke dire consequences from other group members who may be in an opposing gang? Words might be 'leaked' to the enemy and would result in physical violence; the group is not a safe place. The enemy may not be a rival gang, the enemy may be the parents, the foster placement, the probation officer, the school counselor, who also would punish if negative material was aired in 'public'. The damaged adolescent child has had many opportunities to be disappointed with an adult who asked them to be trusting. Why should the therapist expect a different reaction from a disillusioned teenager?

As a result of this anxiety about trust and safety, group attendance is uncertain. When the members do appear, they often are not willing to be verbal and resist making an art object. It is not surprising that they do not want to recall their past; the histories of these young clients are often so brutally sad that a therapist wonders how anything can help! They also resist representing their present circumstances since they may inadvertently reveal actions that are unlawful, unethical, or bring forth parental wrath. At times the therapist may feel that therapy is an exercise in frustration when so much reparation is needed.

Trust is established by being attentive to the young client's resistance as a clue, and not dismissing the reasons they offer to avoid attending group and exposing themselves to additional trauma. When this sense of security is incorporated the foundation is laid for group commitment. Until then the therapist cannot do more than work on the issue of safety. After this period, the therapist can redirect her/his thoughts toward projecting further treatment goals. It is at this time I have found that looking at the historical and primary socialization of the young client is essential. The therapy begins when it is time to explore how the events

of the past live in the present and cause the young person to be responding to events by rote.

Confidentiality

Confidentiality is an issue that must be attended to in every group. The 'rule' that the subjects spoken or drawn about in group, stay in the group, is reviewed at the beginning of each session. After the first two sessions the teens take turns verbalizing the ritual of 'confidentiality'. The artwork is carefully filed away, or if it has been displayed on the therapy room wall the names of the art makers should not be apparent. The art can always be turned to show only the blank side of the paper if outsiders are going to visit the room. The group should be assured that their artwork will not be seen by their parents without their permission. This might be an issue if there is family treatment in the same room.

To avoid difficulties with reporting and issues of risk, the limits of confidentiality must be clarified from the beginning of group. The adolescent must be assured that if a dangerous circumstance arises and the therapist feels that a situation must be communicated to the parents and/or the authorities, they will be present. Any break in the rules of confidentiality will be based solely on the need to protect the client, and they will be included and present when contact is made with external systems.

Shaping the group

When forming an adult group there are some basic considerations that are often considered (Yalom, 1995). The participants are asked to refrain from social contact outside the group meeting. They are cautioned that talking to others about the group transactions will reduce the effectiveness of group work, and that forming any attachment to another member should be brought into the group discussion. There are interpretations made about attendance and being on time for group. I have learned that most of these rules are not applicable to adolescent group. The rule that teens are concerned with is confidentiality; from peers, parents, and outside authorities. Group attachments

are to be expected. An adolescent group that talks on the phone to each other, or plans to continue their association after group is terminated, is a great success. The teenager is so anxious about their image and sharing their weaknesses, that it is not necessary to place restrictions on them, their own boundaries are sufficiently high. Through the years I have found that their plans to spend time together outside of group rarely materialize. On occasion a couple will be attracted to one another, but their peer group at school and neighborhood has a greater pull on them than the false community created for the purpose of group. The fewer the rules the therapist demands, and the more she takes the group into the decision-making process of the group structure, the more open the adolescent is to accepting these restrictions.

Ideally an art therapy group works well within an hour and a half time frame. Since the art task provides an opportunity for all group members to 'talk at the same time', through the mechanism of all drawing at the same time, everyone is able to express their opinions or feelings. Up to eight members can work together, although six is more conducive to group cohesion since more time can be spent exploring each drawing. The art expressions allows the silent member to be heard and the verbally aggressive to be confined to his/her explanation of a personal product. That is not to say that exchange of ideas and a dialogue should be limited; it does allow for a certain amount of balance and control in an adolescent group.

A few restrictions are particular to an art therapy group. Materials must never be thrown, artwork must never be ridiculed as not 'well done', interpretations of another person's art must be subject to their confirmation. Using another person's art upon which to project personal material is acceptable if so identified. Drawing over or destroying another member's art is not permissible, copying a member's product is framed as a compliment. Some of these behaviors are done in 'fun', this kind of fun is off limits. Art materials can be harmful if used as a weapon, therefore the art therapist is advised to be very firm about this restriction to respect the material and use it, not toss it. When the therapist shows respect for the media, and pleasure and joy in handling the tools of art therapy, s/he is modeling respect that these teenagers desire. If a respectful environment is pervasive in the art therapy room, it

includes clients, therapist, and the media that makes art therapy possible. This is a consistency that many of the teenagers do not have in their homes.

The art therapist group leader models an adult whose stance is one of interest and supportive curiosity (Cecchin, 1987). S/he is cautious not to make any pejorative interpretations, either of the art product or the significance of the verbal explanations. The therapist must rely on the art to do the communication and trust that the message will be shared at a pace that fits this population. The teen boys and girls are encouraged to set their own group rules and decide on procedure. Surprisingly, their rules may be more rigid than those normally set by the adult, but as long as they feel in control, that they are 'beating the system', they will be more compliant.

The summation of the therapist's relation to the group is difficult to describe. The leader must be actively involved and at the same time be carefully distant from any form of overt control. Limited transparency is a necessity, and the therapist should be honest at all costs. The adolescent is unforgiving if the therapist does not follow through with promises of confidentiality and respect. Not every person is cut-out for the role of an adolescent therapist. If the therapist has not retained a sense of humor, is not comfortable with sexual issues presented crudely, and has lost touch with the confusion and pain of their own adolescence, s/he would be well advised to choose another client population.

Group cohesion: a realistic view

Yalom (1995) defines group cohesion in these words: 'the group therapy analogue of the patient–therapist relationship in individual therapy must be a broader concept: it must encompass the patient's relationship not only to the group leader but to the other group members and the group as a whole'. He goes on to describe how successful group provides the members with a feeling of belonging, of warmth and support, and they in turn are able to respond to others with unconditional acceptance and understanding (p.48).

Figure 2.4 'The heart is sinking and the pirates take over' (13-year-old boy referring to absent father)

If the therapist of adolescent group pins his/her expectations to this description s/he may be sorely disappointed. It is important to remember that the client in adolescent group is focused on himself/ herself above all other considerations. Individually, members have little to give to others because they are struggling to find themselves. Giving to others may feel like parting with some of their hard earned identity. The group finds identity by a peer structured dress code, sexual and drug orientation, socio-economic culture, and vocabulary. If these criteria are not met then the deviant member becomes the outsider. Conditional acceptance is syntonic with the adolescent, although they may develop passionate attachment to their 'best friend', they find it hard to attach with that intensity to an entire group. The more traditional attachment to group comes if the group continues over a longer period of time. The adolescents in a stable group have time to grow-up together and learn how to move past narcissism into an empathic relationship.

I have created a set of criteria for adolescent group cohesion: (1) the body count, are there enough teenagers present to be a group; (2) if the

teenager comes to group most of the time, it should not be under-rated; (3) if the group talks to one another in the waiting room, they are not afraid to be together; (4) if they continue their talk in the therapy room, they have normalized the clinical environment; (5) if they grab a piece of paper, a drawing tool, and scribble or draw as soon as they sit down, they silently affirm that art therapy is comfortable; (6) if they acknowledge my presence, even if it is done non-verbally, I am not a rejected adult. The group cohesion demonstrated in a teen group is covert, it is verified by behaviors not by words.

By attending to the teens' conversation as they start the session, I derive a sense of their 'concerns of the day'. I may then comment that I have heard (for example) 'a lot of troubles with parents and when to get home'; this subject is translated into an art expression by asking 'draw how you would handle this issue if you were the parent'. The fantasies of a 'good' parent and the just and unjust demands and rules of the home can evolve from a task that has the adolescent reverse roles in the drawing.

I consistently try to have the art directive reflect the immediate interests of the group. If the group has established a spirit of its own, the members will initiate their own ritual of how they share their drawings and their manner of reflecting on the other's artwork. *The less I am in charge, the more I feel that the group has established their own form of cohesion.* I do control scapegoating, projecting negative meanings on the other person's drawing, and the destructive use of the equipment in the room. This is rarely an issue, with a minimum of guidance, most adolescents are fair and stay within limits. If the adolescent's interpretation of 'fair' is not acceptable to the therapist, s/he must have a discussion that explains his/her point of view and stay with the limits that have been set. Some of the adolescent clients have no adults in their lives who are willing to defend their values openly and enter into a dialogue with the teen.

Getting started

Adolescent group forms slowly. The therapist must not anticipate that the group will be functional within a prescribed time frame. Just having

the experience of being with a safe adult and fellow adolescents over a period of time is of great value to the young client. This experience may comprise one of the main goals of therapy. An art task will probably succeed if the subject matter arises from dialogue or the special interests of the adolescent. To mark down anything is perceived as risky, but if the threat proves imaginary, the adolescent urge to be creative becomes dominant over fear. To encourage this transition the therapist demonstrates that s/he is willing to be helpful but will not decide what should be discussed. Adolescents who are excessively awkward with the early art experience, may be persuaded that the art is an opportunity to learn a skill, a product; such as an arts and craft teacher teaches. If the teen starts to do art the therapeutic component of the image will surface. At that time the adolescent will gradually slip from a craft orientation to appreciating the therapy in the art. However, when discussion prematurely touches on serious stress points it is wise to be prepared to quickly move away before the silence once again closes down. The seeds of future discussion are being sowed, they take time to root.

The therapist does not introduce the presenting problem or create art directives that force the issue. This non-directive therapeutic approach may appear to be in collusion with the adolescent's lack of desire to deal with clinical goals. Going slowly more likely leads to success. By taking time to establish a relationship, an environment that is receptive to their narrative is created.

Avoiding a problem may reflect the adolescent's reluctance to share the trauma that brought him or her to treatment. Since a high percentage of cases now seen in therapy are dealing with problems that result from sexual abuse or other acts of violent communication, we must fit the method to the client's needs (Sgroi, 1988; Malchiodi, 1997). The threat of exposing the perpetrator or the conditions in the home, is one of the basic retardants to a young client's communication. They know only too well how the protective service system intervenes and breaks up homes, sends children into foster care, and punishes everyone in the family. The adolescent's awareness and lack of naïveté keep the silence. They are wise beyond their years; not with the wisdom we would desire for our children, but the wisdom of the streets. The street has rules and beliefs that are not necessarily in synchrony with the

law, or with the values we hold as mental health professionals (Smolowe, 1993).

The therapist's creativity is taxed by the quest for activities that fit the social interests and the developmental sophistication of the group. Art therapy tasks should be ones that do not threaten their safety by forcing rapid exposure and have the flexibility to be a long- or short-term project. Each situation will depend on the ability of the adolescents to stay involved.

Signing in

The 'sign-in wall' is a ritual that I have found to be successful in establishing the personality and (hopefully) the permanence of a teen group. A large, 8' x 6', piece of sturdy paper is permanently attached to the therapy room wall. The group members are asked to 'sign in' at the

Figure 2.5 Adolescent free drawing – 13-year-old boy, beginning of group

beginning of each meeting. There are no restrictions or interpretations made about these sign-in marks. The paper is left up for the entire life of the group, and as it becomes an impasto of colors, words, and symbols, it also becomes visible evidence of the life of the group. Since there are no restrictions, except to stay on the paper, this 'wall' also serves other uses for the therapist. The first is to observe the marks individually, and get a sense of the temper of the group; second, a relief valve is provided for the kids to dump their four-letter words and gang signs. As the paper becomes covered with their marks, a sense of group cohesiveness and the individuality of each youth in the group becomes apparent. The sign-in sheet provides historical proof of the group existence. This 'mural' becomes a reference point, as well as the weekly drawings that are placed one on top of the other on another wall. Each member has a space where his/her drawings accumulate, the artwork can be used to reference problems that were addressed or remain as testimony to the life of the group. Both these rituals give evidence of permanence and commitment to group.

The 'wall' becomes important to the adolescents. They remind each other to sign in; make rude, funny, or sympathetic remarks, as they become familiar with the meaning the individual ascribes to their symbol. If the therapist feels swearing should be limited during group time, this is a place to be profane; if there are issues that need to be discussed, and the child is not prepared to do so, this is a place to start with non-verbal marks. The wall is incomprehensible to 'outsiders' and this is of great satisfaction to the group.

Group composition

Adolescence can be loosely separated into three phases of development; 'pre-' and early adolescence, mid-adolescence, and the final phase of adolescence. These divisions are only a convenience for the therapist, since maturation does not progress chronologically or physiologically. These phases roughly coincide with the last grades of elementary school, middle school, and high school. The rationale for looking for these markers is to group teenagers together with similar drives and

sexual/social behaviors. The actual age of the youths may vary; therefore the assessment of maturity is an important issue.

Ethnic and cultural issues should be considered. For example, in neighborhoods with racial tension it would be fool-hardy to place one youth of color, with several youths of a rival ethnic culture. One girl (or one boy) in a group of eight is too anxiety producing. Placing a member with dramatically delayed developmental issues with a 'normal' population is usually too much to work through for the therapist. However, I have found that mildly psychotic youths sometimes are well accepted and protected. Economic differences can also be handled by group process. There are always exceptions to any of these guidelines, particularly in very brief groups in the hospital, where everyone there needs protection. Commonality of problems helps group cohesion.

Setting up the adolescent group is not an easy task. However, unless careful thought is given to the composition of the group the therapist and the members will have a frustrating experience and little will be accomplished.

Pre-adolescents and early adolescence

The hardest age category to evaluate is the earliest phase. When the thrust toward puberty begins, the physical changes have not yet become visible. The internal chaos and new stimulating erotic fantasies are handled differently by each adolescent. Since this phase may be experienced as early as ten years and as late as thirteen, it is hard to recognize. Secondary sex changes lag behind psychological, biological stirrings. For example; if a child has grown very quickly, is tall for his/her age, but the psychological maturity has radically lagged behind; then this child would be a misfit in a group of more mature peers, in spite of his outward appearance. Group is successful if there is some commonality in self-perception, humor, sexuality, and individuation. Too often adolescent kids are lumped together in groups just because they are in their 'teen' years. This misfit can destroy a group.

The dominant psychological view held in adolescence is a narcissistic one, therefore there will be little tolerance for the 'baby' in the group, or the 'know-it-all' more mature person. Helping each other

is problematic at best, but if the members of the group are coming from different stages of their own evolution, there will be restricted communication and a great deal of boredom. The therapist is well rewarded if s/he takes the time to understand the maturity level of the adolescents slated for group, and attempt to match the 'inside' youth with others who are dealing with similar issues. The pre-group individual assessment session with the candidate is essential. The subject matter and rendering of the art product in the assessment hour is usually revealing. The younger age adolescent often is more co-operative in a single sex group. The opposite sex is too stimulating, and too threatening, to allow the group member to settle down.

An 'impossible' group

I recall a boys' pre-adolescent group of seven impossible pubescent bundles of raging testosterone, still too unsure of themselves to trust each other, and certainly not the therapist. Their ages ranged between eleven and thirteen but they were operating more like latency age boys. Finally, after many sessions of unproductive messing around, they were able to express their inner world succinctly in an art form.

The group had spent many weeks scribbling meaninglessly, testing each other and the therapist, and talking 'wannabe' gang slang. I had given up hoping they would draw, that was 'baby stuff'; collage was an invitation to rip and tear; and clay was made for throwing. I spent most of my time getting them to settle down. One day I brought in construction paper and small sticks and glue, remembering that this is an age that likes to make three dimensional objects. One boy decided to construct a medieval castle, and within minutes they all were competing to do the same. Individually and in pairs these unruly pre-adolescents put together impenetrable fort-castles. Crenelated walls and prison towers loomed over drawn draw bridges that were anchored in place. There was one small entrance to the fort, and that was closed with bars and chains. Each construction was unique but all were equally impassable.

They had created a perfect metaphor for their inner state of defenses and need for protection. As these castles took shape I inquired about the

occupants. No one lived there except warriors in full armor, who were engaged in pouring boiling oil over the parapets, and heaving boulders that were dropped from the towers.

It was revealing to me to see that as individuals (as demonstrated in their constructions), they needed to be highly defended, however, acting in group they gained bravado from each other and were 'warriors'. I also experienced, one of the truths of art therapy; *'if the art task fits the problem-saturated situation, it can be expressed metaphorically'*. The castles were worked upon for many weeks and were displayed with pride. While the boys were engaged in a task they enjoyed, they were able to speak in a limited way about some of the issues that had sent them to the clinic. I cannot remember where I heard this remark; 'it is not the client who is resistant, it is the therapist who has not found the proper way to connect!' I believe this is true.

After this project was completed, photos were taken that they took home, and the discussion was no longer of interest. The group proceeded with a different spirit. I provided more opportunities to make various constructions, and they began to have some socially appropriate communication. It is hard to make a firm evaluation of this age group. The parents reported less friction at school, and the boys continued to attend group until summer vacation. Their attendance was my base line for evaluating that this group was useful for these young people.

Middle school and high school

Mid-adolescence is the age group that demonstrates the greatest social change in our society over the last ten years. These children are pseudo-sophisticated, are often sexually active and at the greatest risk for drug experimentation. This category could be called the middle-school age group. They are in the center of their pull toward freedom and autonomy, and have not yet had enough life experience to make successful choices. They defy tradition and set the fashion in dress, music, and language. Their artwork will often be graffiti-like, filled with drug symbols, and scornful of adult standards. This is the age of 'I don't know', and 'who cares'. It is also the age where drawing is a natural expression and, if not adult controlled, prolific and spontaneous.

The urge to create is demonstrated in all their actions that attempt to change the way we commonly perceive the world. This creative drive can be channeled in the art therapy.

Since this age group often complains that their mothers or fathers are always yelling at them, it is interesting to let them share that perception. The group is invited to make a 'parent-face mask' on heavy paper. This is cut out, with holes for eyes and an opening for a mouth. Each member takes a turn in speaking like his/her parent, and mimicking the voice

Figure 2.6 Two views of highly defended castles made in an 11–12-year-old boys' group. Note catapults, retractable draw bridges, moats

and message. At first the group is loud and show-off, later as the members calm down it becomes evident that the messages are confusing, but they are often protective. Each member can compare his imaginary parent to the others, which usually leads to a discussion of what parents 'really' want, and what they 'really' are saying. The next step is to ask the group to talk through the mask the way they would like to hear a message from their parents. After the initial discharge of emotion, this second role play can be productive and moving. The masks give this age group protection against vulnerability, acting in a parallel manner to their inner defenses.

The older group of adolescents are either past the discomforting phase of body changes and total omnipotence, or they are solidified into a mold that leads to anti-societal behaviors of more or less seriousness. This age group can use therapy as a decision-making aid and solidify advances toward early adulthood. They profit from directives that project them into the future. 'Where will you be five years

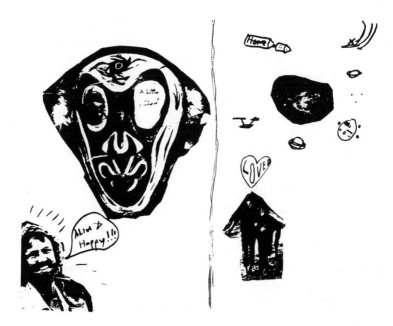

Figure 2.7 How do you see yourself? How do others see you? Collage of composite pictures. Others see him as clown. He sees himself as a lover from Mars (15-year-old boy)

from now?' 'How did you get there?' This age group can also look over their early adolescence and make judgements on their own behaviors.

For the adolescent who is involved with drugs, the artwork can be useful when used to externalize the problem and give the client an opportunity to separate from the addiction and take control. Drug use is so common that the teen who 'uses' is not considered a candidate for a drug rehabilitation program until they are extremely dysfunctional. Therefore, most older adolescent groups will have some members dealing with this problem. Exploring the reasons that the youth has turned to drugs to solve their problems is essential.

The late adolescent's hyper-logical use of their intellect can be channeled by encouraging them to create ideal communities, demonstrate visually how an adult should conduct him or herself, and how to deal with racial discrimination, and other societal problems. No political or social problem is too much for this age group. Adolescents can project their solutions in graphic form in the art and place themselves functioning in this alternative environment; thereby working with external and internal projections and concepts simultaneously. Their creativity is at its highest level, and their desire to change the world is dominant. The therapist should be cautious not to attempt to deflate their omnipotence with doses of reality, the real world will take care of that soon enough. Many great ideas were born in adolescent minds; the adult who wants them to become practical before they are ready to do so, is an adult who 'turns them off'.

New members and time frames

Once a core group of adolescents begin to attend therapy regularly it is very difficult to introduce a new member without setting the group back to the first phase of testing trust. It is better to refuse treatment if the child does not fit in, even if it presents an administrative difficulty for the clinic. It is a serious frustration for the art therapist leader if s/he is not consulted and a child is thrust into the group. Pragmatic concerns may conflict with the aesthetics of treatment.

If a new member must be brought into a stable group, there should be several weeks of preparing the group. They can draw 'how they imagine

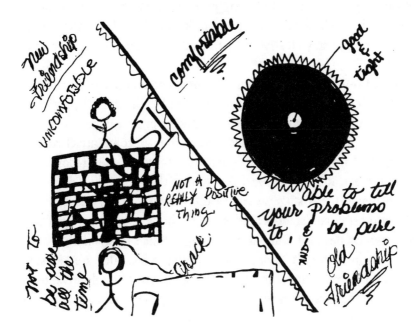

Figure 2.8 The difference between a new friendship and an old 'trusted' friendship (13-year-old girl – Concentric circles of color in large circle on right)

this person will be'; 'how they make new friends'; 'what the group will lose or gain with a new member'. If the high emotions are expressed before the adolescent joins the group, there will be a greater chance of acceptance.

Techniques for group treatment

The suggestions for group art activities, made below, are not 'prescriptions' for success. They are tasks that reflect developmental, generalized concerns of the adolescent client and the stage of the group's development.

In the early phase of the art therapy group, the art task might acknowledge the adolescents' uncertainties and guardedness by creating games 'of finding a way out of a maze', drawing their neighborhood and making changes they would like, telling stories by

illustrating their tales, and 'doing graffiti', and explaining the meaning of the forms. These are the type of tasks that introduces some graphic expression but stay clearly and safely in the range of metaphor and the familiar.

I find this time of treatment the most challenging to my creativity and the need to restrain my impatience to be 'helpful'. If possible, the tasks should be created to last over some period of time, since some members have poor attendance before they become attached to the group, and find it reassuring when they return if they recognize the same project. It may also be a reality that the art product does not go much beyond this stage as far as the drawing artistry is concerned. Under most circumstances adolescent art has a tendency to stay within safe stereotypes and familiar symbology. Since their familiar adolescent-culture symbols change so rapidly, we adults are constantly surprised. In due time, the therapist may begin to explore values and problems that are of meaning to the group. The basic stance of 'not

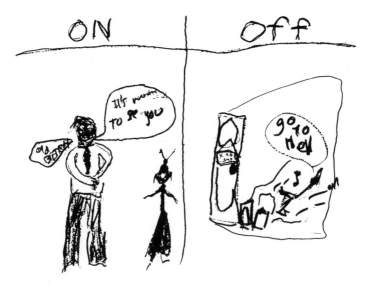

Figure 2.9 How do you turn people on? Off? 'Old bitch.' 'It's lovely to see you.'
Door closed to room – 'go to hell', loud music (14-year-old boy)

knowing' (Anderson and Goolishian, 1988) is of the greatest value to the therapist. If the youth will teach you, then you have made it over the barrier of adolescent suspicion and therapy may follow.

I recommend making suggestions for the art task that reflect the ambivalent stance of this age group. Both sides of the issue are considered in drawings of: 'what would your parents like you to do, and what would you like to do?'; 'what are the things that boys (girls) can do best, and what do they do worst?'; 'how do you act at home, how do you act at school, after school?' By dividing the paper into two parts the boy or girl can freely address their split feelings and through discussion make some choices, or at least see that their peers are just as ambivalent as they are. Success is usually guaranteed if the therapist asks for some help with the group's perception of the parental or adult world and values. Adolescents are idealistic, and even though we wonder at their actions, it is always a surprise to see how critical they can be of adults, yet offer reasonable solutions to problems.

As therapist, the adult figure is in the room, therefore it is essential not to be defensive of adults and try and recall your own teen years when you were also judgemental of the way the world was run. The therapist will have to accept the burden of the projections placed on her/him by the group members. I suggest a drawing, 'Draw the ideal therapist. What would s/he ask/say?' I also invite the group to let me know when I sound like a 'parent'. Then discuss why that does or doesn't work in group.

The adults in the adolescent's world are often the principal negative influence in his/her life. These same adults may also be bewildered and mean well, but still be inadequate in the teenager's mind. The therapist is the recipient of their experiences with other adults. How the group members grapple with the reality of their relationships with adults and their projections of adult motivation is the focus of many sessions.

There are exceptions to the rule about being cautious, not proceeding too quickly, and expecting early revelations from the adolescent in group. There have been times when a teenager is so desperate to move out of a painful situation that he or she opens up immediately and describes every detail of their trauma in an art product that reveals the family's secrets.

The therapist has to learn to respond in a variety of ways, such as preserving confidentiality while still being protective, not keeping harmful secrets, and convincing the youth that involving the family is essential to relieving the problem (Sgroi, 1988). Although the issues are sensitive, if there is a strong sense of confidentiality, decision making can be shared with the group. It is a comfort for adolescents who have shared their problem to find others in the group who have similar difficulties. Handled with respect, the revelation can provide a forum where material can be processed.

Drawings by peers are tangible evidence of group interest and support. If the adolescent in pain receives 'drawings of support' from the other group members, they can literally hold the positive feelings in their hands. In addition, the alternate solutions offered in the group, may suggest resolutions that are radically different from the ones that have been attempted before, either by the youth or his/her family.

How group and family treatment can interface is possible if the adolescent is also in family therapy. The revealing art product may be brought into the family session after careful consideration of all the potential ramifications. This is not feasible unless the adolescent is entirely involved in this decision. The advantage of bringing an art expression to a family session is that the artwork becomes the externalized object that engages the family in a problem-solving dialogue they have avoided. It is hard to deny hard evidence of problematic situations. There is less misunderstanding of the truth (as the adolescent presents it), when all concerned *look* at the product instead of relying solely on words. The image can be separated from its creator, by the therapist joining in the exploration of how this problem developed and under what circumstances. If no one is held to blame (except in cases of assault), the entire family can be rallied to overcome the crisis and make a joint effort to move to a more functional relationship.

Meta-messages

One of the strengths of art therapy treatment, lies in the ability of an art expression to contain a multiplicity of meanings (Johnson, 1987). Although only a limited amount of material presented in an artwork

may be explored in the session, the youth has brought these problems forward into visual awareness and may examine them on his/her own. I firmly believe that a therapy session is only a stimulus to the problem solving or changes that go on *after* the therapy session is over.

In addition to the selection of images, it is important to bear in mind that the adolescent makes the choice of the combination of media, personal color coding, and symbols to represent his/her concerns. The therapist gains the ability to understand how young clients view their world, their family, and the social environment from which they developed through their unique imagery, followed by their personal narratives. The therapist must refrain from interpretations. How we would use color, or how it is used in many cases, is not a 'truth'. Experience helps us to make informed guesses, but guesses are all they are. Our projections are ours, their reality is theirs.

An example of surprising reality

The following is an interesting example of the inability of the therapist to pre-empt the correct meaning of an art piece. In group, a fourteen-year-old girl responded to the suggestion that each person in group would show in collage 'their most treasured memory'. Maria had a history of turmoil and neglect. She had lived her first seven years with her seriously addicted mother who dealt drugs out of whatever home they lived in. They moved from one miserable place to another after their apartment had been trashed by addicts turned violent. Maria was left to raise herself, and at times, care for her mother. Around her seventh year she was taken from her mother by social services, placed with a series of relatives and then in foster placement. Two years before we met, when she was twelve, an aunt (twice removed) gave her a real home. She lived near the clinic in a pleasant house with three cousins. Her aunt was eager to help Maria integrate into her family and sought advice at the clinic. Things seemed to be going well and Maria seemed happy and adjusting to her permanent home.

Maria's collage of her most treasured memory, showed a cottage with a white picket fence, flowers in the yard and the sun shining on a peaceful scene. I observed this collage in the making and silently

guessed that she was depicting her improved living conditions and the affection she was receiving from her aunt and cousins. She seemed very touched by her artwork. When she was asked to explain her art, her 'most treasured memory', she said it 'was living with my mother'. She felt that a dirty apartment was like a perfect cottage, as long as she was back with mother. It was a deeply touching experience, an example of the powerful maternal bond and the strength of the fantasy to transform ugliness into beauty. To Maria, her past, which others saw as neglect, was transformed into a beautiful memory. Some clinicians might see this as an example of denial, of a pathological distortion of reality. That may be true. What we saw in group was a girl who was able to preserve her love for her mother in the face of every misfortune, and be able to project it in a positive image that she could use to replace the sordid truth. How much richer her explanation was than my instant reflection. My speculation was not informed by her individual interpretation of her life, and therefore I missed her authentic meaning and the power of visual transformation.

Ethics and therapist's ambivalence

The following clinical narrative is an example of a dilemma which challenged the values (ethics) of therapy.

A fourteen-year-old Hispanic male client was forced into the art therapy group by his parents. They were extremely anxious because Hector had threatened to join a gang and thus disgrace their family. He would not utter a word in his family sessions (with another therapist). Consequently they felt art therapy with his peers might be the answer.

His school performance had dropped to total failure. Although he did not cause a behavior problem in class, he did not show the slightest interest in academics. He was a competent artist for his age. Narcissistically, he believed he would be a television star and was taking professional lessons in acting to accomplish his goal. In art therapy group, he willingly produced an art product, discussed his family and talked about his ambitions, but he never seemed to move beyond superficial social communication. He once said he hoped that his family would move to another neighborhood so that he would not have to deal

with gang pressure. He gained group approval with his abilities to make effective art expressions.

His narcissistic stance was dramatically revealed through a clay sculpture, where his self-representation stood in the crossed beams of two spotlights that shone on him alone as a camera recorded his acting. Visually it was a delightfully executed sculpture and Hector felt proud of himself both as artist and as the 'star' of the television show he created.

Some weeks later the group was creating graffiti which they felt expressed more than just 'marking' gang territory. As we worked in this format, Hector talked about how graffiti artists use spray paint as a medium. The discussion moved to airbrushing and the similarities between commercial spray painting and airbrushing as an art form. Hector was enthusiastic and interested. He opened up in a more affective manner than I had experienced before. We spoke of his future as an artist and I felt very gratified that I had found an entrée into his interests.

The following session Hector proudly came in with a complete professional airbrush kit; compressor, spray tool, special nozzles and various inks and other paraphernalia for airbrush painting. He showed us how he intended to use this equipment. He planned to work as the artist for the school yearbook and how pleased he was that I had introduced him to this medium. He felt that he had found a new niche for himself in his peer group at school.

The group was not critical or overly curious about his new art tool, nor did they question his ability to afford this expensive, delicate instrument. They were unusually disinterested in exploring this issue. I felt they were protecting Hector from 'adult' criticism or suspicion. I was pleased for him and encouraged his involvement and development of an anti-gang persona. However, I knew what this equipment cost and I was painfully aware that we were looking at several hundred dollars of very fine tools.

What was I to do? If I suggested that he had stolen this air brush I would lose his trust. If I brought it to group I was imposing my concerns, since they had indicated by their silence that they preferred to avoid a discussion. If I ignored the issue I was colluding with a possible

thief. If I reported him to his family they would have ignored the issue, as they had many times before when he had 'borrowed' money and objects from their store. No matter how I spoke to his parents Hector would have felt betrayed by yet another adult.

I decided to question him directly (outside of group), but he declared he had purchased it all with his savings. So how could I challenge his story? Still I felt he was not telling the truth but I had no proof. I seriously examined whether it was my unresolved issues that I was projecting on him. We continued to see one another for several more sessions but no further change occurred. He left therapy because he said 'he had been helped a lot'.

To this day, I continue to puzzle about my part in this situation. Since I am deeply concerned with ethics I am even more distressed with the lack of resolution of this conflict. In clinical case conference, I revealed my ambivalence and the staff was equally torn about a decisive action. There is a good possibility that adolescent sanction of stealing had triumphed over adult ability to problem solve. Many conflicts of this level of ambiguity arise when working with adolescents.

What I did learn from this dilemma was to act more promptly. When I am torn by an ethical decision I arrange to see the teenager and share the conflict. I do not wait until time has given tacit permission to let the issue die. Since I have become more comfortable with regarding my clients as active co-constructors of our time together, it has given me a freedom to dialogue about awkward situations.

Where to establish adolescent treatment

Adolescent group treatment has a greater chance of success if it is offered at a site that does not place the child at risk to attend. The risk is not only physical, such as crossing through gang territory, but also can be emotional, if by coming to a mental health clinic they feel labeled as 'crazy' or 'nerd' which connotes 'different'. Group is well attended in situations where the youth is required to attend by an outside authority, if there are behavioral 'points' won or lost based on attendance. Fragile personalities can use carefully selected supportive group treatment, day-care groups can deal with returning to mainstream. Groups that are

Figure 2.10 'Crippled tree, burning down. Sun setting'. (A drawing by an adolescent at risk)

formed to respond to a specific crisis, such as an eating disorder group, or an adolescent-parent group, can be successful. Group treatment is still viable, however, it must be more defined and structured than in the past where teenagers met just to get past being a teenager.

Inpatient hospital group

Where can we best do group treatment? Hospital, day treatment and residential settings are one solution. Forced into attendance the hospitalized adolescent is often non-compliant but the threats s/he fears usually arise from internal conflicts rather than external. The hospital is safe. Hospital treatment is created to help the adolescent regain connection to his/her peers, restore some social skills, and return to the home or foster placement in a relatively short time. Group is helpful in dealing with the difficulties of tolerating psychotropic drugs

that may help his/her mental status, but have alarming side effects. Adolescents are hyper-aware of their bodies, therefore any external change beyond their control is intolerable. Drugs often bring on weight gain or skin eruptions, these changes can depress an ego that is already fragile. Some symptoms which are disturbing to an adult are not even considered symptoms to the teenager. Manic behavior is admired, depression is feared. Suicide is easily considered, and in some cases a tragic solution.

The art therapy is useful with all of the above mentioned symptoms. Hospitalized clients are able to lose themselves in abstract imagery that can reflect their inner turmoil. If the image was drawn without clear intent, it can become more specific as the teen looks at it. Even if it is an after thought, it still provides a vehicle to focus their feelings upon. Clients come and go in rapid succession. The art is permanent, and that offers some stability to this form of group.

Art therapy is useful in the inpatient setting since it demonstrates the youth's ability to compose a drawing, stay focused for a period of time, externalize some of the discomfort felt internally (both physical and emotional). The therapist must be very attentive to the process and product of the young clients and provide guidelines and structure to help them contain feelings that have brought them to need hospitalization. In group the therapist must be aware that artwork by other kids may trigger the individual. It is better to give clear directives that do not add to the confusion of thought processes, and are slanted toward realistic and pragmatic goals. Therapy groups in hospitals are often open ended, since the stay is generally short. The expectation of group cohesion is unrealistic, however, everyone has a forced commonality, which is to be in the hospital.

The greatest difficulty for the inpatient art therapy leader is that the hospital team sometimes is unaware of the power of visual imagery. The art therapist usually has one or two hospital attendants or recreation therapists in the room to help with any out of control patient. These staff persons should be educated not to make personal comments about the art or join in the art making. They are not members of the group.

Patients who are not ready to deal with their primitive visual expressions can be deeply distressed by their own inner turmoil

emerging in the artwork or by observing the distressing symbols of others. I believe nothing can reveal how very painful it must be to suffer a psychiatric disorder than viewing the drawing of the deeply disturbed individual.

The challenge for the art therapist is to be hyper-attentive to the new recruit in group, and have well rehearsed methods to modify the impact of wild images. A simple but very effective control is to gently stop the artist, who may look like s/he is decompensating, and suggest that his/her art would profit by a border (a frame). The containment provided by the therapist and adolescent working together to create a broad frame around the art is parallel to suppression of the inner turbulence. When I have had to make this intervention in a hospital group, I have been impressed how the other group members have been able to call upon their own resources to allow the person in distress to regroup. This is hard to believe with some hospitalized adolescent groups who have a terrible time containing their behavior. The anger that is often displayed by the inpatient adolescent can be safely projected on paper rather than on others. Art therapy 'boxes' can be used to contain the rage and fears. The art therapist can 'hold' the artwork to give the youth an example of containing behaviors. Perhaps the greatest frustration for art therapists working in the psychiatric hospital is the rapid patient turnover, which limits the impact that an evolving visual vocabulary might provide.

Example of failure

I failed badly when I misjudged how the art image can emerge unexpectedly and visually confront the adolescent with repressed material. The mistake took place in an adolescent hospital program when I offered four teen girls, in a small group, an opportunity to use collage to make their self-image. Objectively these girls seemed smart, medically stabilized, somewhat hyper, but within normal limits of fourteen-year-old female behavior. They made their collage while laughing, and making gross sexual comments (to bug me), and seemed comfortable with this project. However, when they finished and observed that they had made ugly monsters from the magazine pictures,

Figure 2.11 Disturbed adolescent believes everyone is watching him

they were terribly shocked. They rose from their chairs and threw the ugly images on the floor and screamed at me that art 'sucks' and 'they would never work with me, ever!', and they didn't. I realized too late that I had not been careful enough when I offered an unstructured task. Their inner image of themselves emerged on the page, they were shocked and terrified as too much had surfaced too quickly. It was not therapeutic. I learned to be more thoughtful about the art directives offered to teens in the hospital.

Day treatment and residential group treatment

The structure in day treatment and residential settings can be considerably different than the hospital setting. The therapist must be particularly aware of the developmental maturity of the group members. Some individual sessions are recommended before forming a group. The individual sessions are focused on assessing the developmental stage of the client, the extent of the previous abusive history, and the ability to contain behaviors and enter into social exchange. A series of

drawings taken from Silver's assessment series, or some other source, will provide the therapist with a base on which to select compatible persons for group (Silver, 1988). Groups should be small, since individual attention may be necessary, and behavior will be erratic. Some residential centers prefer same sex groups which makes it more possible for the therapy goals to reflect the interests of the members and eliminates the additional stimulus of dealing with the opposite sex. The therapist should anticipate drawings of drugs, drug paraphernalia, and explicit sexual verbalization. This may not be the artistic expression that seems helpful, but in a behavioral residential program often the art room is the only place that the adolescent can be adolescent! Since these adolescents are out of crisis they have regained their defenses. The majority of these youths have solidified into chronic maladaptive behaviors, and because of their traumatic past are unwilling to risk opening up in the art. By being patient the art therapist will find that the group, if it holds together, will slowly move toward exploring issues of importance to these clients. Directing some discussion toward the future, is a safe way to start. The 'future' is often closer than we think, since residential treatment is usually limited to a year. The world is waiting for these youngsters, and if they can work together to improve their self-image, cope with the abuse or personality disorder that brought them into placement, the group will have offered a valuable service.

The art therapist should consider non-directive art tasks, since the rest of their life is highly structured. The adolescents often use group to complain about the staff and the routine. They are reluctant to discuss their family's involvement (or lack of), but at times will disclose abuse in a way that almost seems competitive. 'My life was more horrendous than yours!' The art may show only the agitation they try to conceal, by wild scribbles and torn paper. The more the therapist can help these youngsters move into metaphoric expressions and away from actual events, the greater the chance that they can use some distancing and control.

In rehabilitation programs for adolescent substance abuse and alcoholism, group therapy is often used to encourage the youths to admit and share the burden of addiction. These groups are usually

constructed with a particular approach to treatment, such as twelve-step programs. This subject is beyond the scope of this chapter, but is important and merits special study (Friedman and Glickman, 1986:38).

School groups

Another choice for adolescent treatment, which has become increasingly more practical, is to take the therapist to the clients. School groups, or after school meeting places, are logical sites and provide a better understanding of the immediate crisis or social stressors in the adolescent environment. In school settings the therapist needs the administration's support to promote group therapy as a privilege for many, rather than a punishment for a few. By following the plan suggested above – of starting slow and letting the adolescents shape the direction – the experience can become acceptable and even desired by the larger youth community (Gullotta, et al. 1996).

Figure 2.12 What's good/bad in your life? 'Sleep – school – violent dreams – nothing, empty' (15-year-old boy)

School groups are well funded at the time of writing this text. There are many children labeled attention deficit, hyperactive disorder (ADHD), particularly in middle school. These children are hard to handle in the classroom and the schools beg for art therapy groups to help them control their behavior. This is not an easy task for the art therapist since the school is created for classrooms and structured activities and often do not have art therapy rooms. Therapists must carry their art supplies, and fit into any free space available. The teachers also have difficulty having a child miss their class, and prefer he or she miss someone else's class. School groups are often limited to thirty or forty minutes, which poses another constriction on the type of art project that can be started. Attention must be given to the art product in the schools, since the personnel think of art as art, not therapy. This creates some questions about the confidentiality of the art therapy product. In addition, the staff expects to be informed about the issues the child discusses. If there is a situation of risk that has to be addressed, the art therapist may be asked to act as a case manager. All of these challenges have been handled by art therapists, however it is important to give each issue thoughtful consideration.

Groups for ADHD teens would be unmanageable without some behavior modification system. These behavioral plans are often constructed by giving: close consideration to the time span that these adolescents can tolerate; clearly stating rules of behavior; providing a self-evaluation system of 'points', which can be earned by attention to group process; and consistent rewards for which the group desires to work. Unless these youngsters can be contained they cannot focus on their art tasks. If they do concentrate, even for a short period, they benefit. The art is a permanent record even if their attention is fleeting. The art can focus the attention of the entire group, words are not concrete and are more easily dismissed by a restless group of teens.

There are a few school programs that are specifically designed for art therapy, but the majority of the programs are recent additions without regard for the mechanics of doing art therapy. The greatest success I have observed is creating small groups of two or three teens who have similar problems. The therapist should use some reward and behavior limiting approaches, and set up the art task for the school kids. In this

situation the therapist must be more structured and in control. With common interests and focused attention demanded for reasonably short periods the school mini-groups can function well for the early adolescents. Older adolescents do much better in individual work unless there is a stable art therapy program that is well established in the school.

An after-school group program

A mental health clinic on the westside of Los Angeles offers sliding scale and Medi-Cal funded therapy to a large catchment area that includes many poverty districts and is populated by a high percentage of very poor Latino, Caucasian and African-American families. The waiting list is heavy with acting-out, oppositional, hyperactive boys in early adolescence. It was decided that an entire afternoon, once a week, would be the best approach to help these boys. An expressive arts program was put into place and designed by Rita Coufal, ATR, MFCT.

The boys were motivated by a verbal group at the beginning of the afternoon program. This group set goals, focused on positive reinforcement, taught them self-evaluation, followed by rewards at the end of the day. The program offered drama, movement, and art therapy. It has been a great success, and is now in its tenth year. The art therapy was seen by the boys as the 'real' therapy. The art therapy groups were small, four boys at a time for forty minutes.

As the supervisor of the art therapists who trained and worked there over many years, I was privileged to oversee some art therapy projects that were inventive and highly appropriate for this age group. The projects were designed to last over many weeks, since the forty minute art therapy session was brief, and often interrupted by behavior problems. I will share some of the ideas that I admired.

Flushing away the four letter words

One group was particularly fascinated by every bathroom word, plus variations on them, that had ever been invented. The competition escalated and brought group to an impasse, until the art therapist put

them to work on making a life-sized toilet. The project was quite difficult, but with perseverance they made a bowl, lid, and a flusher (no water) of cardboard. When the toilet was completed, they started each group by writing down their vocabulary of bathroom expressions, and one by one 'flushed' them down. *This is a creative example of not backing away from reality, but taking it to another level where the original need to shock, was transformed into a contained action.* These boys were still thinking concretely; the toilet was concrete, their flushing actions were concrete, and there was humor and cooperation because it was 'their toilet'.

Containment and sublimation

The boys in this program had very low opinions of themselves, which were covered up by bravado and uncooperative behaviors. Many of them were referred to the clinic by the school because they could not contain themselves in class. Many were in special education classes, and some had learning disorders. They felt 'different' and had learned few skills to restrain their impulses. The art therapist suggested that they might like to draw an animal and then construct a zoo to give the animals a fine place to live. They were enthusiastic. A very large piece of paper was attached to the wall; the areas were sectioned off, and decisions were made as to which animal would live next to another. The boys first made their animals on a separate paper, and then cut them out. This served two goals; one, animals are hard to draw for some youngsters and the art therapist helped to reduce frustration and insure success; second, the animals were drawn on sturdy paper so that they would not tear, and with rolled tape on the back they could be moved in case there was a problem about proximity and placement.

I am sure the reader can see the metaphor in all of these actions. The wild animals became projections of themselves: the zoo cage represented, either how they saw their world, or a need for containment; the support of the therapist when s/he insured success in the art, bolstered self-esteem; and the invitation to make an agreeable environment inferred the possibility of change. Each move was planned to be syntonic with the therapeutic needs of these young adolescents.

The zoo creation was worked on for many weeks. Several times a wild animal escaped, endangered his neighbors, and had to be captured. Once, an animal became ill and needed help from the other animals. Some animals had barren cages and some had luxuriant planted foliage, some made friends with the animal keepers and some did not. Never before had these inarticulate boys been able to find words to express their private concerns, when they became animals the metaphorical language made it possible. This project was cherished and guarded by the group, and no one made the error of making an interpretation that would have destroyed their very personal creation.

Volcanoes can be angry

An art expression that I admired, was created in the following manner, and attended to the overt and covert needs of the group members. The small group of early adolescent boys were given a sturdy fiber-paper tray, about 8" x 6", a variety of colors of plasticine, wooden popsicle sticks and other small objects. They were asked to create an island where they could live. Without exception each of the boys, started with a volcano on one side of the tray. The volcanoes were visually very dramatic, with red lava coursing down the sides of the black mountains and flowing into the valleys. In some artwork the lava covered most of the tray, with others the lava stopped at the foot of the volcano.

After this phase, the remaining portion of the tray was considered. For some boys they could not go any further; the dangerous lava was everywhere; for others, green fields and small houses appeared, there were signs of life. A conclusion might be made that the most violent homes were represented by the most explosive volcanoes. This was true in a few cases, but what seemed more consistent was the boys who were more resilient, more open to change, had the greener fields. This observation was interesting, though not conclusive, but it was a wonderful device to metaphorically examine survival tools that could be useful in the real world.

The boys persisted with this project, and guarded it with care. They valued the images and they were willing to talk about needing skills to endure crises, and how they would handle living near a volcano, and

other survival speculations thinly disguised through the metaphor. The only serious disruption came when one member lost control and smashed the clay volcano of his 'enemy'. How this intrusion on a person and his creation was to be handled became a major issue that was brought before the larger group immediately. The solution was a group decision, with the offender making a suggestion that was accepted. He carefully rebuilt the volcano and replaced the lava as the original art maker directed. They shook hands over the completion of the project, which was done while the entire group observed. I cannot conceive of a purely verbal exchange that would have been as meaningful to this age group. Repairing an art piece is an acceptable apology for a boy of this age. He does not 'lose face', and he can demonstrate his reparation of the relationship rather then struggle with trying to find the words.

Parent support group

Parents who have experienced a sufficient number of conflictual situations with their adolescent children to motivate them to seek psychiatric help often feel ashamed of this position. For many reasons

Figure 2.13 'My mom sneaking out of art therapy parents' group (like she always does)' (14-year-old girl)

they may feel inadequate, harassed, angry, blaming, shamed by having their child in treatment. They feel that they may be, or may be seen, as bad parents. The parent(s) of teens in group may feel that they are being 'bad mouthed' to the clinician and the group by their child. They fear losing control of their boy or girl to a more effective adult (the therapist). They have concerns that all their efforts to help their child are not appreciated by the therapist.

This situation can be neutralized by forming a group for the parents of the teenagers that are in group. The advantages can be listed.

- The parents will meet other couples (or single parents) that have the same fears they have.

- They will not blame the home environment of the 'other kid' if they become familiar with the real people that are parents of other troubled adolescents.

- It is a comfort to know that adolescent problems are experienced by many families.

- Sharing stories of their own adolescence often evokes humor and greater tolerance of the kids.

- By enlisting the parents' help the therapist can eliminate the fear that the clinician has power over the youths, or holds a poor opinion of the parents.

- Parenting skills can be introduced and discussed in a non-blaming manner.

- Educational information about adolescent development can be offered.

The group should be offered, if possible, to the parents at no charge, as an extension of the adolescent group. They should be clearly informed that this is not a therapy group, this is a support group. The endorsement of the parents is crucial to the continuation of the adolescent group. The promise of confidentiality can be explained and extended to the parent group. The parent group can be effective even if it meets only once a month.

Starting the group each session with the simple request 'Draw the issue that annoyed you the most this week with your teenager', can be

an excellent start. The amazed look on the parents' faces when they look around the table and find half the drawings are about the same behavior, is therapeutic in itself. The men and women are able to share how they have dealt with certain problems and ask for help with others. The process of group therapy and art therapy is de-mystified. On occasion the adolescent group draws 'message drawings' to the parent group. For example, drawings that tell the parents what they want them to discuss, or issues that they believe they should know more about. The parents can respond by drawing an answer. This should be done with humor, if possible, and controlled by the therapist if it sinks into a blaming message.

Most of all, the parents enjoy each other and find comfort and support from the group and accept the therapist as an agent on their side. The therapist benefits from knowing the parents 'in the flesh' and not the projected image that the teen has presented. I cannot emphasize enough how important a parent group can be for the well-being of an adolescent group.

A caveat: a parent's group cannot be formed until all the issues around, breaking confidentiality, a possible split in the loyalty of the therapist, and goals for the parent's group, are openly discussed with the adolescent group. There is no doubt that the teens will question their parents, and any misunderstanding must be reviewed in group. Their anxiety will quickly diminish if the therapist sticks to her/his promises.

Art tasks that act as co-therapist

Art can support a group as they test for trust, confidentiality, and group cohesion. Listed below are some specific suggestions that have proven useful.

- *Introduction to non-aesthetic art.* Place a variety of media on the art therapy group's table. Have members experiment with the possibilities that are inherent in media. No agenda.
- *Establishing comfort and trust.* Individual drawings shared with one other group member.
- *Extending the relationships.* Dyadic drawings, two persons sharing the same piece of paper.

- *First group drawing to establish group cohesion.* Each member draws self-image abstractly, the drawing is passed from member to member and each contributes a 'supportive' image. Each person shares their reaction to the finished piece.

- *Self-revelation without words, enhancing safe disclosure.* Draw your inner person in an abstract form, showing the various personal emotions by color choice, draw the outer layer that is known to the world. Do not reveal any material in these drawings except that which is comfortable.

- *Advancing group cohesion and trust.* Each member draws around their hand on a separate paper, the hand is decorated as fancifully as the adolescent wishes. The hand is cut out. On a large piece of paper each person places their hand in relation to the others. The hands are movable, with rolled tape on the back. The group looks at the composite 'hand' mural. Change of placement is invited. Discussion. Observations. Further enhancement of the background is encouraged.

- *Advancing greater knowledge of others through metaphor.* On large piece of paper the members are asked to draw an island and place anything on the island that they need to survive. Discussion is encouraged. Only rule is that permission is requested if entering an already established space. If the group is large, two islands can be created and then compared. Group is asked to share their interactions and observations of the process.

- *Greater trust required.* Make a collage of the environment you live in (had lived in). Represent the environment as 'hot', 'cool', 'stormy', 'peaceful', etc. Using representations of nature, music, color, to convey the 'feeling' of living in that home. Discourage attempts to be literal, since proceeding safely and slowly is the goal.

- *Sharing problem issues.* 'Represent your family in plasticine. The figures should be shapes that reflect the character of the family member, and the size should be relative in proportion to their importance to you'. Demonstrate the inter-family relationships by placement close or far from each other.

- *Individualizing members and understanding their world view.* Take the created family figures in plasticine and in the manner of play

therapy have them dialogue, change their positions, and
experiment with possibilities both in the present and the future.

If the youthful client learns to use an abstract form of representation
they will find they are not restricted by attempting realism. If they are
comfortable with representational drawing, that is their choice. The
goal is to encourage the way they can project their thoughts freely and
find the act of creating an art therapy product non-threatening. The art
sends a meta-message that furthers the therapeutic process. *Ideally, every
task in art therapy is based on clinical thinking and is created to serve a therapeutic
goal.*

The suggestions made above are only suggestions, not formulae.
Each of these tasks act as an impetus to foster group cohesion and
success. Each task can be modified in many ways and do not need to be
followed one after the other. To utilize these suggestions, without
regard for the timing and pacing appropriate for the particular needs of
a group, would not serve therapeutic goals.

Summary

Exploring the validity of group treatment for adolescents has led to
some conclusions. Group art therapy treatment remains a useful service;
adolescents still seek peer association and support and are more inclined
to attend group therapy than individual treatment. Art therapy is the
least threatening form of therapy to offer this population. The
over-riding consideration is the need to carefully evaluate the
circumstances where, how, and to whom, the therapy should be offered.
It is defeating to disregard social and economic pressures as the possible
site of whatever disturbance the adolescent is demonstrating. Home life
shapes the child long before a therapist sees him or her in adolescent
treatment. We must find ways to open new alternative views for both
the adolescent and his/her family.

The early psychoanalytical view of adolescent development has
been broadened, which helps therapists be highly sensitive to the
physical and psychological maturation of the client assigned to group
treatment. The adolescent group leader has a grave responsibility to
carefully explore the composition of the group they are offering. One

more disappointment for the adolescent, in a history of failure, is a sad outcome. A group carefully selected can be successful. Success comes when the members have a general level of maturation; they are not in rival gangs or in physical jeopardy by attending group; they are given the opportunity to express their narcissistic views and utilize their creativity. Although there has been much progress in understanding that a teenage child can individuate and still remain connected to his/her family, many adolescents have been forced by circumstances to be totally separate before they are ready. When an adolescent is without a parental system to protect and support him/her, then the group assumes an important function in his/her life.

Art therapy can make a difference between a failing group and one that succeeds. Art offers a unique language that is compatible with the creativity of this age group. It is a mode of communication that the adolescent finds non-threatening, pleasurable, and under their control. If the art therapist group leader attends to the perimeters suggested above, takes a stance of engaged observer, and creates (with the members) art opportunities that visually reflect the concerns of the adolescents, the group will probably stay alive.

Group for adolescents is one of the greatest challenges for therapists in today's mental health service. Group is also one of the preferred modes of therapy offered to adolescents so it will continue to be where art therapists are working. The argument for group is, teenagers seek peer support, however, to consider support the only function of group is limiting. If the art therapy group engenders commitment from the teens, then much more can be addressed. If consideration is given to all aspects of the adolescent problem and the therapist is willing to learn from this age group, a great deal can be accomplished.

Adolescence, Depression, and the Impact of Societal Issues

You guys screwed it all up, don't expect us to try and make it work.

(One of countless statements of hopelessness by an adolescent)

The mental health and judicial systems have pressed clinicians to offer therapy to an age group that has demonstrated most clearly the heightened tensions and disillusionment present in today's society. For example, the criminal charges against adolescent youths have shown the largest gain in the judicial system and placements by the courts have overfilled residential facilities and detention youth-camps. Adolescent children in trouble are not always in the court system, many youths from affluent and educated homes are afflicted by the disease of hopelessness, and many of these youths find depression so overwhelming that they prefer death to continuing to feel so tortured. Therapists are called upon to treat these adolescents, who are depressed and desperate, lack trust and reject therapy. The adolescent child has usually demonstrated over the years, through malfunctioning behaviors, their need for preventative interventions. However, there has been little funding for preventative work, particularly with depressed individuals who withdraw from society and harm themselves, rather than others.

There appears to be limited hope for the traditional therapies to serve this adolescent population, since their resistance to therapy is so strong and their disillusionment so pervasive. However, if we shift our clinical thinking to enable us to enter the adolescent depressive world view, with their perceptions and values, there is a good possibility of offering some alternative visions to these despondent adolescents. Art therapists and art-sensitive therapists, have the skills to provide an

additional vehicle of treatment, a lens to viewing the adolescent perceptions through their client's illustrations and their narratives. Artmaking is less confrontive, less familiar, less judgemental, and without contamination from the customary words which are not acceptable for this age group.

This chapter will offer an overview of the changes in: clinical thinking regarding treatment of adolescent depression; the necessity for differentiating approaches for the male or female adolescent client; the impact of societal tensions; the manner in which the use of art psychotherapy can facilitate a more successful outcome for treatment of adolescent depression.

Overview of adolescent depression

The literature and the opinions of clinical experts on the subject of adolescent behavior and etiology are basically in agreement about the signs and behaviors that demonstrate adolescent depression (Kopelwitz, Klass and Kafantaris, 1993; Kaslow and Racusin, 1990; Cyrtryn and McKnew, 1996; Malmquist, 1978; Blos, 1979; Bloch, 1995; Wilkes, et al. 1994; Herbst and Paykel, 1989; Oster and Caro, 1990). However, it is important for the clinician to recognize the difference between the 'normal' and often exaggerated mood swings of adolescence and the more serious and pervasive signs of chronic depression in this age group. The therapist will be more effective if s/he is aware of the tasks of adolescent development and the fluctuations of emotions concurrent with psychological and physiological changes of pubescent youths. Parry-Jones describes these stages:

> The tasks of coping with the physical changes of puberty, of separating from the family and becoming independent, of developing intimate relationships with others, especially persons of the opposite sex, and of discovering one's capacities or talents for work may all lead the adolescent into an unhappy, sad, demoralized state of mind, as the unknown is faced. For most adolescents, such maturational tasks are achieved with minimal stress, a small number experience a persistent mood of sadness, hopelessness and apathy, which interferes with performance and can led to considerable personal suffering. Such adolescents may complain directly of depression, or more commonly of

lack of feelings, emptiness, self-depreciation, loneliness and hopelessness that things will ever be better. There may be a point at which suicidal thoughts arise in these cases. It is likely there is a history of behavioral problems, difficulties in school, episodes of anxiety and tenuous family relationships. (p.114)

The greatest challenge to the clinician is to untangle all the various symptomatic behaviors of depression, some may be part of the youngster's stage of maturation and others may be reactions to life circumstances, and yet others may be based in physical illness. Therefore a sensitive appreciation of internal and external stressors must be considered before a diagnoses is made. 'The main pointers to serious risk are persistent, severe depression; previous self destructive behavior; and unusually stressful events. The risk is greater if a suicide attempt was made in isolation and timed to make intervention unlikely, a note left, or evidence of premeditation' (Parry-Jones, 1989, p.118).

Although until recently there was some doubt that infants and very young children experience depression, these melancholy adolescents often have a history of head banging, colic, excessive crying, and sleeping disturbances in their infancy. As the child grows somewhat older behavioral problems begin to displace depressive feelings: temper tantrums; disobedience; truancy; running away from home; accident proneness; inviting fights from other children; and other self-destructive behaviors. The youngster is convinced that s/he is worthless, bad, unacceptable. These feelings lead to anti-social behavior which in turn, supports the negative belief that s/he is inferior and stupid (Toolan, 1969, p.114). A history of younger levels of failure lead to the hypothesis that achieving adolescent tasks successfully will be much more difficult for these youths and a depressive state may be predicted.

Art that reflects the adolescent's abilities

The classic symptoms of depression are not always displayed in adolescent behaviors. The teenager will act out his depression, and with action comes the opportunity for an active therapy to be helpful. Art is an action which can be used therapeutically. The overwhelming

lassitude of a depressed adult makes engagement more difficult than the angry, aggressive depression of an adolescent. If the therapist looks for all gradations of a depressive state, the art task can conform to the needs of the client. The media is important; a depressed client who is not willing to make an effort to draw, is more inclined to pick up a magazine picture. Collage seems less challenging, but is not less revealing. The actively angry adolescent can express his/her feelings in paint, pastels, or pens, and then show in a second drawing, the motive for the anger, or what the anger is covering. Often the second drawing will uncover the depression.

The therapist's style also must reflect the needs of the client. If the teen is immobilized, the therapist can chance doing an 'explanatory' (diagrammatic) drawing, then ask if it reflects the adolescent's concerns. If the teen is active, then standing back and allowing discharge and free association to take over, will lead to a discussion about the core problem that is depressive. Generally speaking, most adolescents are afraid of the paralyzing hopelessness of depression. The therapist can acknowledge their fear in subtle, non-confrontive ways, and offer teens some support to sustain them at this time. I believe that small token gifts from the therapist, such as a few felt pens, or pastels, to make art at home, or a drawing by the therapist that illustrates the therapeutic relationship, can be powerful transitional objects. For the depressed teenager to 'take therapy home' sometimes acts as a protective talisman. Since art therapy is a concrete modality, we should take advantage of it in untraditional ways if it serves the client.

Character problems and violence

Malmquist (1978), one of the pioneers in the exploration of adolescent behaviors and their relation to character problems and criminal violence, has this to say about developmental problems: 'Conflicts from earlier periods predominate in those who are predisposed toward character problems and depression. The following are some major areas in which these are in evidence':

1 Difficulties expressing attachments and dependency needs.

2 Low frustration tolerance when environmental sources are not meeting adolescent demands.

3 Difficulties in mastering the anxieties attendant upon the separation-individuation processes.

4 Conflict involving striving for autonomy.

5 An imbalance between expression and control of aggression or sexuality.

6 Developmental arrests, fixation, and conflicts, which relate to differentiating gender identity (p.614).

Malmquist (1978) proposed, and many clinicians have since agreed, that a large preponderance of acting out and delinquent behaviors of teens are utilized to relieve depressive pain and self-depreciation. These acts demonstrate the anger they feel and negative consequences are preferable to experiencing depression. In my clinical practice over almost two decades I have observed that many adolescents substantiate a core of depression, which surfaces in therapy, after exploring the reasons for their malfunctioning behaviors. It is possible to recognize, in some cases, features of a personality that seems predisposed to depression. They seem hypersensitive to any negative remark or situation and take upon themselves guilt and shame and lack a feeling of self-worth. Parry-Jones (1989) discusses 'masked depression'. He points out that inconspicuous depressive symptomology takes the form of restless boredom, poor school performance, somatic symptoms, fatigue, and actions such as reckless driving, promiscuity, drug and alcohol use. It appears that depression and conduct disorder may occur concomitantly and antisocial behavior precedes a high proportion of teen suicide (p.115).

The following are examples of teen drawings from a group of clients that concretize some of these symptoms. Figure 3.1 is an example of an adolescent's drawing of feelings, in reference to the struggle for autonomy. 'Trapped inside myself' is the legend, we can see that although the door is open, it seems impossible to escape the prison. Figure 3.2 is a lively example of free-floating anger. Figure 3.3 shows the adolescent at the bottom of a well. 'No way out' is again the theme

of hopelessness. Figure 3.4 demonstrates the entrapment of the depression and the fear it evokes. Fear that is strong enough for the adolescent to seek the protection of day treatment.

Suicide

The suicide rate is on the rise with the adolescent population and is more frequent in mid-adolescence and later. Any talk of suicide should be taken seriously, and although prevention is difficult, the clinician should initiate actions to keep the teenager safe. Waiting for absolute certainty that there is a serious attempt at suicide is often too late to save the child. Any crisis event with a depressed youngster; such as a break-up of a love relationship, moving from friends, rejection by their peers, serious emotional pressures at home, such as divorce, illness or death in the family, alerts the clinician to act promptly and intervene hastily. Figure 3.5 leaves nothing to the imagination. The grave is isolated and barren, drawn in a manner and with colors (black and red

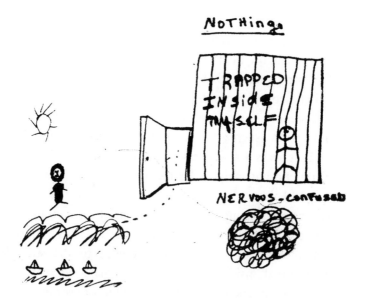

Figure 3.1 'Trapped inside myself'

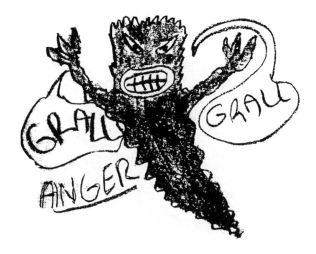

Figure 3.2 'Anger!'

Figure 3.3 'No way out'

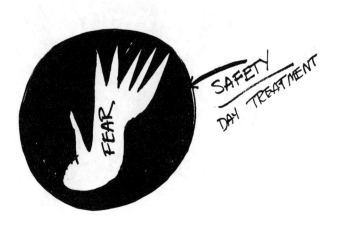

Figure 3.4 Fear and protection

only) which evoke in the observer a sense of bleakness and gloom. To make sure they are understood, and to reinforce this emotional response the adolescent has written words such as: frustration, sorrow, miserable, depression, alone, help, desire to die. An art expression such as this, is a powerful condensation of the verbal narrative of suicidal intent into a visual statement. For a professional, of any discipline, not to take the message in this drawing seriously would be a mistake. The adolescent youth is creative, and they find ways to impact the world.

Depression in hospitalized adolescent girl

A clear example of how a suicidal and hospitalized fifteen-year-old girl looked at her life is revealed in the following drawings. Figure 3.6 is a circle divided into three colors, red, blue, and black. She defined the blue as hope, the black, depression, and the red, anger. 'When I was born the circle started to spin, and the longer it spins the less blue is there.' Figure 3.7, 'the spinning wheel has spun away the blue and only

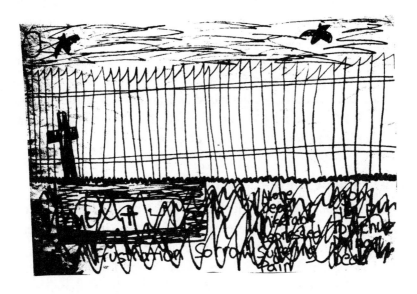

Figure 3.5 Suicide intent

a slice of red remains', Figure 3.8 (drawn three days later) indicated to the staff that she was in crisis since all color was gone and only depression remained. She was then placed under observation in the closed section of the adolescent inpatient. In recovery, Figure 3.9, she felt, 'The spinning wheel has slowed down and may become more blue again, particularly if the red arrows (the parents) do not pierce it.' This adolescent girl felt she had always been depressed, and that she would never change. The art expression was her way of letting the staff know when she needed help. What she was unable to express in words became frighteningly apparent in her drawings.

She had a disturbed family life, but not abusive to the degree that such deep depression would be anticipated. The narrative of her life supports a belief in the theory of a biochemical imbalance, combined with a dysfunctional home environment, which led to her on-going intense despondency. She could never remember being gay and carefree, even as a little child. She felt that her childhood was a sad one

and that her parents were too preoccupied with their own conflicts to notice hers. When her failing performance at school and socially, finally made them pay attention, they berated her and, in her opinion, never attempted to understand. Her suicide attempts were self-destructive statements which forced them to recognize her desperate condition. During her hospitalizations the use of art therapy as an assessment tool was a successful barometer of her mood swings. The girl learned to send messages to the therapist in her art products since she felt that she had no words to adequately describe her despair.

Socio-economic stressors: the family and depression

True and Kaplan (1993) studied the impact of the family on the behavior of the depressed adolescent. In families where the parents were depressed there were increased rates of depression in the children. Elevated use of substance abuse by parents or others in the home, often resulted in depression and impaired social skills. In malfunctioning families, particularly abusive ones, the rate of suicide in adolescence was markedly increased. Psychiatric problems and illness, both medical and emotional, were prime causes for suicidal ideation in adolescents from these homes (pp.45–54). Oster and Caro (1990) say:

> Differentiating family disturbances is a process of separating *degrees* of family functioning not necessarily *styles* of functioning. There seems to be four major dynamics that contribute to the level of expressed pathology within families: 1) family history from both a genetic-biochemical and an emotional stance; 2) previous family processing of past events; 3) quality of family boundaries and structures; 4) and the ability of the family to express and project emotions (p.25).

It has been argued that depression is genetically bound in families where the tendency for generationally patterned depression appears. Kopelwiz *et al.* (1993) have a very helpful chapter in the text *Depression in Children and Adolescents* on psychopharmacology of children and adolescents. They define the two major disorders of depression, articulated in the *Diagnostic and Statistical Manual*, Third Edition, Revised (DSM-III-R), as bi-polar and major depression, the pharmacological interventions, and their effect. I suggest that the reader go to this or

Figure 3.6 'The circle starts to spin' (Divided equally into black, blue, and red)

*Figure 3.7 'Hope is gone. Depression takes over' (2/3 circle black, 1/3 equal
 black and red)*

Figure 3.8 'All – depression'

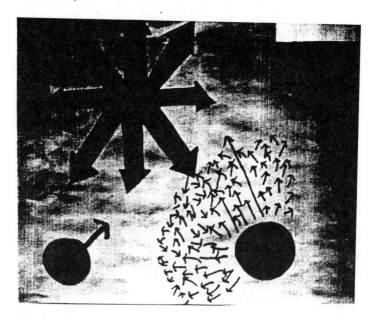

Figure 3.9 'Slowing down. Breaking up'

another source to educate themselves on this subject (pp.235–52). It is interesting that the belief that depression is genetically transmitted is often spoken about positively by adolescents in group treatment at a residential center. They find comfort in comparing medication and onsets of depression and reminisce about their worst bouts and the effects of withdrawal from social contact and other depressive events of their lives. It seems to make the adolescent feel less shamed if they believe that they have a brain chemical imbalance (their interpretation) over which 'they have no control'. However, the general belief among practitioners is that medication together with psychotherapy is the preferred treatment.

Societal pressures

Statistics should alert the therapist and parent about the growing danger of the everyday risks in society that impact the teenager. The Carnegie Council on Adolescent Development (1996) announced that the rates of teen drug and alcohol use, unprotected sexual activity, violent victimization, delinquency, eating disorders, and depression are now sufficiently widespread that nearly half the American adolescents are at high or moderate risk of seriously damaging their life chances. These perils cut across demographic lines; good family life, middle-class advantages, demonstrated parental love, none of these positive values can protect the child in today's society (Sandmier, 1996, p.22). If society is depressed about the conditions under which a large percentage of adolescent youths attempt to survive, it is not a surprise that the school and protective services are making so many referrals for adolescents to receive therapeutic treatment. However, the clinics are not very successful in serving this population, since the adolescent is reluctant to come to therapy, and does not feel that s/he needs help (Riley, 1993, pp.1–15). When adolescents are a part of a socio-economic crisis, such as an unemployed parent, living in a dangerous neighbourhood, facing discrimination because of race or color, they are reflecting the reality of a depressive environment. Their depression is appropriate and a clinician should be cautious not to pathologize the

youth when the real pathology is in the system (Hiscox, 1993, pp.17–26).

Depression induced by external stress

Figures 3.10, 3.11 and 3.12 are selected drawings from a course of treatment for an adolescent boy of fourteen years. He was assigned to adolescent group to deal with depression and suicidal ideation since he would not talk in family therapy. He lived with his mother and stepfather, a marriage of two years. It was reported that the stepfather was emotionally abusive to this boy because he did not show 'manly traits' and was 'too sensitive'. The boy was tall for his age, slender, blond, and withdrawn. In group he verbally contributed little, his drawings spoke for him. In response to the question, 'How do others see you', he drew himself behind bars in a woman's lounge suit. He said his stepfather called him a 'sissy' and constantly pointed out female behaviors in him. The following drawing shows him trying to get his

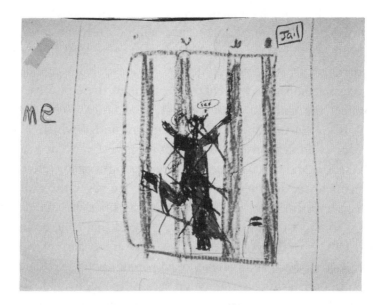

Figure 3.10 'A queen behind bars'

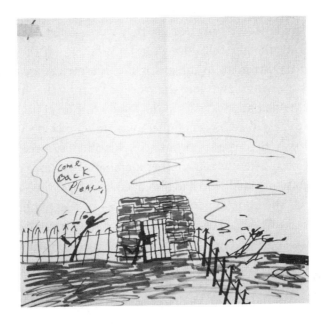

Figure 3.11 'Come back'

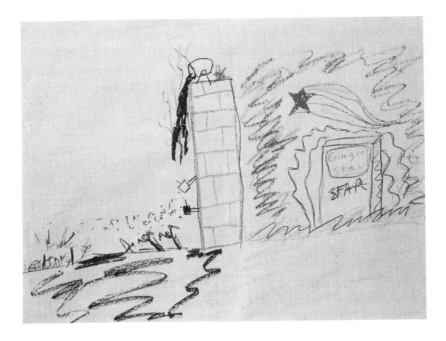

Figure 3.12 A wish to join a dead rock-star

grandparents back from the grave. They are separated from him by a wall. He missed them terribly because they were a refuge and a comfort before their death. The third drawing, he is falling off the wall as he tries to achieve his goal; to die as his favorite rock singer had died. These three drawings let us into the world of sorrow that haunted this boy; he felt he had no escape from the family torture at home. He was beginning to feel that his stepfather was right, that he was a male 'misfit', he was depressed. Fortunately, his identity problems were solved to a great extent when another member of group, a girl known for her promiscuity, and who had also been suicidal at times, picked up on his mood. She said, 'Don't believe that a-- of a stepfather, I would gladly f--- you any day'. This 'compliment' coming from this particular girl, who was aggressively interested in 'men', seemed to be the counter message he needed to hear, and gave him the courage to defy his stepfather and select his own identity. The group took the lead from the girl and assured him that his stepfather was crazy, and they all thought he should punch out the next guy that insulted him at school.

As group leader, I was so pleased that what I could never do, was done by his peers. My opinion of him had no weight compared to the other adolescents. His subsequent behavior in group radically changed, he discharged his anger in drawings, became verbal and less depressed. This is an example of situational depression caused by family circumstances over which the teen had no command.

Gender differences and depressive behaviors

Gilligan, *et al.* (1991) have studied the way males and females express distress. They report that coping methods and manner of expression reflect differences in socialization from a very young age. They pose the question: What is the relationship between depression or emotional stress and acting out? Does emotional stress 'cause' some adolescents to act out or does acting out cause some to become depressed? The characterization of females internalizing their distress, and males acting out their depression did not prove reliable in their studies. Each sex had a proportion of internalization and externalization. Among the young women it appeared that poor family connections, low levels of

connectedness in their relationships, low involvement in religion and, certainly, the presence of sexual abuse, were predictors for depression and suicidal ideation. In their summary the authors felt that a significant number of adolescent girls turn their cries for help inward, and may not be heard. It is difficult to detect their problems, but signs of emotional distress can be seen in eating disorders, suicidal gestures, and, more importantly for girls, a lack of strong connectedness with their families. These circumstances help the therapist to suspect serious depression in female adolescents (pp.129–32).

Depression linked to misinformation

Figure 3.13 illustrates a situation where a normally functioning, but shy, thirteen-year-old girl, became seriously depressed in a very short time and was at risk. She had missed therapy for about a month, and when she came into the room I was alarmed at her depressed affect. She was almost catatonic and sat bent over, unable to talk. She was willing to do a collage. The collage shows a hospital corridor topped with the word

Figure 3.13 A hernia operation is not a hysterectomy

'sad', a picture of food, with 'lots of food. Sick' written, and finally a girl sitting on stairs, hunched over, with the word 'unhappy' scribed above. The collage girl looked so much like my client that it was amazing. I asked her why that girl was so unhappy? She surprised me by saying 'she can never have babies. She just had a hysterectomy'. After some questioning I found that her absence had been due to a hospital stay of three days. When I called her parents to ask about the reason for the operation, I found that she had a small hernia corrected. The girl had not been visited by her family in the hospital, and she had totally misunderstood the medical terminology, and thought she had the same operation as her aunt had undergone. The communication is this family was so poor that she kept her misery to herself. She had stopped eating regularly and the family blamed it on her operation. No one recognized the signs of depression, or chose to deal with it. We discussed the difference between hernia and hysterectomy, and she felt greatly relieved. Continued family work was necessary, but the family was not cooperative. The adolescent was relieved for the moment, however, such insensitivity from her family to radical mood changes in a developing girl, continued to alarm me.

Peer group rejection

Another stress point in adolescent development which leads to manifestations of depressive reactions is activated by acceptance or rejection by the peer group. As the adolescent moves away from the parent in the struggle to individuate, they turn to their peers as a substitute for guidance and support from their family. The peer group consists of other adolescents seeking the same nurturance. Unfortunately, the narcissism of this age leaves the adolescent without the capacity or the skills to provide guidance for anyone, not even themselves. However, the approval of the group is constantly sought and rejection by peers is a major source of depression for this age group. In an informal survey I asked several dozen teenagers what they considered the first cause of depression in adolescent. The majority questioned answered, 'without doubt rejection by peers or boy or girl-friend was the primary cause'. Figure 3.14 shows a boy standing

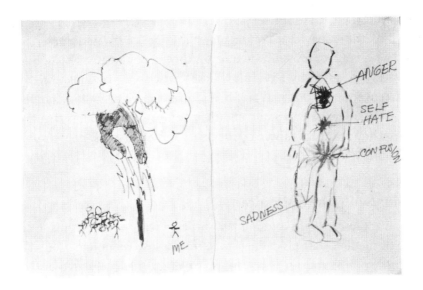

Figure 3.14 'Fate made me different'

behind a wall alone while his peers, grouped together, move away. The hand of fate points at him and marks him as 'different'. When asked to enlarge himself and localize in himself these feelings of separation from his society, he identified anger, self-hate, depression and sadness. It is noticeable that depression is placed in the area of his groin since this boy was noticeably immature, soft, and overweight for his age. He later confessed that he was sure he had been conceived on Mars, because 'how could he be so different and still be part of this civilization?' His depression was chronic and serious, unfortunately he withdrew from treatment when he felt that I had not accepted him as a Martian. As his therapist I felt saddened that I had not entered sufficiently into his world view to accept his interpretation of loneliness as 'coming from Mars'. My attempts to support and neutralize his perception were premature, he was not ready to join the painful society of his earthling peers. He was safer on Mars.

My observations of adolescent girls who are not at risk but are passing through a depressive stage of development, is that often they displayed their emotions very powerfully. They are at one end or the other of the behavioral continuum, either seriously withdrawn and display low affect most of the time, or they are aggressively laughing, provocative, and deny any difficulties whatsoever. The most effective treatment seems to be small group. The girls can see behind each other's defenses better than an adult, and they confront the feelings that they share. They are not confused by the behavior which is meant to disguise the depression.

'Going with' the resistance

In one adolescent girls' group I had difficulty engaging the girls in any type of media or art task. They were from a low economic group and had little or no exposure to any form of 'cultural' imagery and they were bored with the art. In their society they were encouraged to look to early marriage as their only goal, and at the ages of twelve to fourteen they had all been sexually active. The amount of lipstick, eyeshadow and mascara used by these girls would make most of us bend under the weight. Their ideal woman was one that was highly sexual and willing to follow the male's commands. They all were having difficulties at school and were angry with their parents but denied any sense of failure or unhappiness.

After a long period of frustration I decided to follow the group's lead. I helped them draw an 'ideal' girl's face, a girl that was successful and happy. I drew at the command of each teenager, and made the representation as close to their projection as possible. With their own cosmetics they colored in and enhanced the drawing. As they engaged in this narcissistic task they were able to talk through these made-up mouths and get past superficialities, they even admitted to having some feelings and questioned the 'rules' of their culture. I have never seen lipstick and eyeshadow listed in the choice of media for art therapists, but it worked and I felt less incompetent and able to reach these girls. When I stopped seeing art therapy projects in their accustomed form, I was able to respond to a visual expression that fit their needs. When I

allowed them to teach me where to go, the paper faces that were covered with lipstick, eyeshadow, foundation color, found a voice. They shared with me that they were angry and depressed at their status as second rate citizens and hand-maidens to the powerful male.

Studies of gender differences that influence adolescent girls and boys have pointed out to the clinician the differences in the manner in which they are socialized from birth. Contesting the past theories that wrongly attributed pathology to the way women function (Gilligan, 1982) has changed the practice of therapy. It is clear that therapists must treat young women and men with individualized treatment, sensitive to their gender defined viewpoints. In the same vein, the therapist should be aware of race, culture, and developmental deprivations, due to impact of the environment on the adolescent, and how they present in the treatment. This is a field too vast to cover in this chapter but too important to ignore.

The therapist's dilemmas in treatment for adolescent depression

It is essential that the therapist differentiate his/her treatment approach to adolescent depression to better meet the specific needs and level of crisis intervention called for in the individualized situation. The youth that is at greater risk, who has been hospitalized for his/her protection, is in some ways easier to treat than one in an outpatient setting. In the hospital the suicidal child is watched by a team; can experience the protective environment within a therapeutic surrounding, and reconstitute some coping strengths. This is true if there is adequate insurance or financial coverage to provide a hospital stay long enough to make some therapeutic gains. A tragedy may arise if the youngster is released too soon, and the family or foster placement is not equipped to provide the kind of support that these depressed and fragile adolescents need at this time. Therapists offering hospital treatment can become depressed themselves because of their own situational traumas that arise when treatment is terminated while the child is still at risk. Day treatment programs have traditionally been the next step after hospitalization. Intensive therapeutic programs and schools designed to

service the more distressed youth are a positive move. However, the funding for these programs is declining and small group homes and a few residential centers are all that remain of the more generous funding days of the 1970s and 1980s. The therapist's only hope is that a medication program for the adolescent will be followed, that the anti-depressant works effectively and they return to a tolerable living situation.

Care after a crisis

It is as an after-care setting that the family becomes essential in providing a positive outcome for the child. Their watchful and caring support makes the difference between a tragic ending or a decided change. The great advantage of hospital treatment for the adolescent at risk is that the patient is protected from his/her own impulsive solutions to their pain. They are away from drugs, cannot 'accidentally' get hurt, do not have choices about treatment, and are constantly observed; structure is important for these youths at a time when they have lost control and feel so worthless (Rinsley, 1980). This sense of security is absent once the child leaves the inpatient ward. In outpatient treatment the therapist experiences a great deal more anxiety and responsibility when dealing with seriously depressed adolescents. The judgement call; deciding how serious the jeopardy that the adolescent is in, the decisions about treatment, the need to involve the family, and the referral for medication, all fall on the shoulders of the outpatient clinician. If the clinician is in private practice the pressure is even greater since there is no support staff to turn to for consultation at a moment's notice. In addition, there is the legal and ethical system to think about if the treatment fails. This may lead to excessive caution when planning treatment, or may discourage the therapist from engaging this type of patient in therapy.

Long-term treatment following a crisis

A case that presented a challenge involved a fifteen-year-old girl who had been in and out of treatment with me for several years. She was

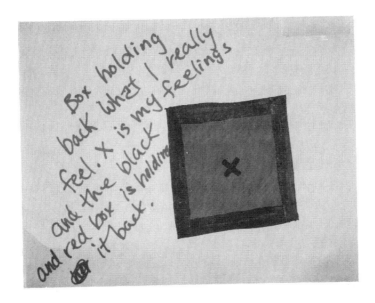

Figure 3.15 'Box holds back my feelings'

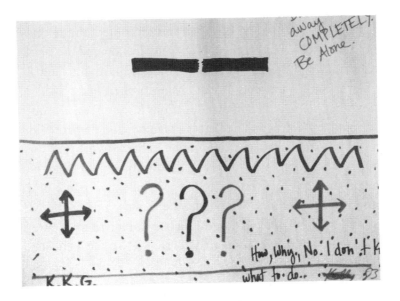

Figure 3.16 Conflicts of loneliness and sexual identity

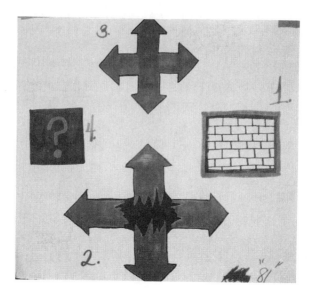

Figure 3.17 Reviewing goal

struggling with an identity issue, and refused to address it at this time. Figure 3.15, a black and red box, had this imprinted on the drawing. 'Box holding back what I really feel. X is my feeling and the black and red box is holding it back.' Figure 3.16, the page is divided in half, the upper black mark represents a relationship broken in half; the lower part shows her being pulled in two directions (the crosses), the question marks about her choices and her lesbian identity, and the word 'lonely'. This teen had established an iconography in her artwork and she used the same symbols constantly as her visual vocabulary. She had just left her gay partner, two girls trying to live as adults in a hard world, and her resources were limited. She had let the X in the box out (her sexual preference), but her pain and depression had not lessened. Figure 3.17, was a session where we attempted to set goals: she explained the drawing in this manner: (1) the wall behind which she had hidden her lesbian identity; (2) the cross roads of decision, and the core of depression; (3) many decisions still to be made; and (4) the future is still a question.

Our therapy lasted over a four year period, with many months where we were not in contact, and then a period of work, and then another parting. The art stayed constant and the symbols were still meaningful when we last worked together. We continue to touch base by phone, and her turbulent life has become more tranquil. She can still remember the drawings and their importance to her as she struggled to gain a positive sense of self. She once said, 'The art gives me the chance to see how I can climb over that wall.' The observant position she could take of the wall, which represented her fear and depression concerning 'coming out', was essential to her process of alleviating her depression.

Even under optimum conditions treating a depressed adolescent is a difficult challenge. The teen is suspicious of adults; has an omnipotent world view; feels more insightful than any 'shrink'; denies a need for treatment, since the world is crazy they are not; the whole society is hopeless, therefore they are powerless. This attitude make building a therapeutic relationship difficult and establishing treatment goals discouraging. Perhaps the first step for the therapist is to 'give up' the notion of therapy *per se*. It is exciting and challenging to reframe theoretical thoughts to match the world view of the young client. By taking the outlook of the client and respecting the reasons that they are in pain the therapist makes the first step to aligning with this population. The fact that no one can truly appreciate anyone's inner world can be the first confession that the therapist can make to the adolescent. The willingness to 'not know the answer' (Anderson and Goolishian, 1998), and still be engaged in the quest for a solution to their problems, is the stance to assume. The adolescent is insightful and sensitive to mood and intent, it is as though they have extra-sensory perception at this time, which seems to get lost in adulthood. Without fail, how the therapist feels and thinks about the youth will leak into the session. Therefore, knowing that the insensitive narcissistic facade that the adolescent presents is a necessary developmental stage to facilitate the move into a more secure level of maturation, gives the therapist the patience to continue treatment. In the early stages of narcissism the youth experiences such a feeling of emptiness that there is fear that any emotional sharing will result in complete depletion of self. When the adolescent answers 'I don't know' to every question, it is because *they*

really don't know, since ambivalence is the dominant experience of this age. When identity is in flux, all is a puzzle, and the formal structure of therapy must be fluid until there is time to find a manner of relating that 'fits' the adolescent client. It is never the same.

Therapist's biases and prejudices

The therapist must beware of their feelings and biased opinions about adolescents, and their own unfinished business of adolescence. Cecchin, *et al.* (1994) have written about the cybernetics of prejudice: 'When we talk about prejudices we mean all the sets of fantasies, ideas, hypotheses, models, theories, accepted truths, hunches, biases, notions, personal feelings, moods, unrecognized loyalties – in fact, *any* pre-existing thought that contributes to one's view, perceptions of, and actions in a therapeutic encounter' (p.9). These authors (Ibid.) urge us to be useful, not helpful. 'In general we believe that to be useful is not the same as being helpful.' They go on to say that to be helpful implies that the client in therapy is damaged and needs assistance from the healthy therapist. Therefore, they believe they can be more useful to the client, rather than helpful, if they give up this prejudice. They remind us that we *cannot not communicate*, and everyone has some bias, some belief system of which we should be sensitive. This is a human quality, and to deny bias is a bias (p.38).

This attitude toward therapy and client-treatment is quoted because it is essential that the therapist comes to the interview with the teen with positive regard and an acute awareness of their biases toward this population. If the therapist can share his/her perceptions with the teen client, the chances for success in treatment are greatly enhanced. Adolescents are not surprised that the adult may not understand or agree with their outlook, they expect the grown-up not to agree. The stance that does surprise them is the adult who is willing to demonstrate interest in hearing how they perceive events and who will be open to changing their original bias after hearing their narrative.

Figure 3.18 Confusion and ambivalence

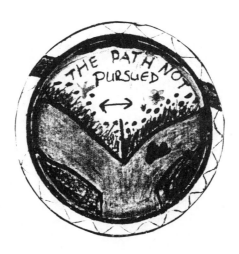

Figure 3.19 'Two paths, two choices'

Figure 3.20 Abortion

Figure 3.21 Dreams of the future

A question of abortion

An example of a situation in therapy that called for putting aside bias, is shown through the illustrations made by a fourteen-year-old girl as she was deciding whether or not she would have an abortion. She lived with her mother who was flagrantly psychotic. The parent was supposed to be on medication but she was non-compliant. She constantly accused her daughter of gross promiscuity, and totally ignored her promising school performance and helpful support at home. In due time her message was rewarded and 'Mary' did have sex and became pregnant immediately. Mary shows her path of decision through drawings Figures 3.18, 3.19, 3.20 and 3.21. The first is her 'state of confusion', with joy (the sun) of having a child, balanced by the storm clouds of losing her own youth. In the next drawing she represents the two paths she was forced to choose between; abortion or child rearing. The next is a graphic rendition of her choice. The last, her dreams of a happy future. This is a situation where the therapist is faced with controlling her own biases toward an issue that is very controversial for many persons. The role of being supportive and not judgemental seemed particularly important in this crisis. The adolescent gained from this process, she not only made a serious decision on her own, she evaluated the choice in a mature manner, and throughout the process exercised maturation and self-confidence. She moved from depression to decision, aided by the ability to externalize her distress in art which allowed her to take an observant stance of her emotions.

Reaffirming art therapy as the therapy of choice for depressed adolescents

What are the strengths of this age group? Adolescents are at their most creative period of their lives; they are active, super-charged or melancholy, passive or aggressive in the blink of an eye; they intellectualize and can think abstractly; they are highly critical of the society and often have idealistic ways to change the world. All of these traits have the potential for change, not only for the individual but, in the future, society. The challenge is to find a way into adolescent lives that fits their strengths and allows them to tap into creative solutions for

their problems, particularly to alleviate the burden of depression. Depression is the antithesis of creativity, so if the therapist can coax the strengths of the youth back into function s/he can find a window into their innate developmental patterns. For example, the tagging and graffiti of the gangs and disadvantaged adolescents is a clear language of anger (in most cases) projected visually, since they feel that since no one listens they must force the world to 'see' them. Society has not yet channeled this creativity in productive ways. We can appreciate the loss of potential when we view some of the more complicated graffiti 'pieces' that are done with real artistic skill.

As the art therapy illustrations have demonstrated above, this modality is a form of communication that is accepted by the adolescent. It is successful because:

1 The adolescent is in control of their communication. They can draw what they wish, and share verbally what they choose. Non-verbal communication is more comfortable than attempting to put ambivalent feelings into words.

2 The pleasure of activity, the newness of the modality, the feeling that they are speaking in their own voice in their products, reduces their resistance.

3 The respect they feel from the therapist; as the clinician honors their art they feel respect for themselves.

4 An opportunity to be omnipotent and project their idealistic viewpoint in a concrete manner. They may intellectualize and criticize adults, the world, even their peers, in a safe place.

5 They can problem solve through the advantage of externalizing their problems and taking a fresh view of them from a distance. They can experiment with change on the product before they risk making a change in reality.

6 Adolescence is a time of rapid change, the tasks and stages of development of early, mid, and late adolescence differ. The therapy must fit these stages and reflect the age appropriate concerns. The artwork provides assessment and clarification of the seriousness of their depression and the client's change is mirrored through their imagery.

No matter how minimal the art expression or how defended the youth, or how resistant to therapy by using graffiti and adolescent vocabulary to avoid being understood by adults; the kinesthetic movement necessary to create anything is active not passive.

The product is always a confirmation that the person is still productive. In short, it demonstrates to the adolescent that they are still perceptive and that they continue to have some control over their choices. They have power which can be activated.

The creative process is syntonic to their developmental stage, and therefore, not imposed but natural. This is a therapy that 'fits' the adolescent's psychological needs and development processes, an opportunity to interrupt the societal biases aimed at teenagers, which names them as uncooperative and resistant.

A case example of how the art therapy can assist in understanding a depressed adolescent will demonstrate some of these points.

Carlos came into therapy with ill-defined complaints and symptoms. He reported that he was tired all the time, that his decent grades were dropping, and that he felt disinterested and distant from his friends. He had formerly been a well liked, social, average student. The most traumatic recent event was that his grandfather had a stroke. Carlos lived with his grandparents, his biological parents were no longer in his life. The grandparents had immigrated to the United States as adults, and were still speaking their native tongue in the home. They held fast to their cultural values for raising children and their own peculiarities which were slowly revealed by this boy. For example, the grandparents lived in a divided house. There was a line drawn down the middle of the home, his side, her side. In the refrigerator the food was separated, his, hers. The money was not divided, the grandfather doled out to his wife and grandson the amounts he decided were correct. They had lived this way for many years. Carlos had begun to evaluate this strange system as he grew into his teens. With greater maturity came less acceptance as he compared his home life to that of his friends. The day that Carlos made his first rebellious move was the same day that the grandfather had a stroke. Carlos had eaten some of grandfather's Jell-O from 'his' shelf of the refrigerator, he was caught, and rather than stay to hear the punishment he ran out the front door. When he returned he found

grandfather hospitalized for a stroke. He made a recovery but the illness left him partially damaged and very irritable. Grandfather was well enough to berate Carlos and make a huge issue of the stolen Jell-O. Carlos became withdrawn and melancholy. He had no place to go, no resources outside of these two persons, and no money, since the grandfather demonstrated his anger by canceling his allowance. He was unable to join his friends at the movies or any other small outing. He no longer felt he could be attractive to girls if he had such a poor appearance. Most important, Carlos felt guilty for causing the stroke. He imagined that his Jell-O stealing precipitated the illness.

The information, related above, came out slowly over the course of treatment. Carlos wanted and did not want help. This ambivalence on many issues is one the therapist can expect when working with teenage kids. His first two offerings in art therapy were the expected adolescent images, safe and uninformative. When asked for his goals, Figure 3.22, he drew a Lamborghini sports car. Figure 3.23, a badly copied cover drawing from an album of rock music, a common ploy that adolescents use to shock the therapist. Figure 3.24 the imagery changed; a dangerous dwelling on the side of a mountain, with the inscription 'Abandon all hope ye who enter.' This shack demonstrated insecurity and contained 'the constant fire in the home where he lived'. Figure 3.25, 'the explosion of the house that was on the mountain'. This drawing needed no explanation. His anger had finally exploded and he felt less depressed. Figure 3.26 is a revealing drawing focused on his life at home. The words freedom, friends and sarcastic all refer to the fights with the grandparents; the things he wanted and the way they responded to him. These expressions are next to a tearful eye, a locked door (which represented his restricted freedom), a hand that slaps, a gun to kill the depression (demonstrated by the sad face). The final drawing Figure 3.27, was created later in therapy. He expressed his wishes for the present; no nukes or AIDS, the right to bear arms, lots of money and no sadness; the other side of the page was supposed to address the future ten years from now, he felt little confidence that he could predict the future. Carlos was aware it would be hard to predict positive futures for males from his socio-economic-cultural position in society.

Figure 3.22 Adolescent reluctance to be self-revealing

Figure 3.23 Shock the therapist!

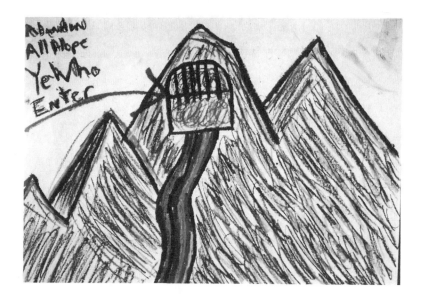

Figure 3.24 'Abandon all hope, ye who enter'

Figure 3.25 The house explodes

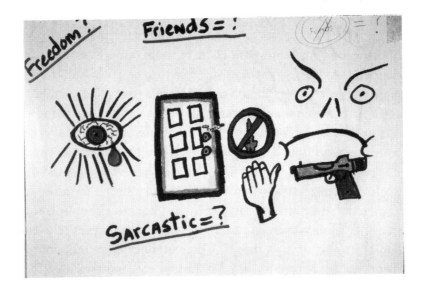

Figure 3.26 'Conflicts at home'

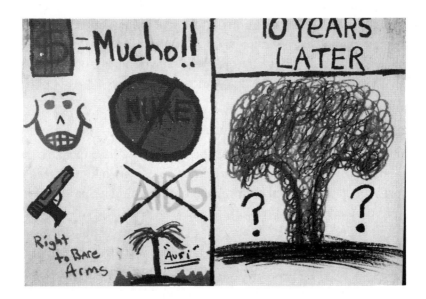

Figure 3.27 The present and the future

These drawings did not directly address the material about which Carlos was talking as he drew. They did, however, metaphorically give the therapist clues to where he/she could make inquires that were related to his traumas at home and his internal reactions to stress, demonstrated by his depression. There were also a means to monitor his anxiety and evaluate his safety. The fact that he could sublimate his anger in the art allowed him to verbalize it in a controlled manner. The struggle to gain autonomy at home, the anger and guilt he felt toward his grandparents, the confusion about the future, and the need for guns to protect himself from danger, were all clues offered in the art therapy. As he drew he could talk, he felt that the therapist was interested in his artwork and the questions seemed less intrusive since they arose from the material that he offered. He had the freedom to elaborate through the metaphor, relate it to reality, or to deny the meaning entirely. These examples are only a few of the many drawings he did over the course of a school year. His depression lifted as the therapy confirmed his effort to individuate. The therapist also helped by engaging the grandparents by telephone around some age appropriate liberties he should be allowed at sixteen years. The clinic was able to arrange some in-home nursing through the social services for the grandfather, and that reduced the tension at home. The conclusion of treatment found Carlos, a youngster with some problems, not depressed, and with the energy to make some changes. Therapy cannot cure the client's environment, but it can help the adolescent live in a stressful world.

Readings in art therapy literature

Some additional contributions in the art therapy literature that have bearing on the multiple problems of the adolescent youth that lead to a depressive state are listed below. Each of these difficult problems have some component of depression for the adolescent and the articles are recommended as further reading for persons treating adolescents.

Landgarten (1981) provides the reader with the experience of long-term therapy with a depressed adolescent. The chapter provides multiple art therapy examples that demonstrate the evolution of treatment (pp.159–84). Art therapy has been used: to scale adolescent

depression (Silver, 1988), in discussions of suicide (Conger, 1989), substance abuse (Cox, 1990; Friedman and Glickman, 1986), Satanism (Spietz, 1990), masochistic personality (Campbell, 1990), bereavement (Raymer and McIntyre, 1987), juvenile delinquents (Larose, 1987), adolescent families (Riley, 1988), violence in the home (Malchiodi, 1990), residential treatment (Linesch, 1988), adolescent group (Schneider *et al.* 1990), self-image (Larose, 1987).

Summary of treatment of adolescent depression

Adolescence is a difficult time for most persons, to make the passage from childhood to adulthood is the most dramatic personal journey we all must take. The changes that are intrinsic to this process, reviewed above, are physical, psychological, and gender defining. 'Adolescence' has become a process that is imposed on children at an earlier age by society with every decade. Now we see youngsters stimulated sexually by media, peer and pressure, forced into adult oriented sports programs, and coping with violence and neighbourhood dangers, irrespective of class, economic security, cultural identity. Life has become a chain of competitive situations. The anger and frustration that is observable covers the depression that is experienced within. A pain that renders the adolescent hopeless and cannot be tolerated. The acting out gives some relief.

In many adolescent lives the message on the TV and in their music has replaced the voice of their parents. It is not surprising, since they listen to TV many more hours than they do to their family (Pipher, 1994). These immature adolescents are ill-equipped to face develop-ment tasks that are in advance of their natural growth process. Gangs have taken over a parental role for many disenchanted youths and their depression, disgust, and violence is focused on the ills of society. Their adolescent acting out has changed the picture of America.

The early clinicians who looked at the adolescent developmental patterns and tasks of maturation, provided the first window on the tensions that accompany this process. For many years therapy with this age group was guided by treatment focused on intrapsychic anxieties; now we must include the interpsychic relationships, the external

pressures which traumatize our youths. The stages of development and the notion of psycho/sexual progressive advances as the basis of adolescent treatment have given way to the more progressive, pragmatic theorists of today. The adolescent of the 1990s and 2000s must cope with an environment that is threatening, and face it with the weakened abilities that are natural to the adolescent transition. Their developmental stages are not sequential or predictable. Therapists would be well advised to resist labeling their youthful clients until they have thoroughly explored the realities of their world. When the world is depressed, depression is not a symptom, it is a 'normal' state.

The help a clinician can offer is minuscule compared to the problems of adolescent behaviors in our social establishments. This is reflected in the escalating numbers of severely depressed youths and the rising teen suicide rate. Therefore, it seems crucial that when we do have an opportunity to intervene in the life of a teenager we should have all the tools possible at our command. The advantages of offering a therapy to depressed adolescents that is syntonic with their belief systems is the rationale for the use of art therapy. This age group is notoriously resistant to the way adults conduct their lives and how they have constructed society. If we attempt to over-ride this attitude we are confronted with a power struggle we are bound to lose. Offering a pleasurable experience that evolves into a therapeutic one, under the direction of the adolescent, is a solution that eliminates part of the struggle. Art therapy is no panacea for establishing the therapeutic relationship and reaching desired goals; it is an approach that has proved useful and provides information and communication in a manner most often accepted by the adolescent.

Severely Damaged Adolescents in Residential and Therapeutic School Settings

You can't feel pain if you are in pain.

(Quote from self-mutilating adolescent)

Introduction

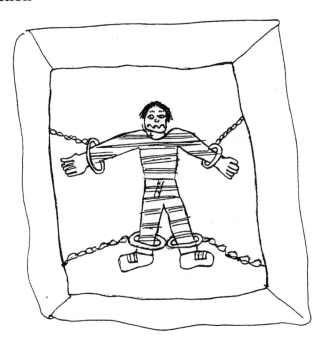

Figure 4.1 'You don't feel pain when you are in pain' Memories of hospitalization (17-year-old boy)

Adolescent youths who are disadvantaged, either by environmental or mental and emotional problems, often find there are only two options open for them if they wish to remain in school. One is to attend a school designed for the most troubled youths in the school system, or placement in a residential setting, where school is integrated as part of the program. This chapter will describe two facilities that have been created to 'catch' the kid who is falling out of the system. Since my personal experience working in these two facilities has been confined to supervision and consultation, I have interviewed two therapists who have met the challenge of working successfully with these seriously damaged children.

When providing treatment for adolescents, a major consideration is *how* the practice of art therapy is influenced by the severity of the malfunction, and *where* therapy is offered. Like any other form of therapy the treatment is tailored to the needs of the client. However, in some residential and school settings the administration or the funding source impact the therapy. Therapeutic decisions are influenced to vindicate state or provider stipulations and payment. A time-limited clinical treatment plan, extensive records aimed at the reduction of targeted behaviors, and verified outcome studies, are often requested by the agency. These demands cannot help but shape the strategy of the therapist. To illustrate how these qualifying factors can be responded to creatively is the text of this chapter.

Our dialogue will clarify the rationale for providing the contrasting approaches to art therapy treatment in these two agencies: agencies that serve approximately the same level of severely psychologically distressed adolescents. The advantages and disadvantages of a residential environment versus a specialized public school for emotionally unstable youths will emerge in our conversation. What became clear when the interviews were compared, is that the tension that has existed between 'art as therapy' and 'art psychotherapy' is a non-issue. Each form of utilizing imagery and creativity with verbal dialogue is valid in the context of where it is offered. There is no 'right' way to practice art therapy, as has been said many times before. Here is an example that should put these arguments to rest. One agency offers art therapy that is close to the studio art approach, the other offers an

integrated form of art psychotherapy that enhances the solution focused model. The adolescent population is comparable; what differs radically is the environment. When a child is separated from his/her home and family and lives in a residential center, the therapy must respond to this primary need. When the child must return home every day to a chaotic family situation the therapy must respond to this circumstance. Ignoring the surrounding world and the impact of social and family stress, pretending that therapy exists in a vacuum, is no longer valid. That notion has been discarded long ago. Each therapy team has had success, and each have reached their goals by parallel paths, the adolescent has benefited in both cases.

A major point of interest is to differentiate how therapeutic treatment is modified by the clinical classification and role of the art therapist in the facility. In one case the art therapist is primary therapist, in the other he/she is adjunctive. Both positions are equally important to the agency where they work, and both therapists are highly regarded by their administration. In both circumstances the therapists are a part of a team of professionals and the client's treatment is projected in case conference. The goals for treatment are swayed by the philosophy of the agency, and agencies tend to change their objectives over time.

The questions that the therapists and I will explore are listed below.

1 Describe briefly the setting in which you work and the services provided to the adolescents.

2 How does this setting affect your treatment? Restrictions and benefits.

3 How do your adolescent clients respond to art therapy? Consider the pluses and minuses of the modality.

4 How do you offer the art therapy? In the sense of the media, the setting where therapy is offered, what is your attitude toward the product?

5 Are you more or less involved in the process rather than product? Please explain how you work with the process. Is assessment a part of your approach to using the art?

6 What dominant theoretical approach is the most useful with this population? If you have modified your theoretical thinking explain why. Are you using a brief therapy theory? Explain why or why not.

7 How does your approach differ from the treatment offered the client in other aspects of their therapeutic encounters with professionals in the agency?

8 How do you evaluate change in the client? How is this information shared with the other professionals on the staff? Are other staff persons using art with your clients?

9 Describe different art projects you have experienced with your adolescents. Give some specific ideas to the readers. Help them conceptualize what works and what doesn't. Are some projects long term, why? Who can tolerate long term, why?

10 Has the adolescent population changed since you first started working with them, how? Has the mental health system had any influence on your treatment?

11 Do you see the families of the adolescent clients? How does that affect treatment?

12 Do you believe that society has become more judgemental and pathologizing of fairly normal adolescent behaviors?

13 Summarize the belief system that works best with adolescents, and the art therapy approach that is most effective. Do you believe that in the long run your adolescent kids benefit from the treatment you provide?

Interview with Aimee Loth in a SED public school program

SR *I understand that the program at the public school where you offer art therapy treatment is known as a Severely Emotional Disturbed (SED) program, for middle-school and high-school students. The Community Health Center services this program with employed clinical personnel as well as interns. The art therapy room is adjacent to the classrooms and on the campus. The room is designed and equipped for art therapy, but is shared by other therapists as well.*

Figure 4.2 'The get-away' (16-year-old)

AL Yes, the main clinic is a large county-contracted mental health agency serving Medi-Cal (California state funded mental health care) and low income uninsured clients. In addition to the principal clinic we have satellite services, including this small clinic at a public school which serves emotionally disturbed and learning-disabled students. A majority of the client base at the school is comprised of children from poverty level, single-parent families. The adolescent youths are seen in family, individual or group therapy. Many of the adolescents suffer from being exposed to drugs prenatally; live with parents who struggle with severe mental illness; and many have witnessed family violence. A large percentage of the children have, by the age of thirteen, a criminal record. The positive aspect of this setting is that therapy is expected and often required. Prescribed by courts or parents, therapy is not seen as a stigma by the students, although often it is considered ludicrous. Considering their background this makes some sense.

SR *Does working in a public school, or a program labeled 'SED', affect how you provided services for these adolescents? Do you find there are both advantages and disadvantages to a school setting?*

AL The SED milieu in itself is not the primary force affecting treatment, however the population is generally more severely at risk than in a general outpatient community. More impactful is a recent ruling of Los Angeles county to enforce a six-month time limit on mental-health services (psychotherapy) for clients seen at the clinic. Unless the clinician can make a convincing case for an extension, therapy is arbitrarily terminated. This has necessitated the adoption of brief-treatment models. The difficulty lies in treating severely impacted teenagers in a six-month time frame. The art therapist is given the challenge of using art therapy within a brief model. The therapists working here at the school setting, where the clients' services are funded through an individual government program, are given the option of a one-year treatment period. The clinicians usually develop a therapeutic plan that includes six months of individual and six months of group treatment, with weekly family therapy a requirement for the year.

The benefits of a school setting are that the clients are on site and easily accessed. Most of the teaching staff support the student's involvement in treatment. However family treatment can be very difficult because the parents tend to see therapy as an extension of school-day services, activities which do not require their involvement. This can and does impact the treatment. Since the clients are children from chaotic families, with systemic dysfunction, minimal change can be effected unless the entire system is modified. It is paradoxical that the most chaotic families, who could most benefit from family therapy, are also the families who are too disorganized to attend. There are exceptions to this lack of commitment: I see a mother who must walk two miles, with a stroller, to attend family therapy. She cannot afford bus fare, and considers them unsafe, so she makes this tiring journey to help her son.

SR *Do you have a highly resistant group of adolescent clients? Is art therapy accepted or rejected? Do they try to take advantage of a situation that seems less structured and make it difficult for you?*

AL The conventional wisdom concerning teenagers is that they are hard to treat, or rather that they are annoying and provoking and the

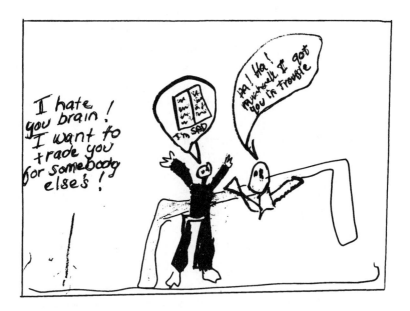

Figure 4.3 ADHD 13-year-old boy separates his brain from himself – 'Ha! Ha! I got you in trouble'

therapist finds them hard to tolerate. I look at this behavior in the context of an appropriate developmental stage. In practice, the majority of my experiences with teenagers have been positive. They seem to drop most of their hostility when they are offered media and opportunities to engage in non-threatening visual expressions. They are generally fairly sophisticated about the language of therapy, since they have been in the 'system' for many years. Art therapy does not fit into their experience of 'head shrinking'. That is to my advantage.

I have found that young men and women respond differently to the art therapy process. (I specifically refer to the late adolescents as young men and young women. They are rarely given this respectful title.) For the most part, young women respond very favorably to the use of art as therapy. Many aspects of the art therapy process are attractive to young women because it honors the creator and the narrative of the art maker. I have observed that the young women I see are often cued from an early age not to trust their own opinions, to dislike themselves, to discount their tendencies to bond and form close groups. The influence is more profound if a cultural component

is added which views women stereotypically in a demeaning role. The art therapy modality has attractions for female clients because it honors the inner voice by offering a personal avenue of reporting which does not clash with the messages of their environment. It fosters and encourages the expression of the self.

For example, I was working with a small group of fourteen- and fifteen-year-old young women, who were working on a project of adorning boxes with images of their 'outside self' (how others see them) and their 'inside self' (how they see themselves). One group member arrived in her usual talkative and cheery mode, but in the process of sealing her 'heart' inside the box she began to cry. She shared her fears about losing her primary therapist and the group. She questioned who she really was as a woman. After creating a heart shaped box, she colored the lid and the back and inserted her 'heart', made of plasticine. Then she firmly secured the sides with more clay until it was impossible to break into. The art process provided a powerful catalyst for her to appreciate her vulnerability, and to metaphorically create protection for her pain. Sharing with the group provided a safe place for her to shed her 'outside self'. The sealing away of her heart was an attempt to protect herself from feeling the overwhelming sadness. The process of making visible the intangible anxieties she was experiencing, provided her with an opportunity to gain command of a difficult situation.

In contrast, working with the young men is more challenging. Adolescent males are much more defensive and defended than the women. Most of my male clients are poor, African-American or Latino, with gang affiliations replacing the male model in the home. The culture of the street discourages sharing outside the 'family' and the method of problem solving is aggression. I am often the 'white lady' or the 'teacher', and held in some respect, but in their eyes, incapable of really understanding their world. I cannot, and do not, argue with this truth. These young men test me with profanity and vague threats of possible harm, but also with a respect and guarded courtesy that is in opposition to their aggressive behaviors. I clearly request the latter treatment and return the attitude of 'respect'. The issue of respect is the core of street conflicts, therefore I do not take it lightly.

Figure 4.4 'How you see yourself' Using the box, a container. 'Outside.' Smile now, cry later (15-year-old girl)

Figure 4.5 'How others see you' 'Inside' (Clay heart in blue)

The clinical challenge is to make the art process work for these young men who have been in and out of jail, psychiatric hospitals, probation and foster placement. More so than with the young women, I design directives that guarantee a sense of accomplishment and success. Construction and clay projects are helpful, using the minimum amount of materials necessary. Due to the prevalence of ADHD (attention deficit, hyperactive disorder) and mood disorders, the groups are limited to four participants. This decreases stimulation, allows me to attend to each person, and insures my safety. For instance, mask-making has proved successful as a long-term project. Instead of the 'persona box' two masks are made, the 'streetface' and the 'loveface'. They gave the faces their names. The fact that these youths even admit to having two 'faces' is an opportunity for exploration. With these masks they can exaggerate the facial expressions, role play verbally, and take chances on revealing themselves when screened by the masks. Any product is a success. Humor is also therapeutic in a setting where tension and gang-related stress is always present. This project often stimulates parody and mocking of adult values.

SR *The question often arises, 'how do you introduce art therapy to an adolescent'? Is it difficult to fully explain this approach? Do you mainly spend time on the product or enter into the process? Does the medium which the adolescent uses influence the process?*

AL The art is presented as a given, an aspect of treatment that is not an option. An explanation is confined to sharing my belief that it will be helpful. It is not useful to go into long explanations which only provide these adolescents with an invitation to enter into the usual adult-teen struggle.

It is important to offer media in a structured manner, and modify the structure according to the abilities and needs of the client. The client base at the school includes many young people with ADHD and mood disorders, it is unwise to overwhelm them with materials. In general I begin with just a few markers and one piece of paper, or perhaps a few collage pictures. It is extremely important to lessen distraction. Never offer entire magazines from which selections are to be made. The adolescent will read the magazine or just keep turning pages. Very few of the teens I work with can even get through a basket of collage pictures without getting bored, distracted or frustrated.

Therefore, I offer six or ten images at a time, on a clear table, with a clean sheet of white paper, and a few markers or colored pencils. Teens who can handle more supplies will invariably ask for them. Giving new materials can be a very productive moment of trust and nurturing, a reward for self-regulation.

This is illustrated by a young woman I worked with, who enjoyed using beads to make jewelry. She had been distant and uninvolved in group when, by chance, she was the only member to attend that day. I offered her the beads to continue a project, and when she left she expressed a wish to take some with her. I gave them to her, noting that she had done an excellent job and what a pleasure it had been to work with her. She was shocked that I would give her the beads without something in return. The next week, she came to group with items she had made for the other members. The art making had been a way to give to others, to express creativity, and helped her share herself and open up to the group.

In another instance the gift of drawing tools encouraged and affirmed a young man's self-expression. After a period of testing, he brought drawings and writings he had done at home to the sessions. Artwork he had drawn with supplies given in art therapy. They had become a transitional object, connecting him to the positive environment of therapy. It is a challenge to even imagine the deprivation of these adolescents' lives. What may appear to others as an insignificant sharing of materials, is to these youths a precious gift.

I initiate the art in the same manner that I would use introductory words; however, I replace the verbal question with an art directive. Not 'tell me what the trouble is', instead, 'take a few of these pictures and make an image that reflects how you are feeling'. As the art is being made the adolescent often talks about the issue he/she is illustrating, and later makes a brief comment about the completed product. While creating the piece there is no need for eye contact and that makes it easier to have a conversation. When the process of creating is over, looking at the product is too close to criticism to be comfortable. In their lives they are constantly found fault with, therefore they pull back from anything that approaches evaluation.

SR *Are you an art therapist that is focused more on product, or on process? If you agree that the process is the most productive aspect of the art therapy modality,*

how do you work with the process? Do you use assessment as part of your treatment plan?

AL Art therapy should be process oriented. The therapist is conscious that the process of art making is beneficial, however, when the process is brought into awareness it is art therapy. Great pains should be made not to stress the product and to find something, in even the smallest mark, that helps the adolescents see a positive aspect of themselves on the paper. In terms of process, if possible, avoid 'one session' art directives. The act of bringing out an art product from a previous session can serve several functions; the obvious use is that it refreshes memory of the issues previously discussed. More importantly, when an art therapist brings out a saved piece of art he/she demonstrates continuity to the client. It verifies that the art is unique communication, so valuable that it is preserved. Looking at the art together is more effective than asking, 'what did you say about that problem with your dad?' Art can be expanded and elaborated as a non-verbal dialogue. For example, a 'Life Story Line' can be used for weeks, as each important event is explored, concretized and added to the narrative. I do not focus on the art expression as the essential core of art therapy, rather I observe, ask, listen, and encourage the exploration of the thoughts, selections, and decisions which made up the process of creating the product.

 The use of art therapy assessment tools varies with the philosophy of each therapist and how they have been trained. In many cases these procedures are emphasized in reaction to the critical view of other professionals that art therapy is not quantifiable. Diagnostic drawing exercises and art psychotherapy differ and should not be confused. I do not use assessment protocols, however, I do attend to the art diagnostically, to see if the client is working at age level and check if the art indicates appropriate emotional development. I am constantly asked to look at the art of colleagues' clients, and to offer diagnostic feedback. I almost always say; 'I have no idea what that means – what did you ask, what did the client say, where is the other art? I do not make a judgement on the basis of one drawing'.

SR *How do you choose a theory to match the needs of these severely disturbed adolescents? Does the severity of their distress lead you to modify, or create, a synthesis of theories to fit their needs? You said earlier that you were confined to a brief therapy format, how has that worked?*

AL I am using a brief, solution-focused model, informed by a social constructionist belief system, and cognitive-behavioral interventions. A brief model is mandated due to the agency's treatment guidelines. The cognitive behavioral component of practice is important because the majority of my clients have problems with impulsiveness and aggression. I believe in short-term treatment, it works for the clients and for me. I think teenagers *can* solve their problems, *can* gain insight, and *can* be generative. With some of the clients I see, change will not occur, however, if I believe that change is possible it will empower them to envision new solutions.

SR *Do you believe that your philosophy of treatment differs from the other therapies these adolescents have encountered in their long involvement with the corrective systems? Are you in harmony with the other professionals in the agency?*

AL My own observation is that these youngsters are therapy wise and therapy weary. They have been 'therapized' by social workers, correction counselors, court mandated therapists, hospitalized; medicated by psychiatrists, and assigned educational therapists. By now their normal resistance to being asked intimate questions by an outsider is reinforced by a sophisticated knowledge of the psych-talk and the words they can use defensively and respond mechanically.

 The treatment I offer is unique because of the art; my conviction is that the adolescent can change destructive behaviors, and that brief treatment does work. Using creativity and imagination is an unfamiliar approach, as discussed above, and does not seem like therapy at first. The adolescent is not quite so defended when offered media by an adult without a critical or corrective agenda.

SR *How do you evaluate change in these adolescents? Do you interface with the other members of the staff concerning the young people you see?*

 I have observed that transformation of an adolescent's belief system comes about in subtle ways. Therapy seems to be effective if the therapist convincingly conveys trust in the youth and projects conviction that they are capable of changing their role in a destructive, repetitive family pattern.

AL The adolescent sets their goals, and together we evaluate whether or not they are met. In groups or family therapy one or two goals are agreed upon and these are the framework of the sessions. Approximately every six weeks the clients and I discuss if the treatment is producing the results they hoped for at the beginning.

Figure 4.6 Adolescent girl's collage slashed while mother starts to blame

Figure 4.7 Conjoint drawing – 'Anxiety and instability'

The clients know that information is available to all the therapists who are involved in their treatment, as well as some aspects appropriate to share with the teachers.

We formally present cases for review to the clinical staff and the child psychiatrist. The history, goals, and progress of each case is reviewed, and the assigned clinician receives guidance. At this time if the clinician wishes to extend treatment beyond six months there is a special evaluation. The art therapist is expected to present clinical material in the same professional manner as the other therapists. There is no differentiation made between disciplines. The art is shared as part of the case presentation, and in my experience has been received with respect. Other staff members are using art with their clients in a very rudimentary way. I attempt to stress the difference between using art and being an art therapist when I am questioned by others on the staff. When asked to give informal supervision and consultation of artwork used by a social worker, I help her understand how to use art in a safe and informal manner. I do not find that my position is threatened because others use non-verbal expressions, nor do the staff members see themselves as art therapists.

SR *Do you have some favorite directives you use with these difficult teenagers? Are your art projects usually short or long term?*

AL The art directives and projects I use vary widely, they usually reflect the crisis brought into the session, the current attempts at achieving the set goals, or a new developmental dilemma. The challenge is to create directives on the spot, as well as planning ahead for specific clients or groups. I find complex and extended art projects are more successful with adolescents. They like to be involved with an art layout that does not seem like busy work or is too simplistic; art that does not remind them of the remedial occupational therapy they may have had in the hospital or in the juvenile correction holding tanks. The masks and boxes have been mentioned above. Boxes are a wonderful resource and art therapists should have collections of them in all sizes. Boxes transformed by art, can easily be a concrete metaphor for 'holding' behaviors, untenable feelings, domestic violence, divorce, and all the other miseries that these youths would like to be able to contain.

The 'life line' is a successful task. At this adolescent stage of intensive self-interest, when identity is in question, making their 'life'

visible and 'real' is a project that is therapeutic and interesting to this age group. I ask them to 'begin with your first memory and end with the present'. Choose collage pictures to illustrate the events of your life, add words and comments as you wish'. This directive has worked well with the boys in group. They enjoy recounting and illustrating their lives, looking for the most scary and tough images. Although their first reactions were full of swaggering bravado, the stories they told of their life circumstances were moving. The boys are able to see and share with each other their experiences in a thoughtful manner, which they would not have done otherwise.

The use of art will refocus the group and avoid the verbal posturing and one-upmanship common to a group of 'toughs' who have done the circuit of day treatment, residential and juvenile hall placements. One seventeen-year-old who had been through this 'circuit' was very difficult to engage in the art. However, when creating his life line he was cooperative. The project was worked on for three weeks, and at the end he had a piece that covered a four-person work table. He said: 'Looking at this I see all the time I've wasted. What an ass-hole I've been. I feel like I have ruined every chance.' This was remarkable coming from a kid who accepted no responsibility for his actions during all the sessions we had had over a year of twice weekly sessions. This art piece is still in progress. We are working to envision a positive future, adding more paper and more images.

Most of the directives discussed above, as well as the spontaneous visual illustrations that are created, require two or three sessions for completion. I prefer extended art projects because they allow for elaboration, alternative solutions and encourage depth of thought and exploration. They serve to join one session to the following one. These long-term projects are not destroyed if group members come and go, as is often the case with these adolescents. They can be interrupted if a pressing problem arises, then resumed when it is appropriate. Art expressions that are used for a single session, are like surgery. Immediate attention focused on a crisis that must be attended to instantly. The therapist explores the problem, helps reduce the crisis, and uses the art to concretize a possible solution to the situation. 'Surgery' is necessary, but most of the pain I see is part of a long entrenched 'illness' of relationships. Short-term therapy is used in a

Figure 4.8 My life line. 'Unfare' 'Miserable, miserable, miserable...', 13 times from 13-year-old boy

unique manner for these long standing problems. The immediate concern is addressed, if it is solved, then the next crisis is faced, each time with clear goals and evaluation of the situation. In this manner, if the adolescent or parent suddenly stops treatment, there is not a lot of unfinished business that has been started and left in mid-air.

There are adolescents who cannot tolerate long-term projects for multiple reasons; they may be too impulsive, or so compulsive that leaving a work unfinished would cause anxiety. These youths do not have the ability to sustain attention and interest over time. Task oriented long- or short-term art therapy is successful when it reflects the needs of the individual. With adolescents there is no concern that they will not tell the therapist what they require.

SR *Has the adolescent population changed in any way since you started to work in this setting? The drive-by shootings and general violence that exists in this section of the city appears to be just as active as in the past. Does this atmosphere have a great deal to do with how these adolescents view their future?*

AL The group of adolescents we serve has not changed. They are angry, depressed young people from dysfunctional homes, with psycho-

logical and physiological problems. The social environment, and economic deprivation has not altered, it is the mental health service they receive that has changed. We have seen a rise in developmental problems and dysfunctions due to physiological problems, such as attention deficit disorders, and drug use. Many of these problems depend on medication for relief, as well as psychotherapy. The combination of the two modes of changing behaviors makes me even more enthusiastic about the brief therapy approach because it fits the circumstances of adolescent treatment. Contact with these youths is not guaranteed. For most part, the adolescent is willing to come to therapy only for a limited time. We must utilize the most efficient form of intervention in a brief time frame. This is often the last opportunity for preventative measures to attempt to stop a rapid decline into a life of on-going unhappiness or crime.

Art therapy treatment is particularly effective because it results in a concrete product that can be reviewed and contemplated by adolescents between the sessions. These macho fellows would not admit to it, however, the image does anchor the therapeutic discussion. The following week when they refer to the art task, they often surprise me by their insightful remarks.

SR *As you know I am very interested in family treatment. I am interested to know if you see families of your adolescent clients? How does family work affect your treatment?*

I have heard you discuss a family dynamic that is amazingly similar in many of these adolescents' lives. The client lives with a single parent and is frequently an only child. The parent is customarily a very damaged person who comes to parenting with a history of abuse in his/her own childhood. They regularly see their child as an embodiment of everything wrong about themselves. They are highly critical of the adolescent, and so fearful that they will be left alone when the boy or girl matures, that they set up a destructive love–hate relationship. The adolescent is also fearful of leaving because he/she is aware of the parent's fragility. They both are extremely angry, torn between leaving and staying, and afraid of revealing their hurt to anyone. The family sessions deteriorate into vicious blaming from the parent, and hostile non-communication from the adolescent. These families seem almost unworkable, and often the treatment is changed to individual for the youth, and occasional crisis interventions with the parent. In fairness to the parent, the adolescent usually has a equal part in sustaining this system.

AL I agree that this family constellation is distressingly common. The boy who is quoted at the beginning of this chapter is an example. He started head banging at three when his father left, and has continued self-mutilating behaviors until recently. He is totally involved with his mother, and yet he is extremely angry about the bind in which he is caught. If he lets himself express his frustration he is afraid of where it will lead him. He senses his mother's dependency on him, and he cannot reconcile that need with her punitive behavior. His conduct at school is impossible, and he may not be able to continue in public education. Outside the home he allows his anger to show, at home he is mute. His mother is so burdened with guilt that she is unable to set limits or deal with the grave disturbance of her son. She gives up and says, 'I have done my best for you, what else do you want from me?' He shares her guilt and he feels even greater enmeshment.

In art therapy he has been able to demonstrate through drawings how he sees his situation. For example, he feels chained to the wall of a prison. He can demonstrate through his art expressions, and by his temper displays at school, the internal state of anger and despair he feels about his situation. The goal of therapy is to support his efforts to individuate without rejecting his family entirely. The mother is counseled to appreciate the typical trials of adolescence, and to see her son as having normal adolescent problems. She is also counseled to look outside the relationship with her son and find other areas of interest to focus upon. Therapy has helped, it hasn't cured.

A youth I see in another family, is the recipient of endless, vitriolic blaming. His parents constantly say, 'We have given up our lives for you, and see how miserably you have turned out!' This adolescent has severe learning disabilities, and acts out his frustrations and anger in a violent manner. The parents are not able to see the connection between his lack of ability due to physiological defect and his rage at their disregard. He uses the art to decompress when he is ready to explode. In a similar mother–daughter dyad, when the parent started to verbally abuse her child, the daughter started to slash her completed collage. The art clearly reflected how the girl felt 'slashed' by her mother's criticism. When the dynamics are made so apparent it is almost unbelievable that the parent resists understanding the message. The parent is in as much need of psychiatric help as the adolescent.

Figure 4.9 'Anger I feel at home. Anger I feel at school'

Our clinic has recently instigated a new policy that enhances the efficiency of solution-focused therapy. Upon intake, the parent education classes are written into the goals for the family. The family is strongly urged to attend or they might be refused service. This is helpful in many ways. It addresses the home environment at the same time that therapy is addressing the immediate crisis. It exposes parents to other parents with disturbed teenagers, and facilitates treatment. The class also frees therapy time to provide individual attention for teenagers; sessions where the client may express his/her opinion without encountering his/her parent's wrath.

In the future I plan to start parents' sessions with a single collage image, or two, that we agree represents the issue they wish to focus on during the hour. Shortly before the session is completed, I shall ask them to readdress the image and modify it to represent what was accomplished in the therapy time. This simple use of imagery helps to keep the discussion on track and infers that there will be change introduced during the hour. Simplicity is a necessity with these

parents who have exhausted their minimal parenting skills and are ready to force the adolescent out of the home. By starting with an uncomplicated visual representation I hope to bypass their concern about doing 'art'. These parents have little tolerance for any interruption to their need to ventilate about their malfunctioning teenager. Family therapy is a challenge with this population, but is sorely needed.

SR *Do you believe that society has become more judgemental of adolescents and pathologized their behaviors more than necessary?*

AL The media and the schools are filled with incidents of violent adolescent behavior, this has an effect on all teenagers. I see normal adolescent behaviors labeled as pathology because they occur in a hyper-stressful environment. The rebellious teenager who might in other circumstances 'outgrow' their difficult behavior, now turns to gang affiliation which consolidates his/her delinquency. In other cases he/she is relegated to special schools where their self-esteem is shattered because they feel separated and fear rejection from their peer group. This latter group is often the deeply depressed adolescent.

The art therapy approach de-pathologizes the adolescent and focuses on his/her strengths. This affirmation is possible because there are creative opportunities that do not challenge the same skills that are tested at school. It takes a very small victory to instill the notion of success and counter a highly negative pervasive pattern. We are not talking about making great changes, only enough to survive the circumstances they are grappling with at this time of development. Given time to mature many acting out teenagers move into a more stable adulthood. We are attempting to give them this time. Perhaps this is not the most rewarding group of teenagers to work with, but they are the most worthy of every inventive and creative intervention we can construct to enhance their self-image.

Interview with Roberta Lengua in a residential setting

The adolescents who live away from home in this residential center are not significantly more disturbed than those who attend the public school program discussed above. In an unlocked residential center, the criteria for placement are based on the inability of the child to function at school. Their home environment is usually the deciding factor when

determination is made to place a child away from his/her family. Either the family is so chaotic or abusive that it would put the youth at risk to remain at home, the parents may be homeless, or the family may decide that they do not wish to cope with the adolescent's behavior any longer. The latter choice is the one which is most difficult for the teenager to deal with. The rejection, which is a voluntary act by the adults, is a deeply traumatic event for these already dysfunctional children.

Under these conditions, which the adolescent sees as an involuntary placement, it is not surprising that he or she is unable to appreciate the attractive surroundings of this agency. Opened in the 1930s the property is extensive, the buildings placed separately, trees and flowers, as well as play areas, occupy a rolling estate. The agency was opened as an adoption facility, and then converted to a mental health residential center some years later. I believe that even though these teenagers act as though they are unaware, I cannot imagine that this environment does not have some positive impact on them. However, if beauty and comfort represent the pain and loss of separation, the result is psychological 'blindness'.

The art therapy building sits separately on the corner of the campus. It is an entire building devoted to the expressive arts. Movement therapy, art programs, and art therapy, enjoy spacious quarters. This structure conveys a message to the clients of respect and value for these services. The creative therapists have not always felt this respect, since the agency has been dominated by social workers. However, over the last few years there have been important beginnings of change. Art therapists have been assigned families, their voice is more clearly heard in case conferences, and there is a grant which provides a consultant to the program. I consult in that position.

Roberta has been on staff for many years, she is young and does not have the 'look' of a traditional therapist. This is to her advantage, since these teenagers consider her a role model and the girls, particularly, benefit from this association. There are two other art therapists on staff, and a social worker liaison who is supportive and provides clinical supervision. The agency system has some resistance to accepting art therapy on an equal footing with traditional psychodynamic treatment, but the prejudice seems to be weakening.

SR *Tell me a little more about the agency and how you offer art therapy services to the residents here?*

RL This is a residential treatment facility that houses approximately ninety young people, ranging in age from six to eighteen years of age. A day treatment program also serves about twenty children up to twelve years of age. In addition there is funding for non-public school, for resident adolescents and those from the community (who do not receive therapeutic services). Boys and girls live in separate dormitories, called cottages, and during the week attend school on campus together. Higher functioning adolescents can attend a public high school and can work off-grounds at regular jobs. Children with custodial families usually have weekend home visits from Friday night to Sunday evening. The residents attend twice weekly therapy with a social/case worker whose office is in their cottage, and who usually conducts family therapy at least twice a month.

The treatment team includes: a unit director, psychiatrists, social workers, and youth development counselors (YDCs), who provide day to day care for the residents, and help the school with behavioral issues. In addition the program provides a career/vocational counselor, religious/cultural personnel, recreation therapists and other activities facilitators, such as sports and crafts, on-site school teachers and principal, and creative arts therapists, which includes art and movement therapists. There is a caregiver who sleeps in the cottage with her/his charges. With this tight regime the adolescents are virtually never left unsupervised. This program has evolved over time to respond to the needs of the children and adolescents they serve. It is a complete and highly respected provider.

SR *Every agency places restrictions on treatment of their clients, as well as offering special opportunities that benefit achieving therapeutic goals. How has this affected your department?*

RL The facility does not demand a certain form of therapeutic approach for the creative arts program. A behavioral program with rewards and consequences is dominant throughout the rest of the program. Most social workers think psychodynamically in individual treatment and behaviorally when setting long-term goals. Our approach, which is more flexible and shaped by the art therapy modality, has a different 'feel' to the adolescents, and the physical distance and separateness of our building seems to affect some aspects of treatment. The physical

distance stands as a visible metaphor for a therapy that has its own set of values and structure.

Having a detached department of art therapy does result in some restrictions. The distance interferes with communication and information availability. It limits the capacity to affect management of the client's schedule, home visits, and prompt information from staff about cottage issues.

The benefits of our location are that there is an aura of separateness from the rest of the agency; it often feels like a detached island of security. There are no behavioral contingencies attached to the therapy or attending art therapy, which creates a more purely therapeutic setting. For the adolescent this acts as a relief zone from the milieu, the stress of dealing with many people, as well as peer and behavioral issues. Most adolescents are pleased when they are assigned to art therapy treatment.

SR *Your adolescents have had various therapies most of their lives; how do they react to art therapy?*

RL Most adolescents initially respond with the same wariness they would to 'one more therapist' in the long line of mental health workers with whom they have been involved. While our department is part of the treatment team, we do not have the same constraints to monitor behavior as other staff. We are able to take a positive stance and allow adolescents to set their own pace to explore what they really want out of therapy. In addition, adolescents do not display behaviors in individual art therapy that appear in the milieu with their peers. However, self-control is not demonstrated in group art therapy, where peer interaction can elicit negative patterns of behavior seen elsewhere in the milieu.

After the therapeutic relationship has been developed, most adolescents look forward to attending art therapy. They often take responsibility for rescheduling an appointment when they have to miss a session. The art therapy space is a respite from the constant scrutiny and evaluation of the adolescent's behavior and progress, a place where their voice can be heard through their drawings. Through the art we are able to more subtly explore therapeutic issues, avoiding confrontation before an adolescent is emotionally prepared to deal with it. However, sometimes this 'safe space' is so comforting that it is difficult to get adolescents to look at their issues. They want

to retreat into a holding environment that asks nothing and to which they need to give nothing. A youth this damaged probably would not be capable of evaluating painful issues and implementing change. I recall a young teen boy who for several months curled up on the couch and appeared to sleep. He came faithfully to his appointments but offered nothing. It was difficult to decide how to handle this apparent rejection of help. In due time, at his own discretion, he left the couch and entered into the process of art therapy. Dilemmas such as this, do not have an answer, it seemed important to let him come to his appointment, not turn him away, and let him test the tolerance of our environment. Later on I suspected that he had not been asleep, since he made reference to my passing the time by drawing while he was 'sleeping'.

SR *Describe how you introduce art therapy to these adolescents. Do you have any expectations about the quality of the art product that the clients produce? In such a tight community the adolescents may have spoken to each other before-*

Figure 4.10 'The black hole pulling me to the blue giant'

hand, and have made many interpretations of art therapy before they walk through your door.

RL I usually set up a mini 'intro' session, in which they are introduced to art therapy, and the art therapy rooms. They are encouraged to open all the cabinets and drawers to check out all the art materials and begin to decide what they are interested in working with. In this session, they are reminded that we are part of the agency, and issues of safety and confidentiality are discussed. They are also asked to express their own concerns and ask questions. We make it as clear as we can that the media and therapeutic space are freely offered and that everything they do here is their choice. In this manner they are motivated to think about what they specifically want to work on; from the art they want to create, to issues they want to project in art and discuss. Often an adolescent comes in with ideas for artwork they want to initiate, when they do we do not interfere. Others are hesitant or not psychologically prepared for spontaneous expressions of art. In these cases I will show them how to use different materials and to experiment with them, how to mix techniques and media, hoping they will be interested and want to try them. Sometimes, when a client is not able to decide on what they want to work on, I will give a general directive to help them get started in creative work. For example, 'draw or collage one or two things about yourself that will help me get to know you'. I attempt to foster the attitude that the product is not as important as utilizing the space and time for personal growth, discovery, and change.

I am aware that the word is passed around the agency, that art therapy is an easy way to spend an hour. This is not a problem, since the therapeutic value of the art soon becomes apparent to the adolescent. I can observe how they move from a supercilious position to one of engagement, without the need for explanations.

SR *How much emphasis do you give to the art product? Do you prefer to focus on the process? Do you have an assessment protocol, or use any assessment tools in your sessions?*

RL I am more involved in the process of supporting the creation of the art and observing how the session unfolds, than evaluating the product. Even themes are hard to track since adolescents will often experiment with abstract expressions and not explain their meaning. Assessment takes place constantly during the span of therapy, but not through a

Figure 4.11 Watercolors above, soft pastels below

Figure 4.12 Experimenting with media (13-year-old girl)

formal structure. For example, I watch for how the adolescent delves into the work; how they discuss the artwork or personal issues; are they obsessive/compulsive in their actions or subject matter; are they intellectualizing and avoidant in their discussion, do they use defenses learned from years of therapy? I observe if their artwork become less structured as they work, or does it become confined, with more boundaries or outlines. I explore if this shift is reflected in their behaviors outside the art therapy room.

When there are specific themes in the artwork, I ask them if they will verbalize the meaning of the images. I also assess if their narrative fits with the way the artwork was executed and how the finished product looks. If I see a disparity, I attempt to explore their ideas about this gap. I evaluate how much they understand about themselves and how much they can move in the direction of self-awareness and change. My type of assessment is parallel to entering into the process and learning from it.

SR *Have you found a theoretical approach to treatment that seems to be effective with these youngsters? Or have you created a modified version for yourself? Do you use a short-term framework?*

Figure 4.13 Client informing therapist of their process

RL I am not certain there is one specific theoretical approach that works for this population. Most of my clients have been so 'therapized', they can talk psycho-lingo better that I can, so I attempt not to use language that makes them feel I am using some psychological formula. A humanistic approach is the closest philosophy to my way of thinking. I attempt to create a safe environment and allow the clients to reveal themselves. We can afford a leisurely pace because we are fairly certain that our clients will be in residence for a year. Given a supportive environment and a trusting therapeutic relationship, I believe that the client will naturally move to self-exploration, growth and individuation. The hypothesis that the adolescent will, under optimum conditions, spontaneously move to expressions of self and creativity is the primary stance of our department.

Since the general atmosphere of the milieu is geared toward judging and modifying the youth's behaviors and attitudes; it seems contra-indicated to repeat that stance in our department. In addition, the client is often extremely reluctant to submit to more of the 'therapy as usual' approach he/she receives everywhere else. With art therapy they are able to feel, often for the first time, an unconditional regard from our staff. They are given the therapist's full attention, an adult who is interested in their expressions and how they perceive change. In the art therapy room they are able to feel 'normal'. In many of the other activities at the agency the adolescent is made to feel less than normal. The residents live under constant scrutiny.

Through artwork and verbal communication I attempt to help clients make their own interpretations, and explore different options of viewing a problem or issue. When the therapeutic relationship gets to a point of trust, familiarity, and comfort, the adolescent's issues that need to be worked through seem to naturally emerge. At this time the youth is ready to make changes and want my help, advice or opinions.

I worked with a young woman for an extended time, who consistently expressed loathing for her parents, both in her art and verbally. Her treatment goals projected that after residential placement she would move to a group home. The family could not exist together. Gradually there was a shift and contact was re-established through the family meetings. Unexpectedly, my client expressed surprise at herself: she was getting along with her parents and realized she liked them. There no longer was a reason for her to

be in conflict with them. She even accepted all their shortcomings, although she was not quite ready to accept her own. She was sorrowful that the conflict between them ended in a sort of 'whimper' rather than a 'victory' on her part.

Although we had discussed family issues the entire time we worked together, her stance had remained adamantly conflictual. Her artwork consisted of experimentation in painting and multimedia, that did not specifically have to do with her family issues, but were rather expressions of self, beauty, and creativity. I speculate that when she felt sufficiently positive about herself, she was less threatened and vulnerable and willing to risk reattachment to the family. Art can build strengths that are demonstrated in areas that are not necessarily the subject matter of the product.

The protective space of the art therapy rooms and the art process has helped adolescents encounter their positive self, a self which is often ignored in their families. When the adolescent is accepted as a valuable person, it may be one of the very few times in his or her life this has happened. His/her creativity is validated, and their opinions attended to. These experiences facilitate growth, self-exploration and discovery and are the impetus for change. The teenagers change because they begin to recognize their positive, creative, healthy self from a position of self-worth, rather than from a series of behavioral mandates and reinforcements. This does not discount that the program in the milieu is an effective part of the clients' conduct modification. These reward and consequence techniques are important for this population because they lack normal impulse control or they are 'acting out' in reaction to the abusive discipline they have known in their homes or foster placements. Art therapy in our setting is not confined to the product, it is part of the whole therapeutic atmosphere.

SR *From your statements, I imagine that you do not use formal assessment tools in your treatment. How do you evaluate change and report progress to the administration?*

RL I evaluate change by looking at how the adolescent's art process, art product, and communication changes over time. For example, I am very aware if a client repetitively creates restricted artwork for a few months (perhaps tight, line drawings with pencils) and then suddenly changes to a loose expression in paint. I puzzle with the youth if there

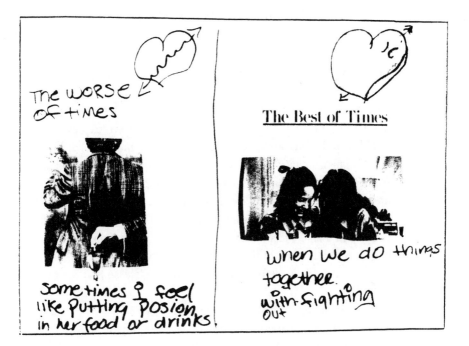

Figure 4.14 Adolescent girl reveals her home conditions. Conflicts with her mother

is any internal change that matches the process I have observed on paper. He or she may not fully respond, but they are pleased that I am so attentive.

In addition, I also pay attention to how the adolescent is doing in the milieu and if there is any change in general attitude and behavior. The information we gain in the art therapy department is shared with the other professionals involved with the case. There is continual communication with the social/case worker through weekly progress notes and quarterly case reviews with the treatment team. My evaluation of the client presents my interpretation of his or her verbalization, process and the artwork itself. Other staff members use artwork with their clients when the child spontaneously initiates a desire to do a drawing. However, they clearly recognize how their use of the art expressions and the process of art therapy differs.

SR *Describe some of the art projects that you have found acceptable to your adolescent clients. Are these directives transferable to other settings? How do you feel about long- or short-term projects?*

RL I find it hard to make generalizations about artwork and what works successfully with adolescents. Every youngster and adolescent in our agency has an extraordinarily complicated background that has impact on his/her development. Most of the art expressions are self-directed and often non-thematic which makes it difficult to extrapolate a specific directive or art task. As I have described above, the art room is a haven where the adolescents do abstract, unstructured art as a relief from outside pressures. They derive visual and kinesthetic pleasure from painting and drawing, this soothing activity in a safe place helps them to calm down. Some youths will begin to reveal some of their troubles as they paint or sculpt, but the trigger is not from the product, but from the release that the process provides.

For example; a girl who was depressed and very restricted emotionally, only experimented with a variety of painting techniques with black paint. Occasionally, when she seemed somewhat less depressed, or perhaps excited about something, she would add blue to the palette. When an attempt was made to discuss the artwork, she responded that her favorite color was black. After the artwork was completed and put aside, she was able to verbalize her feelings and discuss issues. It appeared that when she was in the process of creating, her unconscious opened a channel for her issues to come forth. The non-verbal expression, followed by verbal associations, was her process. This example typifies the difficulty to clarify an art directive in this setting. Trusting the process is my best suggestion.

In my experience, long-term projects are usually created by higher functioning female adolescents who have remained in the placement for an extended period of time. The older girls approaching eighteen years of age are able to commit to an extended task. These girls believe that, for the most part, they would be on their own at discharge which is mandatory at eighteen years.

As an example, a group of girls were close to terminating their stay at the facility. It was important to them to review the gains they had made in residential placement, and project how they were going to handle their future. They were realistic that they either had no family,

or if they did they were not welcome. They chose to use collage, with multi-media additions to the magazine images. I do not support collage over other art techniques but I find that this age group often selects this media. For this project that was complicated and required a great deal of imagery, their drawing skills were not sufficient to meet their expectations.

As they were working on the art piece, each girl discussed the issues and problem areas in their lives they wished to work through. The development of the artwork seemed to follow their psychological growth. Their art process paralleled their evolution, personal 'pieces of growth' and change were reflected in the images. They illustrated their experiences in the therapeutic setting in which they lived. These young women found the right pieces in the rehabilitative program to foster their changes, just as they found the right collage images to demonstrate how they had 'put themselves together'.

I would say that we use short-term solution-focused methods on a long-term basis. That is to say that we believe in simplifying goals, making small changes, and trust that the adolescent has the capacity

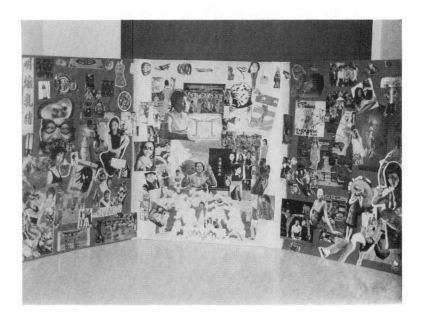

Figure 4.15 8' triptych. Collage – construction by 14-year-old Asian girl exploring her Asian heritage and culture in America

Figure 4.16 Right panel

Figure 4.17 Center panel

Figure 4.18 Left panel

to reach the goals he or she has set. We think in terms of a series of short-term goals, and long term is defined as a year's treatment.

SR *Has there been a noticeable change in the adolescent population you serve? Have the mental health services to the clients been modified?*

RL The population has not radically changed in the seven years I have worked in this setting. However, in the past three years there have been two on-site suicides, which have changed the policies of the agency. The atmosphere seems darker, more serious, than it was previous to this experience. In spite of these tragedies, the agency's mental health system has not affected how I work with clients, although the length of stay for the residents has been shortened. Having a 'separate' art therapy building has given me the opportunity to explore the concept of what it means to have a safe therapeutic space. What does therapeutic safety represent for clients, especially adolescents? How do they experience the separation that we offer?

Does it help these teenagers who are attempting to individuate as their families are struggling with their own dysfunctional styles? We are an individuated modality that functions in connection with the larger helping complex. Our place in the system is symbolic of maintaining individuality without destructive separation. We hope the adolescents can recognize this reality and turn it into a metaphor for themselves.

SR *Are you using art therapy for treatment of families? It has been an uphill fight for the art therapists to be seen as persons trained to take full responsibility for family treatment. Are families and their adolescent child who lives here, seen by more than one therapist? How does that work for you?*

RL The family therapy approach at our facility differs from the philosophy of seeing the whole family together on a weekly basis. When an art therapist sees a family, she does not see the adolescent individually. The family has art therapy bi-monthly, the adolescent is seen by a social worker weekly. This split of individual and family therapy has caused troubles that rise from misinformation and lack of continuity.

Often when we art therapists get a referral for a family, it seems to be a last ditch effort for the treatment team working with the family. These cases are usually the most difficult, and the social worker has given up working with them. Evaluating how well art therapy works with these families is biased by the fact that they have 'failed' therapy, or have been 'failed' by therapy, many times before. In spite of this challenge, the adolescent seems to gain a stronger voice through the art process, and that voice is heard in the family sessions through the artwork. The adolescent is encourage to send art 'messages' to the parents so that they can participate in the discussion in a peripheral way. Even if the family is unable to change its patterns, or recognize the maturation and growth of their adolescent, the youth knows that an effort has been made on his/her behalf.

Families of the residential adolescent are often highly dys-functional and extremely resistant to treatment. Many families are present only because it is mandated by the agency as a condition of keeping their child in the residence. They are burned-out by adolescent rebellion and a child who, in their opinion, is a hopeless case. There are occasional exceptions when the art therapy provides a form of communication that quiets the angry voices and allows the

unsaid traumas to surface safely in the art. When there is some clarity about the dynamics and relationships, the family no longer needs to desperately place all the pain on the child's behavior. They can come to a resolution of their adult difficulties, and release the adolescent from the toxic role he/she has played in the family construction.

SR *Do you believe that society has become more judgemental of adolescents, and pathologizes even normal adolescent behaviors?*

RL In some cases, society has pathologized behaviors that are not 'abnormal', they are stages of development. Some parents are unable to be tolerant when their teen tests limits, or tries to become a separate person by aggressively expressing individuality as he/she moves toward adulthood. Some of these parents project their own dysfunction (their unconscious desires to act out) onto their adolescents. Many adolescents 'comply' with this unspoken mandate, and are severely disturbed by this paradoxical situation. They sense the meta-message, while hearing a contrary verbal message. These types of double binds do lead to pathology unless they are unraveled.

Unfortunately the adolescent residents here have all been judged as 'lacking'. Society supports this notion with the general fear and dislike of adolescent behavior, and most of these youths do what they can to promote this delinquent image. The teenagers are convinced that there is no viable, positive alternative available to them, therefore they make no effort to combat the critical judgement.

The belief system or art therapy mode that works best with adolescents must be thoughtfully developed by each art therapist. Our department has evolved an approach that is more consistent with 'art as therapy' than 'art psychotherapy'. However, the art process is slightly modified since we must also be consistent with the goals set for the client by the social workers. There are some adolescents who show the ability to engage in the therapeutic process from the start of therapy, others who do not. For the non-verbal youth, the phenomenological approach, which allows the art to be the first channel of self-communication is helpful. I think about development and attachment/separation issues, and the impact of the family on the adolescent. With the population we see at this center, the therapeutic choice varies with each child, but we rely on the art process to inform us of which theory will be the most effective at the moment. I believe a therapist must be aware of how the adolescent stage of development

influences the way he or she works, and must be in empathy with this age group. I consistently attempt to support an adolescent's individuation and self-exploration process. This attitude often means letting the adolescent be the guide.

Figure 4.19 Untitled construction of wooden sticks. 'Exploring possibilities'

Summary

There is a noticeable symmetry and points of differences when reviewing the experiences of the two therapists working with these difficult teenagers. The similarities I found dominant are those that follow. The families often have histories of abuse through many generations. The expectations of all family members are ones of ambivalence, love–hate, lack of respect for the individual personality. In many cases the child's maladaptive behavior is exacerbated by physiological dysfunctions such as: attention deficit disorder, prenatal drug damage, and physical and psychological impairment due to abuse.

The parents live in a violent world and the child knows no other. The adolescent enters into puberty with a paucity of skills and little, if any, adult support or positive role models. The turbulence of adolescence is experienced within the turbulence of their homes. There are no boundaries to keep them safe. They all have suffered the pain of separation, from their family, and from their peers. Their maladaptive behaviors escalate as they continue to fail at school, and their self-esteem plunges with failure. The parents have used up their reservoir of patience, and now see their child as almost unredeemable. They have little hope that their involvement in therapy will be helpful.

The greatest difference that surfaced in the dialogue regarding the treatment of the adolescents, reflects the positions of the therapists within the agency. Roberta is an adjunct therapist who has more freedom to emphasize the autonomy of the art therapy environment. She utilizes space and separateness as a component of the adolescent treatment. The success of this approach is due to the needs of a youth in residential treatment, and Roberta's conviction that non-directive treatment with art expressions is the most valuable in residential placement. Aimee is asked to take full responsibility for her cases. She is designated as a primary therapist. Therefore, she must follow family treatment, school problems, set individual goals, and issues of case management. She therefore is open to a complexity of systemic demands, from social workers, probation, clinic policies, and parental pressures. The clinic has imposed a short-term treatment limit on all the therapists, and the art therapist is no exception. This leads to the challenge of synthesizing the art therapy with solution focused theory. The challenge has resulted in a positive outcome for the adolescent client and for the art therapist.

Each art therapist appears to have found a setting that complements her style of offering therapy. There is no question that the place where the client receives treatment has an influence on how the treatment is conceived. To ignore how the context of the therapeutic relationship impacts the process of therapy, creates problems. To take advantage of the context supports success.

Residential settings have the advantage of having the adolescents on-site. The boys and girls are often glad to break away from the

behavioral programs and have some freedom with creativity. The outpatient school setting is less structured, therefore the therapists have to hope that the adolescents and their families will keep their appointments. In the SED program the teen returns home every day, he/she does not feel totally rejected. However, some of the homes are so toxic that it is a question whether or not it would be helpful for the youngster to move away. In contrast, residential placement reinforces the adolescent fantasy that everything will improve if they go home and are accepted. They are disappointed more times than not. The residential client is isolated from the neighborhood gangs and street pressures, the school teen still feels engaged with the 'normal' world and its temptations. There are different areas of conflict intrinsic to each treatment environment, and with these conflicts the resistance and acceptance of therapy. The issue of 'where' treatment is offered, and 'how' it impacts the course of therapy becomes clear as these settings are compared.

There is another level of treatment for adolescents who have broken the law. They are placed in a locked residential center, or mandated to a correctional facility for juveniles. Their placement is through the court system, and the youths are usually wards of the court. Some of the adolescents that are seen in both the SED public school, and the residential center discussed above, have emerged from this system and are on probation. The issues of criminality, sociopathic behaviors, and severe conduct disorders in adolescents are material for another text. Many of the therapeutic considerations we have discussed carry over into treatment with incarcerated youths, but there are many degrees of severity that are not discussed here.

These two agencies, serving these troubled youths, are difficult places to work. Yet almost without exception, when these disturbed young people are given a place to be safe and to creatively express themselves, they take advantage of the opportunity. There is no place in society where remedial relationships and creative therapies are more valuable than in these programs designed to rescue adolescents from a future of failure.

Adolescents and their Families

Why am I here? I don't have a problem, they do!

(An adolescent's evaluation of family therapy)

Chaos theory and family therapy

Figure 5.1 A family of eight drawing an 'Island', in family art therapy

'A butterfly stirring the air today in Peking can transform storm systems next month in New York' (Gleick, 1987). This often quoted condensation of chaos theory struck me as an apt description of the approach of adolescence in the family system. Long before there are overt physical signs of adolescent growth there are perturbations[1] in personality and relational interactions that foretell the future change in the entire family. Butz, *et al.* (1997) who have applied the chaos theory to family therapy have contributed many thoughts that I find clarify the discomfort that families feel when their children enter into the process of adolescence. I think most parents would agree that the term 'chaos' aptly describes that state to which the family feels reduced at this time. However, if the family can be reassured that chaos is an agent for change and not for destruction, they will have a more tolerant attitude toward their own 'butterfly'. In this case the butterfly is often an ungainly youth with more feet than grace, and a mouth that is generally irritating.

Scientists who follow chaos theory predict 'leaps', 'jumps' and 'spontaneity' as precursors to change, not an orderly progression of incremental transformation. Families, like other complex systems, do not make orderly changes in gradual increments, but rather in discontinuous leaps. This theory suggests that changes in systems occur in leaps following a gradual accumulation of stresses that a system resists until it reaches a breaking point (p.49).

Most therapists have heard a family member remark about their teenager, 'I do not know what happened. One day he (she) was a pleasant child to be with, the next a monster'. The accumulation of internal stress within the youth, and the emotional reactions to that stress, constitutes the family crisis during the adolescent developmental period. The family becomes destabilized as a result of the struggle to accommodate to the profound interruptions of their accustomed patterns. They are at a loss to find ways to put the relationship-organization back together as it was. It is a little like Humpty-Dumpty's men who tried to put him together again. Impossible!

1 Perturbation: adding or reducing energy or information to a system that results in a changed state of equilibrium.

The power of provoking discontinuity in the family system has been recognized and honored by many of the family therapy theorists. Strategic interventions to disengage the family from unsuccessful patterns of problem solving, reframing, paradoxical interventions, have been used by many family therapists (Minuchin and Fishman, 1981; Haley, 1976; L'Abate, 1986; Selvini Palazzoli *et al.*, 1978; Fisch *et al.*, 1982). They found that introducing small increments of change can radically alter the family's epistemology. When the family learns to perceive the problem in a different frame, the problem is no longer a problem. This certainly seems to be the key to working with adolescents and their families. The youth will still be an adolescent after the family understands the dynamics of this period of the family's development. His/her behaviors will be no less 'unusual', but they will be less of a problem.

The function of adolescence could be reframed as the impetus to move the family out of a complacent, unproductive state, and into a new level of development. Satir (1967) maintained that homeostasis was not a positive goal for family health. She felt that over-long stability led to problems and she supported destabilizing the family. Certainly the teenager is discontent with how the family reacts to his/her opinions, and wishes to change their viewpoints to match his/her own. The main focus of family therapy with an adolescent is the parents' struggle to maintain the rights to their valuable convictions and give themselves permission to let go of those that are no longer productive. The youth rebels against set rules to test their validity, and in this manner questions if these boundaries will form a part of his/her own future philosophy. Most of the troubles in families come about because they do not have firm, but flexible, boundaries against which the teen's rebelliousness can bounce.

However, not all the chaos is caused by the development pressures of the biological and psychological changes in the youth. These stressors are made infinitely worse if the external stressors of poverty, poor parenting skills, prejudice, and substance abuse, adds to the chaos that is inherent at this time. These forms of externally imposed chaos can be better described as random disorder, rather than chaos which contains

the promise of resolution. There is 'order' in the chaotic system that leads to change rather than to dissolution.

This chapter will look at the evolution and pressures that are present in most families during the time of adolescence, and consider a form of therapy that appears to be successful in most cases. There are no general rules that work for all families because there are no families that are the same. There are, however, similar situations that often arise during this time in the life of a family and their members. There is widespread agreement among families that when a child 'hits' adolescence there will be troubles. The problem that is not anticipated is how early this change begins. Adolescence starts biologically in late latency when the beginnings of growth and hormonal alterations are not physically apparent. These ill-defined sensations are no less a mystery to the child; new doubts about parental wisdom, the rousing of sexual desire, and the heightened focus on gender, are all discomforting new sensations. The youth will usually have no words for these feelings. Therefore, the therapist should be able to offer a variety of approaches in the family sessions that will allow non-verbal as well as verbal communication to emerge.

Family art therapy

Families who come into therapy with major complaints formed around their adolescent's behaviors and attitudes, have, under normal circumstances, had at least ten to eleven years of living with their son or daughter. They often feel that a 'stranger' has moved into the body of the child they have known for a decade. I believe a general assumption can be made that the family is mourning the loss of their more adaptable pre-adolescent child. Taking this fundamental non-pathologizing attitude toward the family gives them time to tell their 'problem narrative' and regard them in a developmental framework; a family in chaos. Since most adolescent change comes as a new experience for all members, there often is a need to create a new vocabulary to describe the situation.

It is useful in the first session to ask the family to represent the issue they *personally* see as the family's problem; using art expressions instead

Figure 5.2 Our home before we went to the shelter

of struggling to find words to express their confusion. This allows all members of the family to have a voice in expressing their viewpoint, children as well as adults. Adults awkward with drawing are urged on by children, and a mini enactment of the family's mode of interacting is displayed. Too often the early session in verbal therapy consists of the adults complaining about the teen. By focusing on a task that infers that everyone can have an individual opinion, that blaming noise is reduced. It is useful for all to see that there are a variety of alternative viewpoints; whereas often the assumption is made that the family thinks 'as one'. Moving away from pointing the finger at the adolescent instills hope in the teenager that therapy is not created just to get them out of the family. He/she would like to move out (in fantasy), but the practicality of this move keeps him/her at home. 'Moving out' is often a metaphor for individuation, and that is as uncomfortable for many parents as it is for the youth. It is better to have the adolescent grow up within the

family setting (unless there is abuse). If nothing more, it gives everyone a chance to see, with or without therapy, the normal stress of adolescence diminishes as the child matures.

If there is chaos in the system, the family should be offered the opportunity to organize themselves around a task. The art therapist suggests that they create a 'family mural'. Each member draws with an individual color, and soon it is easy to track who is taking over and marks over other person's marks; who is a silent strong person and makes supportive images; who fills in other person's objects and offers little of their own; who verbally tells everyone what to do but is tentative about doing their own image. Landgarten (1981) observes, 'While the family is engaged in creating an art product, the clinician watches the *process* to gain understanding of interpersonal dynamics. The family's approach to the art gives the art therapist an opportunity to observe the gestalt of the family's structure, assigned roles, alliances, behavioral patterns, communication systems, and styles' (p.22). It is this process of observing and preserving the family's interactions that is so unique to art therapy. Families are not going to openly reveal their more personal selves to the therapist until some time has passed. However, since the art expressions are new to them, often concealed material surfaces in the image that would be avoided verbally. I believe that the therapist profits the family by taking a 'not knowing' approach. With a constructionist approach s/he can puzzle about the content of the drawings and rely on the family members to recognize important material (Anderson and Goolishian 1988). Co-constructing solutions keeps the family in control and the therapist free to share observations and alternative opportunities for growth. *Using art therapy with a family combines assessment and therapy in one continuous flow.* Roles and behaviors are observed, narratives are listened to, and alternative solutions are honored; this results in a holistic approach to problem solving.

Example

A family was asked to draw together anything they decided upon. The grandmother immediately delegated the decision to the adolescent grandson. He reluctantly suggested 'surfing in Hawaii'. The parents

Figure 5.3 'What it feels like at home!' (13-year-old girl)

Figure 5.4 'My dad' (plasticine) (12-year-old girl)

vociferously rejected this idea because it was too costly to travel. When the younger daughter pointed out that it was 'only a drawing' they conceded it would be fun. They proceeded to make a drawing on this theme but left little room for the son to contribute. He was finally able to squeeze in his airplane, flying off the page into space. In the after-drawing discussion they blamed him for not cooperating and not contributing. When the conversation was directed to 'who's idea was it to go to Hawaii', they admitted that son had originated the theme. He had been given no credit up until then. When he was asked why he drew so little on the page, he said 'it didn't matter, they would have seen whatever I did as subversive'.

This observation leads to a discussion of how the parents perceived him as moving away from the family, and how unready they were to trust him to leave. His individuation represented to them (it surfaced later on in therapy) as a dissolution of the family. If one person left, then everyone would drift apart. Working with the images and repeating each generation's concerns, provides safety and comfort to the family to confront painful issues.

Value of the art product

It is useful for the success of therapy to be able to use a tangible art product as a reference point. While the process reveals the meaning of the product it is helpful to use the artwork as a focal point from which the dialogue emerges. Words can be denied and behaviors 'forgotten', but a visual record of a family transaction can be preserved and utilized as the treatment requires. From the beginning of therapy the family tasks that provide an opportunity for the entire family to work together send the message that working together is a goal. The difficulty in the family is everyone's problem, and they are the agents of change. This is a particularly difficult concept to project in verbal therapy.

At times there is a reason to have the family members draw individual products. Perhaps they might be addressing 'What does it mean to be a 'teenager'?' When they have shared their drawings and exchanged their views, there should be another component to the art therapy. It is helpful to end a session that has individualized artwork

Figure 5.5 'Our house where dad kept all the food, and made us stay in our
* rooms.' Drawing in family session*

with a task that will consolidate the session. I ask all the members to put
their drawings in the center of the table and arrange them in a manner
that reflects the earlier dialogue. This allows a summation of the
conversation and reflects on the issues that have been discussed during
the session. While the drawings are loosely placed in the center of the
table, the art therapist can move them to demonstrate some of the
observed dynamics. For example, the drawing of the adolescent can be
disengaged from the other drawings. When it is separated visibly, and
moved back and forth to touch and leave the other drawings, the notion
is introduced that this is the process of adolescence. The youth can
experiment with how much distance he/she feels comfortable with
now, how much in the future? The art product becomes a dynamic tool
and enhances the process of therapy. Discontinuous change is
recognized as their opportunity for change.

Facilitating family trust

During this developmental period the issue of trust becomes a major topic in family therapy. From the parents' view, they are reluctant to trust their children with new freedom when their behavior appears to be so erratic and impulsive. The youth does not trust the parent's ability to understand his/her new abilities and judgement. It is the task of the therapist to facilitate opportunities to clarify and modify these perceptions. As an example, when the parent(s) work together to create a collage that delineates 'how they would feel if they could trust their teenager'; and the adolescent makes a product showing specifically 'how and when s/he can be trusted', negotiations have begun.

The notion of specificity is an important tool in therapy. The family members and the adolescent too often talk in generalities, and tag each piece of behavior onto all the previous disappointments. An important skill is to focus on each separate transaction in the immediate present. To achieve that goal, I encourage the family to *do* something with the product. Divide up the images, cut them apart if necessary, exchange a piece of one representation for another. Bargain. Negotiate. Discuss fears and consequences. Working with pieces of paper or clay become a metaphor for the exchange of information that is often lacking in a family. Moving the discussion to a situation 'once removed' can give the members a chance to practice necessary communication skills in a non-threatening manner.

If the therapist is comfortable with a strategic approach, s/he can assign tasks to perform at home; and predict that most families fail to accomplish their homework (Weeks and L'Abate, 1982). Predictions have a way of setting up a degree of defiance, which motivates the client(s) to prove the therapist 'wrong'. The therapist could, for example, prophesies that if the family loans the car to the teen, he will not remember to return it on time. If the adolescent *does* bring the car home on time, instead of defying the rules, and the parents loan the car *without* predicting that she/he will be late, the therapist is pleased to be wrong. If the teen is late returning the car, then it indicates that I asked something of them that they were not ready to do. I do not use a 'strategic intervention' to trick the family. Since resolving chaotic patterns is

accomplished through an uneven process of discontinuous growth, there is bound to be success and failure as the family accommodates to a new pattern of relationships. Predicting 'failure' is protective and supportive. The prediction is framed as normal, expected behavior on the road to an alternate outcome of the script.

Parents' expectations and fears

'Grow up without changing, keep me informed of your activities and your friends; have a relationship in the future but don't 'fool around' now; have a beer with Dad but don't drink when you are out.' All of these paradoxical messages from parent to child, are based on powerful emotions and fears. The fantasy is that sex will lead to rape and pregnancy, drinking will turn the teenager into an alcoholic and drug user, and other behavioral disasters. More than these concrete anxieties is the parent's deeper fear of losing the child and his/her love. The

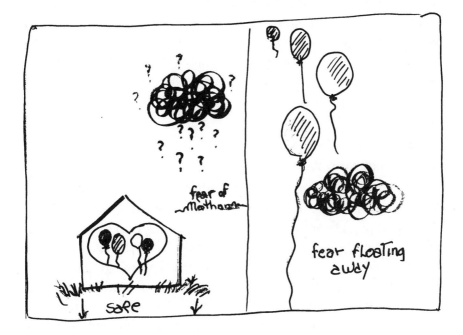

Figure 5.6 Mother illustrating her entrapment in an abusive marriage, and her subsequent escape

obstacle to expressing these strong feelings has a base in societal teaching. We have been socialized to talk indirectly about our fears and emotions, particularly to our teenage child. There is a pervasive apprehension that if these concerns are verbalized they will somehow become true. A self-fulfilling prophesy (Watzlawick *et al.*, 1967). The value of art therapy lies in the possibility it offers to picture these thoughts without saying the words.

Parents may remember some of their own adolescent indiscretions, which they are reluctant to share. More powerful than their real escapades are the internal fantasies and projections that have colored their memories. Their own adolescence issues are projected on their child, and fears and protection becomes tangled up with actions in the here and now. Sometimes the parent will unconsciously program the youth to act-out the unfinished tasks of their adolescence. Thus sexually repressed parents may show inordinate interest in the 'affairs' of the youth. A subtle form of encouragement results in the predicted consequences. These are difficult dynamics to tease out, however, by letting the art product 'speak', many clues will surface. It is not useful to assume that these second level communications are meant to be destructive. Usually meta-messages are inferred without the conscious knowledge of the sender. Messages such as these only become harmful when the owner of the desires is not the one who is carrying out the action (Stierlin, 1981).

Psycho-educational information

Helping all the members of the family learn about the adolescent process results in clarification that reduces the experience of chaos. Education provides information that allows the system to settle into a new relationship, one that includes the adolescent. When behaviors are seen through the lens of 'normality' rather than pathology, the stress is reduced considerably. Psycho/social education synthesized with individual attention to the unique patterning of a family can bring relief to crisis. This approach can provide the calm that is needed to make a transition to a more appropriate developmental environment.

Figure 5.7 Guns blazing, man hanging. Reaction to a family session

Even in the most disturbed family there are areas of 'normalcy'. The parent(s) and children can identify with the larger community of families going through a parallel developmental stage and feel encouraged that others seem to have survived. To provide the greatest success for education and support for parents of adolescents, it is most helpful to establish an adult group which addresses these issues. Common interests, an exchange of coping techniques, and empathic listening can be more therapeutic than most theoretical treatment approaches. The art is minimal, but essential. Each member pictorializes their 'frustrating moment and pleasant surprise of the week'. This request allows each adult to draw about their difficulties and their successes. The family group provides the setting for everyone to 'speak at once' through the art, which has been discussed above. After they display their art product each family can give the others feedback and comment on the changes that they see taking place. Through the art product the group can move quickly into the subject that catches their

interest or appears to be the dominant theme of the group. Educational material can be introduced, reading matter shared, and resources reviewed. The family group is an economical vehicle for dissemination of valuable resources.

Fluid assessment: developmental maturation

I have spoken out many times against the notion that the strength of art therapy lies mainly in its use as an assessment tool. Art therapy, for me, is a synthesis of therapeutic illustrations and the client's process. However, there are situations in family therapy that demand close attention to developmental stages demonstrated in the imagery. Children draw the human figure on a continuous scale of greater definition and awareness of appropriate placement of body parts (Lowenfeld and Brittain, 1982; Malchiodi, 1998). An art therapist looks to these developmental tags to help them evaluate if the child is on course for their maturation.

In adolescent families I have found surprising use for this scale of development. I have found that at times the parent demonstrates in their art a lower scale of development than their teenage child. By this I do not mean the parent draws badly, I do mean that their drawings are not appropriate to their chronological age. This can best be illustrated by a case example.

Example

Joey was brought to the clinic because at thirteen years he was still soiling his clothes with feces. His mother, father, and younger brother, Chris, eight years old, made up the family. In addition, both sets of grandparents were extraordinarily involved in their daily life and comprised a vital part of the extended family. It was significant that the parents asked for treatment only after the school demanded that they do something about Joey's encopresis. The teachers and students could no longer tolerate being around him and his terrible body odor. The parents seemed concerned and anxious to cooperate, now that the school had made this behavior an issue. They complained that their other problem, which they considered as stressful as the encopresis, was Chris's repeated running away.

Figure 5.8 Teen boy sending message to parents

My first impression of the family was notable. Mother and Joey had a remarkable resemblance. Their chunky body type and rather enlarged head made a curious impression. Father was pleasant, but seemed to have trouble being attentive. Chris was entirely different than the others. He was lively, aggressive, and impatient with therapy or any psychological connection to his brother. He refused to come to therapy unless threatened, and 'ran away' from the sessions several times. The parents did not chase after him. The family lived within walking distance of the clinic, as did the grandparents. It was to his grandparents' home that Chris ran every time.

The background material that I gathered in the first few intake sessions was interesting. However, before the history was taken I felt a

strong drive to explore the physical likeness of mother and Joey. I had worked with handicapped persons in the past, particularly Down's syndrome adults in a specialized educational program. The body type and facial structure of mother and son reminded me of the bodily structure of my former students, however, the resemblance was a 'shadow', not a clear identity. After some research I found that there are many levels of this genetic difficulty and the mother and son's description could possibly fit in the category of the least affected Down's syndrome persons. This suspicion stayed in my mind, but did not influence my usual approach to form a relationship and deal with the presenting problem.

Mother was mildly distressed about her son's soiling. She explained it as something that would pass if he just stayed with the family and stopped retreating to his room for hours. She did not seem to understand that it was quite unusual to have a teenage son that was not toilet trained. In his room he had his companion called 'string'. For a long time I did not know that it really was a piece of string. He caressed it and played with it. During these play times he had the most frequent 'accidents'. Mother would attempt to lure him out of his room where he played with 'string'. Before dinner she regularly bathed him in the shower. She saw nothing exceptional in bathing her thirteen-year-old boy. Strangely enough, I became more tolerant as I looked at her actions from her viewpoint. I understood that she saw him as a young child. She also was a child-like adult, who was not able to judge her actions from a mature stance.

The greatest clue came through looking carefully at a series of drawings made in conjoint sessions with mother and son. Joey's scribbles were not age appropriate in any aspect, and mother's were drawn with an approximate age-skill of a child in kindergarten (Malchiodi, 1997, pp.68–71). These drawings informed me of how, by speaking in a manner that she could comprehend, I could appeal to her to interrupt the sexually stimulating bathing. It also helped me understand why the grandparents were 'in' this family almost everyday. The family could function if there were sufficient supportive members to reinforce the limited skills that the family did have. I had hoped I could turn to the father to intervene in the rituals that had been

established, but he seemed not to be a reliable resource. Dad came home after work everyday, turned on music and danced around the house for several hours until he was tired and went directly to bed. In spite of all this unusual behavior the family was a loving one. Their greatest concern was with Chris and his rejection of them. He would never verbally criticize his parents, he just ran away! On the few occasions that he would draw in a session, his drawings were technically interesting, well executed stereotypes. His performance in school was outstanding, but he was mortified to be known as 'Stinky's' brother.

Very slowly some changes took place in Joey's ability to gain control. He admitted that soiling gave him pleasure, so we looked for pleasures that could substitute. 'String' gave the command to defecate, so 'String' was assigned other duties. The parents took Joey for medical examinations, which effectively eliminated their belief that he started soiling after an illness, some years ago. They needed to be told firmly by a medical authority that Joey's problem was not physical, it was psychological. Dad was persuaded to take Joey to some sports events if his son was clean for the number of days that we agreed upon. Mother was educated (very simply) that showering her son did not help him. She was a devoted believer in therapy, and that made my suggestions take on a weight that was exceptional. At the mother's developmental level she still perceived clinical help as a form of 'magic'. Joey was enrolled in a school for children with problems. His academic performance when I met him was very low, except in math, where he was at grade level. His school work was becoming impossible for him in middle school. Many other approaches and tasks were used to assist this family, too many to record here.

This family seemed to have so many problems that I was extremely unsure I could be of any help. In fact, when Joey came to a session smelling so bad that I sent him home, I despaired of any treatment being effective. I tried not to take his behavior as a hostile gesture toward me, but that is how it felt. The dynamic that hooked me into wanting to help was their obvious affection for each other. Dad proudly told me of the lovely gifts he gave his wife, she spoke lovingly of him, her children, and her attachment to her mother and father. I realized that they were all functioning the best they could at the level of their ability. The one I

was most concerned about was Chris, who really was the misfit. He was so highly defended at this time that I could not reach him. My hope was that as the family became more normalized he would not have to run away from an embarrassing brother, and parents who were not capable of controlling the behavior. He was praised and given anything he asked for, but that was not enough for this intelligent boy who was probably the most high functioning person in the family. He was sharp, but he did not have the loving warmth of the other members.

Throughout the therapy the drawing process was directed toward spontaneous products that became comprehensible to me only after they identified material in the scribbles. The artwork was most useful as a diagnostic tool, and was the trigger that directed me to the form of treatment with which this family could identify. Without the art they would have been unable to communicate since their ability to conceptualize their problems would have been too difficult. As Joey moved into adolescence slowly, he will profit from therapy that will access and support simultaneously.

When we terminated it was an emotional parting, they had become very devoted. I felt as though I had joined the extended family and provided them with support through a difficult time. Parting was not easy but their connection to grandparents, aunts, and uncles and, now, supportive services, made it a satisfactory and memorable experience.

Incongruities in developmental patterns

Having a parent that is developmentally younger than he or she appears, happens rather often in adolescent therapy. I have written about it extensively (Riley and Malchiodi, 1994) and I recommend family therapists pay close attention to this situation. Many clients have had drug problems; being on drugs is a time-out for development. If the parent was using for some years, those years were unavailable to the maturation process. Therefore, we often see 'adolescent' parents attempting to raise adolescent children. Looking at the art can be a great help. Offering art suggestions that are tailored for adolescent interests can provide the therapist with insight as to the parents' developmental stage. Helping two adolescents growing up simultaneously (parent and

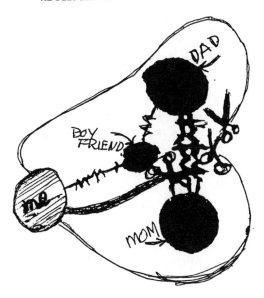

Figure 5.9 Spontaneous family genogram. 'Cutting the strings to the family'
 (14-year-old girl)

Figure 5.10 Collage by adolescent concerning 'confused' messages about
 alcohol in family

child) is quite a task, but it is necessary, particularly in situations where the teenager is confused why his/her sensible suggestions are not honored. A parents who is also 'adolescent' cannot let go of their narcissistic desires, and the family system is skewed. This is a family where there is such a constant state of chaos that the discontinuity never is resolved. When the adolescent crisis is controlled in both parent and child, the new patterns will have an opportunity to emerge.

Single parent families

The largest group of families that come into therapy when the child becomes adolescent, is the family headed by a single parent. The single parent is usually the mother. The number of one-parent families more than doubled between 1970 and 1990. Mothers headed 88 per cent of these families, fathers only 12 per cent (US Bureau of Census, 1991). Seibt (1996) points out the many additional burdens that face the single parent and he lists the common emotional traumas experienced by the children in these families. Divorce is particularly hard on the school-age child, with confusion, frustration, anger, and embarrassment, combined with a feeling of helplessness and abandonment (pp.41–9).

When the youth in the family reaches adolescence, I have observed a new level of chaos disturbs the relationships between parent and son or daughter. The mother calls for clinical help with a situation that has gotten out of hand. She has been coping for some years with the financial and emotional parenting obligations that are an inevitable part of working a job more easily handled by two. When her child reaches this new level of maturation two dynamics often come into play. The first, is a renewed hope that she may have more support and assistance from an older child, support that some wives have from husbands. The second, is a fear that the progressive need of the teen to move away emotionally from her, will leave her even more deprived than before. The adolescent feels the opposite. The son does not want to remain or become a 'father-like' support for his mother, and the girl does not want to parent her mother or share her 'man-less' image. Both sexes are turned in upon their own needs and adolescent dilemmas and have little to give. Their natural withdrawal is seen as something unusual or

punitive, which adds to the already cloudy definition of the complex parent–child relationship.

The greatest need for these families is to clarify this time of transition. Particularly in families where the cultural definition of family togetherness is much closer than the general American view of allowing increased individuation for the teenager. A series of developmental-educational sessions are helpful. Art therapy tasks that both mother and adolescent can work on individually, but in the same room, can be the best way to make these needed changes clear and negotiable for both generations.

Some suggestions for art expressions could be:

1. Demonstrate how close you were when _____ was young. How close now? How close would be acceptable? This task can address the dynamic of moving in and out of the child-relationship into the adolescent-relationship. Using clay figures makes the 'moving-around' aspect of this expression more dramatic and more flexible.

2. Artwork that allows the parent to visually demonstrate all the roles she plays in the family, both male and female. For example, breadwinner, repairman, plumber, seamstress, housekeeper, etc. The teen does the same. They can appreciate their interwoven dependency to keep the family together. The following task would be to appreciate each other's contribution and then realistically face the new association. The teen needs to develop away from the family and the parent needs to ask for specific chores, and be consistent. Ask for chores not emotional support.

3. The most difficult art expression will be a response to a future oriented question. How will it be when the teenager has moved away? What outside group support will you each have created? When should you start making preparations for this move? Does moving out mean losing connection?

These suggestions focus on the developmental stage of adolescence which is the most painful for many single parent families. For many women the hope of some more mature relationship with their child is sadly dashed when the teen becomes more difficult, rather than less of a problem. Many women rely on their oldest daughter to be an equal

emotional confidant, and this loss is painful. The chaos heightens at this period of time, and the art therapist can be of the greatest help by providing education, understanding, and a safe place to confront the unspoken fears. If the clients wish to retain their art therapy products, they can be bound (informally) into a journal which can be referred to after termination. Short-term therapy, entered into several times if needed, reinforces that this time of crisis is a developmental phase, not a break in the family's relationship.

Problematic families

There are many families who have decided that they no longer can tolerate the behavior of their adolescent child. They come to therapy to extrude him or her from the family. Faced with this challenge the art therapist should ask for a clear statement from the parent. Concretizing the desire to remove the child is very important. Too often this is a threat that is part of the dynamics between parent and adolescent. Request this art task; 'Show when you will ask your son (daughter) to leave, and where s/he should go.' Turning a threat into a statement will effectively clear the air. If a response to this directive is avoided, the therapist has been informed. Empty threats only escalate the chaos and distress. The statement clarified with the art is confrontive. It is easier for the parent to threaten and blame verbally, than to make a definite commitment to extrusion. This same technique is applicable to the magic number '18'. 'When he is 18, out he goes.' Being legally adult has little to do with maturity, particularly in disorganized families. The greater the chaos, the less opportunity for psychological growth. The responsibility of the therapist is to attempt to buy time to allow maturation to take place.

I believe that clarity is the essential intervention needed for these families in pain. If there are alternatives to living at home that are feasible, I ask for information. If a residential placement is possible, again the concrete contacts and data are requested. Adolescent placement after sixteen is not often available, and the danger of their child having to live on the streets can bring some reality into the family.

Over the years it has become increasingly apparent to me that family relationships that have become seriously dysfunctional are the creation

of the entire family, not only the adolescent. A constellation of interactions that are creating dissonance can best be interrupted with a narrative approach (White and Epston, 1990; Byng-Hall, 1995). As the family relates and illustrate their story with their artwork, the art therapist will find numerous moments when the storm quiets down. Periods of calm seem to raise anxiety, which starts the cycle of stress again. The dissonance between what the parent and teen say they want, and how they act when they get what they want, is contradictory.

It is important for the art therapist to intervene quickly and anchor the positive exceptions to the dominant script, then some movement is possible. I have actively interceded by drawing a diagram or descriptive abstract of what I heard. Making my observation visible, not as a 'truth' just as an offering, catches the successful transaction they have overlooked. It is not common practice for most therapists to do an art expression, but these families are not common either. Crisis situations require inventive moves to add a useful push to the discontinuity of the family's movement. However, having illuminated the positive interaction that has been overlooked in the family story, the art therapist should move away from the center of the system.

Butz *et al.*, (1997) support a less power oriented stance for the therapist. They believe:

> Families follow their own internal dynamic processes that will unfold through time, in ways a therapist cannot predict. The dysfunctional behaviors of families are often the result of issues acting as attractors, pulling the family into seemingly bizarre, inconsistent behavior patterns. Interfering with these processes is necessary only when the family becomes 'stuck' in repetitive dysfunctional behaviors. (p.200)

It is difficult not to become overly involved with a family if, for a multitude of reasons, the adolescent seems to be the scapegoat. However, a victim has power, and the adolescent has a hand in some part of the family dance (except in abuse). Providing the family a forum for viewing their interactions through the form of art therapy, is a help. If they are not in a position to utilize that help it is sad but realistic not to be a rescuer. I find it unprofitable to search for a villain in these situations, often the family passes through a maelstrom and considers it

less tumultuous than I have imagined. If the therapy has provided a momentary break in the dynamics, it is safe to say that a ripple effect may have been introduced. The clinician may not be around to see the resolution, but we always hope that the system re-forms into a more functional pattern.

There are family situations where the adolescent youth is at risk. Adolescent girls are often victims of sexual abuse, boys are also sexually molested. Drugs and alcohol can threaten the entire family. Single adolescent girls with babies are in dire circumstances. Run away kids are selling themselves to keep eating. Guns have become commonplace to many adolescents, and shootings are a daily occurrence in some neighborhoods. These serious situations must be addressed, and therapy can help but the problem is too engrained in the social fabric to imagine that a therapeutic intervention can solve these grave difficulties. These issue deserve more attention than there is space in this text. I was struck by the voice of one gang member, when the city of Los Angeles had an open forum on graffiti control. This tagger responded to the question 'What is the core problem in this situation?' He said, 'The families are at fault. They do not control their children.' The twenty other gang members agreed with him.

Summary

The model of chaos theory applied to the discontinuity in family functioning that is instigated by the onset of adolescence, is a way of understanding a period of family development. The adolescent chaos is anticipated by most families. However, when it does disengage a family from their accustomed patterns it is always more unsettling than they imagined. Each family will react in unique ways to this event, an event that is inevitable if a child is raised through to adulthood. Except in the most painful situations the families survive and the youth enters into young adulthood. When the passage becomes too stormy often the 'expert' is asked to help navigate the course.

An art therapist can use some of the methods suggested above to help the family see that adolescent behavior is part of the struggle to gain adulthood, and not a plot to dismember the family. Externalizing the

behaviors from the adolescent through the art expressions is a primary step. Then working as a team is necessary, to move the family from the stage of development that was formed to raise a child, to the more difficult stage of holding and letting go of the teenager. That re-conception of the adolescent and the parental relationship is the challenge. Art therapists who can help the family chart their way, and avoid the toxicity of blame and disrespect by providing tools, such as, support groups, therapy, education, and good cheer, can make this period less chaotic. The family itself will introduce their own methods of integration and form a new constellation of behaviors that will let the adolescent find their wings and still be an integral part of the system.

CHAPTER 6

How Therapists Get Tangled Up in Adolescent Treatment

Draw, Dammit, Draw.

(Frustrated art therapist's secret thoughts)

They came bursting into the therapy room. Six wild, aggressive, unsocialized, early teen boys, laughing and punching each other, on a high that was in contrast to their usual sullen approach to the art therapy room. The group was newly formed and although this arrival was going to be hard to calm down, I thought, 'At least they are making a connection'. After they took their seats I inquired what had caused their laughter? They vied to tell me how they had found a bird's nest in the tree in front of the clinic. The nest was filled with fledglings just ready to fly. As a group they took the nest down, pulled out the baby birds and threw them in the street to be run over by cars.

I was aghast! I sat dumbfounded, unable to respond, as the boys continued to fool around and expand on their exploit. My rage was so overwhelming that all I could do, in my position as therapist, was to gasp, 'I suppose you have felt, at times, that life has tossed you out onto the street to be run over'. That was it! I threw my role as 'understanding therapist' out the window and told them that I was very upset. Killing innocent life was abhorrent to me, and I could not look at them for the rest of the hour. They were excused from this week's group.

This happened many years ago and I still feel a surge of anger when I recall this wanton act. I have long since explored the reality of those boys' lives, their insensitivity and lack of respect for life should not have been unexpected because of their brutal home environments. I have also seriously considered my inability to step away from the act and see it in

the framework of their development. None of that intellectual deconstruction reduces the spontaneous reaction that this act elicits in me even today. They hit my button! Part of my personality was threatened or could not cope with this careless act. There is a place in me that will not excuse some deeds, and this one personified an action I found inexcusable. I cannot defend my decision to dismiss the group. I do know if they had stayed I would have liked to have killed them all! Or so it seemed.

My strongest belief when working with adolescents is that honesty and appropriate transparency is the keynote of an authentic relationship with this age group. The teen client has an uncanny ability to sense if the adult is attempting to project a false image. In reference to the example offered above, I do not believe it would have been useful for me to pretend that I could deal with this situation. I believe that it is my responsibility to uphold some principles that I hold dear. Principles that I feel are ethical and hold to standards by which I conduct my life. This is the type of disclosure that I have no trouble supporting. When an adolescent asks me a personal question I tend to answer it in a straightforward manner. Only when they intrude in areas that are not appropriate do I refuse, and I tell them why. A decision about the ethics of sharing feelings and personal information with clients is a serious subject to consider and one that each therapist has to come to some conclusion about.

Countertransference

Psychiatric literature has examined the phenomena of counter-transference in countless publications. Among the few definitions that I reviewed (Sugar, 1980; Epstein and Feiner, 1983; Giovacchini, 1985; Alexandris and Vaslamatzis, 1993; McCown et al., 1993), Mishine's (1986) seemed the most concise. She explains this reaction to client's words or behaviors; 'Countertransference is distinguished by its arising, not out of the patient's behavior alone, but from unconscious and preconscious forces within the therapist that cause the therapist to react to the patient in ways inappropriate to the current reality of the therapeutic relationship' (p.334). She further suggests that 'Frequently

clinicians are tempted to counterattack which can result in rejection, punishment, or hostile demands for compliance' (p.335).

Exploring the issue of countertransference from the belief system of psychiatry is an interesting study, however this text is oriented to the more action oriented therapies and closer to a reality-based interpretation of therapist's reactions. The explanation that seems to make the most sense to me is one that suggests that when the therapist feels irrational and out of control emotionally with the adolescent client, he/she is probably close to his/her own unresolved adolescent issues. I prefer to discuss how the therapist is affected by his/her adolescent clients in the light of the therapist's own unfinished business of adolescence.

Therapists get tangled up in their relationships with teenagers. Art therapists have an additional temptation of being inappropriately drawn in through the adolescent's artwork. This chapter will report on some of the stories that therapists tell, and some of their ways of resolving this issue. There is no question that most adults react strongly to youths in their teens, and therapists often avoid having to deal with adolescent clients. How to see this situation in a manner that fits with the youth of today and the current theories on treatment of these youths is an area that is worthy of further exploration.

Some stories of entanglement

The stories I tell below came from my therapist friends, from my own experience, and from the literature. The therapists who were brave enough to tell me their tales of woe, are all highly educated, experienced, and dedicated professionals who have a majority of adolescent cases in their practice.

Common difficulties

Adolescents are committed to questioning authority. The therapist is seen as an authority figure, therefore, compliance is not commonly attained early in the therapeutic relationship. Knowing this truth, and living it, are two different matters. Most therapists see themselves as

'good guys', not punitive adults like the ones in the youth's family. (How punitive the adults really are, is a judgement made through the adolescent's vision.) On some level it seems obvious to the therapist that the teen should appreciate how kind and giving he or she is. We are skilled and empathic. As art therapists we offer media and creative opportunities. Why are we rejected? This irritation grows as the weeks go by. The adolescent is open about the fact that they are in therapy only because they are forced to come. Even more annoying is their lack of interest in the art materials that have been offered. The black and red markers have been pounded so hard into the paper that they are ruined. The clay disregarded, and looking at collage pictures is used to pass the time. Where is the creativity of this stage of development we have read about?

Transparency and failure

The hostile teenager just sits and won't talk or draw. Shall we tell the adolescent what feelings of anger are evoked when this behavior continues? Kottler (1992) has this opinion; 'We must be sure that we are not disclosing our feelings to let off steam, to inflate our own egos, to

Figure 6.1 'I am failing! What to do?'

put the client down, or to strike back. If we genuinely desire to give feedback that can be helpful to the youth, such an intervention can be a turning point in treatment' (p.113).

In addition, as in most of the situations I will explore, it is an embarrassment to admit our failure. Particularly, since the art therapist has propounded that creating images will reduce resistance in this age group, and with this kid there is nothing! It is hard to lose face with our contemporaries. How this impasse is handled has a great deal to do with the innate optimism or pessimism of the therapist. The competitive challenge thrust toward the therapist can be solved in several ways; two are the most common. One is to continue the struggle until circumstances change the system, such as, the parent removes the child from treatment, the adolescent is referred out, or better still, the child grows older and moves into a different stage of development. The second is to acknowledge the frustration and helplessness felt with uncooperative clients and seek support and consultation from peers and hang in there.

Kottler (1992) quotes Adler (1982), 'I finally had to conclude that feelings of hopelessness and helplessness were part of the burden I had to bear as a therapist, and I was not alone in experiencing them. I also began to see that these feelings came up with greater intensity with certain kinds of patients' (p.4). Kottler (1992) reflects,

> The experts in our field have not made it easy for us to talk about our problem clients; the tendency of these experts is to publicize only those interventions that work, quietly ignoring their efforts that have failed dismally. As a result, some of us feel that we are the only ones who ever encounter difficult and resistant clients. (p.4)

Since we share excellent company in our failures, we should take heart and realize that it is normal not to expect constant success. Perhaps it is more normal to fail, given the damaged kids most of us face daily in our practice.

Failing to produce art expressions

Failing to elicit artwork from the client is a specialized distress for the art therapist. If the art therapist feels that therapy is productive only if s/he can show art products, then there is a false burden placed on the

Figure 6.2 'When will they give me some freedom?' (15-year-old girl)

evaluation of success. The art expressions are an extension of therapy, not a language that stands outside the therapeutic relationship. In most cases, when the client's defensive barriers are lowered the art images will surface. If not, there is probably a reason behind the adolescent's inability to communicate visually. Producing art is not a criterion for good therapy. Imposing a value that arises from within the therapist, and not from the client, is a sure sign that the therapist is having a problem. Performing for the gratification of the adult is the last thing most adolescents will do. If the therapist needs to control the production of art it is anti-therapeutic.

Understanding that art and therapy are one is a concept that can be accepted intellectually. However, that inner voice says 'You are not an art therapist unless there is artwork!' Guilt and discomfort is not allayed by cognitive reasoning. It takes many years to accept that creativity does not always manifest itself concretely.

For those of us who work with adolescents our greatest ally is the recognition that our clients will grow older and move into another phase of development. Adolescence is a short period of our lives, the changes are rapid and there are new opportunities to make contact as

these changes occur. This time of life is one where all systems are in flux, change is inevitable. If the therapist has not taken the lack of cooperation personally, there may be another chance at joining. I comfort myself by remembering the words of a fourteen-year-old girl. 'Now, after a year of group I don't hate it at all. I even like to draw!'

Getting caught in the middle

Most adolescent clients are still a part of a family system. The 'family' may be defined loosely, as the adult person or persons that are responsible, over a committed period of time, for the well being and protection of the youth. However, the majority of cases I have seen consist of a birth parent(s) and some other extended family members. How that family functions within the parameters of their cultural, socio-economic circumstances is of vital concern to the therapist, but is not the issue emphasized in this discussion.

Clarita comes into the art therapy office for her first appointment. She has been ordered into therapy by the school, and is being monitored by a social worker. She has been truant, and a 'run-away' for the last six months and is considered a girl 'at risk'. I am surprised that Clarita is only 13 years old. She is amply developed, heavily made-up (gang style), her hair lacquered to stand up in a fan, and her clothing revealing every curve of her body. She makes no attempt to deny that she runs away from home as much as she can, and would do anything to get out of the house since 'he' moved in. 'He' is an illegal immigrant who is living at their home, and who is going to marry her mother to become a citizen. He bosses her around and she suggests that he makes sexual overtures to her. She stays in her room and feels like she is in jail. She 'hated' her mother because of her weakness and willingness to serve her new 'husband'.

After Clarita left the session, I was conflicted with many emotions. I had some judgmental thoughts about the way she presented herself as a sex object; 'She was just asking for it!' I was angry with the Mom bringing in an illegal immigrant under the pretext of marriage, and not 'protecting' her daughter. She must be an irresponsible woman. I had an immediate dislike for this guy who was intruding on the household,

even though I had no idea what he was like. In other words, I had completely fallen for Clarita's version of the problem. I had added a few prejudicial ideas of my own, and had muddied my thinking all around.

Where did this all come from? My ideas of how girls should look, or my envy of a girl who was so confident of her body and sexuality? My concern about responsible parents, or my admiration for a woman who would risk breaking the law to be with her lover? These thoughts were ambivalent and ill-founded. However, I have learned by experience that, for me, I can clear my thinking better if I allow these biased thoughts to surface and become conscious. When I become my own observer I can take some distance, let go of my initial biases, and allow the process of understanding the family's dynamics to take first place in my evaluation. Needless to say, the circumstances of Clarita's behavior and her mother's actions were quite different than this initiative story.

My purpose here is to share how easy it is to get caught up in irrational decisions based on our own values. The interesting aspect of giving yourself permission to recognize the 'untherapeutic' first impression, is that you can track your own patterns of prejudice and restrain their influence on treatment.

Sex and sexuality

The adolescent male is rarely enamored of the adult female therapist. They may have fantasies and make verbal overtures, but the reality of a inappropriate relationship is the exception. Even one exception cannot be excused since it is the responsibility of the therapist, not the teen, to use self-control. Why is the therapist not often a sex object? The first barrier is age. Most therapists are not still in their teens. Even the youngest therapist can become 'adult' through dress and behavior. Most persons over their early 20s do not have the 'look' that attracts the young male client. That does not mean that the female therapist will be let off without gross provocative, sexualized, remarks. Clay penises appear regularly on the art therapy table, and stories about sex and assault enter into the dialogue gratuitously. The anatomical dolls that I kept in the closet, were always in the 'position' to have sex. I began to have a fantasy that they really were attracted to one another. The girls

flirt with the male therapist non-stop, unless they are shy, then they think about it. The teen girl is more likely to groom herself for the therapist, and slow down the therapy by being either over-compliant or hostile, vulgar, and confrontational. Both genders can tax the therapist to the limit with their sexualized innuendoes and crude remarks. Testing, testing, hoping to get a antagonistic remark from the therapist that will confirm their stance that all adults are against them. There are many adolescents that do not use this mode of aggression, but it is common enough to be part of the concerns of working with adolescents.

There are many ways of dealing with this issue, but I would like to focus on the reactions of the therapist. Is it beyond reason to imagine that anyone of us might be attracted to one of our adolescent clients? I confess that pimples and baseball caps worn in reverse are not a turn-on for me. However, the raw energy and high levels of testosterone flying around the room does (at times) lead me into my own fantasy world. If this happens, the therapist of either sex does not have to be inappropriate in their actions with his/her teen clients. Perhaps any-thing about sex is a taboo subject that makes it hard to discuss with fellow clinicians. I think it is a subject that is well worth investigating. How these personal reflections are taken care of is one matter, the other primary issue that must be addressed is tolerance. The therapist must be comfortable with encountering sexualized behaviors, sexualized verbalizations, and sexualized images in the art therapy. Sex is on the teenager's mind, why would it not be in the therapy room? The adolescent tests the therapist in many ways, this is one of the most common. It amuses me when a youngster uses a four letter sex word to shock me, and I casually ask if that word means (for example) intercourse? The kid is often appalled that I am using a 'bad' word. Translating vulgar slang into proper English takes all the fun out of the encounter.

The therapist's method and attitude toward dealing with sexualized content and provocation, has a great deal to do with their own comfort and belief system about sex. Since sexuality is a part of our lives it is important to seriously consider how to handle it in the therapeutic encounter. The limits of your tolerance, the ways to normalize and

deflate the challenge from the teen, and how you incorporate some truth into the dangerous fantasies of the adolescent, is a primary issue of adolescent treatment. My observation is that when I became comfortable with exaggerated sexualized statements, I could respond in ways that did not irritate the youth and limited the testing.

The adolescent process stirs up many of our own unfinished issues of adolescence. How we responded to our own sexualization should be carefully considered. Keeping our own experiences out of the present relationship with the client is of primary importance.

'Bad parents'

There are many cases with adolescent clients where the parent is presented as a hurtful person, who has seriously damaged the child. If the teen is the client with whom the therapist spends the most time, s/he may easily be convinced of the veracity of this negative image. The best antidote is to bring into therapy this incredibly evil monster and make up your own mind. I find that a drawing task, with both child and parent together on the same page, is my best way of seeing the dyad in a fresh manner. The placement of the images, the verbal commands, the respect (or lack of) for each other's space, and finally the comments after the drawing is completed, are most useful. Many other behaviors can be observed that are unique to this relationship. The 'monster' may be a mouse.

Cases have been lost when the therapist relies solely on the story taken from one member of the family. We must hear all the narratives and respect each story as valid for that person. Only when we synthesize the various views and find how they were created, can we take a position. In defense of the adolescent's story; too often the teenager is not heard. The art expressions can make their views more visible and lead to greater understanding. Their art is often more expressive then their vocabulary.

How the therapist buys into the different aspects of the story about the parent–child relationship could very possibly be influenced by his/her own family system. This is not an original idea, but the subtle bias that moves us to focus more on one member of the family, and give

one person more time or more respect, could all arise from our personal experience. If one member of the family uses the art more fluently than the others, perhaps that taps into an unacknowledged identification with artistic ability. If the therapist has children, particularly adolescent children, there are a multitude of opportunities to find the waters muddied. It is a concern about which to be sensitive, to take to your therapist or trusted colleague. None of us are without fault when it comes to getting our own projections mixed up with the client's reality.

A problem that may make a therapist angry, is one where the adolescent plays the therapy against the family. The youth reports that 'the therapist says, '_____', you are wrong to make me come home early'. These remarks will eventually send the parent to the telephone to clarify why she or he is being made to be the bad guy. This puts the therapist in the awkward position of trying to explain away the teenager's manipulation without destroying the therapeutic relationship. The anger evoked by this ploy must be resolved before therapy can comfortably proceed. An open discussion of this dilemma with the adolescent may be the way to clear the tension. Again, consultation with other clinicians is the best recommendation.

Reporting to authorities: behaviors that place the client, or others, at risk

A mother came in to the clinic with her eleven-year-old son. He was oppositional, disliked going to school, and had an 'attitude'. She sat directly across the table from me and laid down her challenge. 'I whomp' my boy, and if you report me I am leaving and denying everything!! What to do with this statement? Shall I rush to the phone and call social services as she drags her kid out without any help? Will I lose my license if I don't? Shall I stay and see it through, and find out what she means by 'whomp'? Do I really want to know? All of these decisions can be defended and all can be right or wrong. I am really tangled up in my choices.

In these circumstances I believe that the therapist's trust in human nature is called into play. My belief system holds that most human beings are trying to do their best. However, 'best' is a variable that must

Figure 6.3 'In my face!' (or that's how it feels)

be individually weighed. I do not hesitate reporting abuse, I only fear doing it before I hear the story from the client(s), and can evaluate the circumstances. My client that 'whomped' used a woven belt of soft yarn. She put it in my hands as soon as I told her she had choices to make; give me time to present alternative ways of getting her child's attention or find treatment elsewhere. To clarify my decision I called the department of social services and asked them if this was reportable. I only asked for advice and did not have to give a name. They said it would be reportable if the child had bruises. He did not. I shared this with the mother.

By adolescence, the reporting is often more to protect the youth from violence and self-inflicted harm, than from parental threats. By mid and late adolescence the teen's physical growth has usually reduced all but the worst of bodily harm. The exception is teen girls who are

being sexually abused at home. That is easy to report but not to deal with. Another clear situation concerns youths who self-mutilate; they must be protected. The therapist must first deal with the behavior and then their own distress. Many actions of adolescents are outward signs of inward pain. The runaway from home; the wanna-be gang member, the promiscuous girl, are all flags of turmoil. How can we report internal states of despair?

Reporting has another aspect for the therapist. If we report then we become the 'bad guy' in the eyes of our clients. Most of us like to be liked, and most of us dislike losing a client. Both of these preferences are at risk when we bring in the outside authorities. It is not pleasant to be berated by a mother for 'betraying' her when she told about an abusive situation. I make every effort to remediate the relationship, but it is often not possible. I never report behind the client's back. No matter how angry they are I always invite them to stay in the room and present their side of the story to a protective services case worker. This method of sharing the crisis tempers the distress I feel about reporting. It also seems to help the client feel that, even though the circumstances are stressful, their story is respected.

I have experienced extreme frustration with parents who do not follow through on their adolescent's medication. The teen can wear a parent down with opposition, but to give up on this issue, is to me, close to criminal. An unmedicated bi-polar child will often fail in school and with peers, an unrecognized depression can lead to suicide, and many more clinical examples of the need for firm direction can be recalled. When a therapist sees neglect that can set the child on a downward spiral, it is hard to not obsess about how to step in beyond the therapeutic boundaries.

Suicide and avoidance

The threat of suicide would seem to be a situation that would move a therapist to immediate action. However, if the suicidal symptoms are covert the therapist may not want to engage in the emotional and case management commitment that it takes to deal with this most serious disturbance.

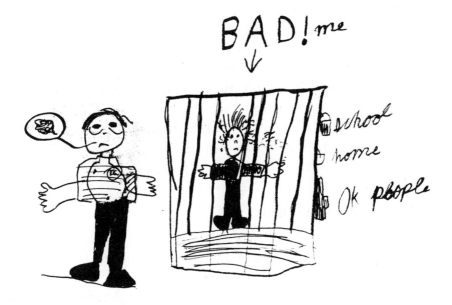

Figure 6.4 How I see myself: 'Locked up, bad, and the jailor is thinking bad thoughts about me'

Sugar (1980) addresses this issue:

in adolescent suicide I include not just the next of kin, but anyone involved in care-giving to the adolescent, and all of them may have biases or problems related to a suicide attempt. Perhaps the divergent notions about suicidal youngsters are based on anxious reactions, denial, and ambivalence. Treatment of suicidal patients is often anxiety-provoking or depressing, and it may require a particular type of fortitude and optimism by the therapist to continue in this endeavor. Perhaps in the course of training the therapist could decide whether s/he feels sufficiently empathetic to work with suicidal adolescents. (p.159)

The art therapist has another level of information to confront, the message which is conveyed in the artwork of the teen at risk. After the first recognition of the suicidal ideation in the imagery of despair, the therapist is constantly scanning every art product to be certain that no signs of immanent destruction are buried in the art. Many art therapists

have been extremely depressed when they have overlooked an indicator in a drawing that, after the fact, s/he sees might have been a revealing image. Accepting treatment for the suicidal adolescent is a heavy burden, and the art can often impact the therapist on a personal level that is haunting and traumatic. I suggest that projecting these client created images in self-created art can externalize the anxiety and make it available for control. The aftermath of unsuccessful treatment can evoke a multiplicity of reactions in the therapist, many related to personal loss, and others to fear of professional incompetence. This is a time when the therapist needs a therapist.

Tangled up in the client's art

Art therapists are usually very sensitive to visual images. As visual thinkers, they think through the pictures in their minds, they recall whole representations of situations, and they graphically solve problems in projected symbols. They are vulnerable to the artwork created by their clients. The drawings of abuse by a disassociative client or a child, can linger in his or her dreams. The violent images created by an adolescent can be incorporated into the visual memory bank of the therapist. Belligerent and aggressive marks can be carved into the art therapist's own visual knowing (Riley, 1997b).

Thinking visually is an advantage and a burden. Not only experiencing and dealing with the secondary trauma of the violent images, but intense envy of beautiful artwork that is tossed off by the irreverent teenager, may elicit strong reactions in those who think primarily in images. How many times I have been envious of the skill and spontaneity of the young artist who does not even recognize his or her talent. It is a challenge not to try to become the mentor of the talented artist client, instead of the therapist. When I have made the mistake of being too involved in hoping that the young person will take his or her art seriously, I have often failed at the task they asked me to help them with. The therapy became contaminated with other goals, namely mine.

Another art therapy difficulty lies in the unplanned revelation of personal issues that surface in the client's art. There are times that bringing this material to the client's awareness is helpful, other times it

is premature, and the therapist needs to hold back. How do we make that decision? There are no clear guidelines, and one or two hasty interpretations will seriously affect the therapist's choice. This indecision can be a personal dilemma for the therapist, and impact his or her confidence. Verbal therapy contends with 'slips of the tongue' and other free association revelations, and art therapy offers access to non-verbal revelations rather frequently. Most art therapists have set themselves guidelines as to when they feel comfortable bringing unconscious material to the client's attention. However, we are not always right, and this decision is a serious one to be weighed on each occasion. The choice is clouded if we are tangled up in other reactions to the adolescent client. Adolescents are usually very suspicious that the therapist is using their art to evaluate them and get too close. If their artwork is revealing of some situation they have chosen to repress, then it is a major decision to confront the adolescent with the therapist's notion of what the art has uncovered. Even more than with adults, timing and pacing is everything with an adolescent.

Media and materials

Media, the tools of the art therapist, can elicit mixed feelings in the art therapist. Deliberate destruction of my pens, pastels, and other materials, can stir irrational protective feelings, followed by resentment and anger. I place a high value on art material, and although I under-stand that my view is not one that is necessarily held by others, I still find that I 'rescue' my media when they are going to be demolished. There are times that I can tolerate these actions and others when I feel personally assaulted. I do not mean to imply that I am concerned when pastels break and pens get mashed by pressure when they are being used for expression. My heated reaction is when they are being broken to express hostility and aggression. When I observe this type of destruction I have to make a conscious, therapeutic, decision how to act, or I would instinctively pull the media back into safety. I think I over-react emotionally; I also know that I can contain my impulses and make choices about my interactions with the belligerent teenager. Recognition is important, control is essential. After discussing this

tendency at length in the proper setting, I even think I know why I am so protective. However, the feelings are still there and I must monitor them as I would any other reaction to my clients.

Some art therapists are in love with certain materials. They do not offer a wide variety of choices, and almost force their favorite media on the clients. Rather than fit the materials to the needs of the client, they follow an idea of their own. This is not a problem for other forms of therapy.

Every move and suggestion, every group of materials placed on the table in front of the clients, are significant to the therapy. To exclude any aspect of the art therapy transaction is to ignore how symbolic every aspect of the therapeutic relationship can be. The client scrutinizes the therapist, her words are filtered for subtle meaning, and the significance and symbolism of the art is viewed with suspicion. This holistic view of the art therapist's position should remain in the forefront of decision making regarding the relationship with the clients. Adolescents have a fine tuned antenna for the smallest details. Do not underestimate their sensitivity to all aspects of therapy.

Intrusion on the art therapist's private life

I offer here a group of reflections that I have heard from thoughtful clinicians who suffer in various ways over the position of their adolescent clients in our society. These concerns are serious enough for these clinicians to weigh heavily on them away from work.

One art therapist is frustrated seeing adults treat the adolescent in the family as a member with a lesser status and not valued as a person. She sees this situation projected in the artwork of the families with whom she works. Her concern is reinforced when we remind ourselves that the majority of teens are able to get through adolescence with relatively little distress for themselves and their families. Therefore, the families that anticipate adolescence as a slide into pathological behaviors, are asking for trouble. She feels that parents forget their own adolescence and project a negative image on all the adolescent's actions. It appears there is no escaping the disapproving judgement of the adult community. What seems even more defeating is the adult's lack of

Figure 6.5 Trapped by unresolved concerns

curiosity about the changes in their maturing child, and make the assumption that they already know all the answers to the adolescent's difficulties.

Another issue that elicits passion is an appreciation of how society is so physically and emotionally confining. The adolescent has no safe arena to explore, experiment, and be safely creative. This concern ties into the therapist's interest in the environment, and is exemplified when he/she observes that their adolescent clients have such a limited scope of freedom in a large urban area. They find that their professional and private lives often overlap, and that can be unsettling and tiring.

For another therapist, it is frustrating that many adolescents are reluctant to take responsibility for their share in the problems of their homes and relationships. 'It is always the other guy' who started the trouble, or the parent or teacher who did not understand. This issue stirs up powerful reactions in a therapist who was raised in a family where, as the oldest child, she was expected to care for her siblings, and support her depressed mother. She was taught to be super-responsible. Her

awareness of this entanglement, keeps her from acting out with her clients, but demands some of her emotional reserve not to do so.

Generally speaking I believe each therapist has an area in his/her history, or in their relationships, to which the client's problems and personality will resonate in a powerful manner. Clarifying these areas and examining how we can learn from these reactions is important. Countertransference is a label given to a human condition common to all relationships, in and out of therapy. How to turn these feelings and memories into a support for our adolescent clients is the goal that must be kept in mind. If we separate our commitment at work with our reactions from our private life, we will not be overwhelmed with anxiety when these feelings arise in an unexpectedly impactful way.

Final thoughts

I realize that I am closing this chapter by projecting on the reader judgemental qualities that evoke some of the embarrassment and anxiety that was mentioned above. I am concerned that I have 'exposed' my weaknesses and failures too openly. That my skills will be seen as inferior and that my colleagues would have much better solutions to some of my dilemmas than I have. This is natural, I tell myself. The process goes on. The awareness that is necessary in one part of one's life cannot be turned off completely in the other areas of existence.

There is no way to be a therapist and not have powerful relationships with your clients. It is even more unreasonable not to find working with an adolescent a trigger for all sorts of personal memories and reactions. For some of us, that is the attraction and excitement of working with this age group. Call it countertransference or call it entanglement, the label is immaterial. All our anxieties become worthwhile when we have the pleasure of encouraging the expressive adolescent art and supporting their journey into young adulthood.

Short-Term, Solution Focused, Art Therapy Treatment

Can I go now?

(The adolescent desire for treatment)

Figure 7.1 'The get-away' (16-year-old)

It is obvious that it is senseless to imagine that clients will respond to a therapeutic approach that they regard as an imposition. More than an imposition, the adolescent sees therapy as a form of torture inflicted by grown-ups on 'innocent' teenagers! The adolescent client is very clear about his/her opinion of therapy, particularly about the notion of

spending hours and months of their precious time discussing issues that are painfully private. A teenager finds it unnatural to be asked to talk intimately to a stranger. They feel forced into a situation that is an adult creation, one which has no helpful aspect. Faced with this adolescent concept of therapy the outcome of any treatment plan seems doomed from the start. To counteract this prediction of failure the therapist must first, pay attention to the reality that teenagers are usually 'made' to go into therapy by parents, the court or school system. Second, there must be some creative thinking about the adolescent therapeutic experience that will provide clinicians with some hope of success. The following chapter will explore the notion that the integration of art therapy with solution oriented, short-term treatment can raise the percentage of successful therapeutic outcomes with teens.

Introduction to a brief therapy approach

An action oriented therapy is not constructed on the premise that the client will benefit by dwelling on internal psychological processes through contemplative introspection. Instead, utilizing short-term art therapy, the adolescent will be engaged in creating externalized, visual illustrations and narratives that focus on strengths and the 'here and now'. Problem solving is accelerated when visual and verbal skills are combined. The term 'constructing' is used here in an abstract and a literal sense. The rationale and structure provided by theories of brief therapy support the hypothesis that success with this model is more than random good fortune (Cade and O'Hanlon, 1993). The validity of integrating art expressions and solution focused, narrative styles of problem solving is a sound concept.

The belief system of short-term therapists, and examples of how to synthesize these tenants with visual expression, will follow. A single case example will be explored to illustrate techniques and goals that can be achieved in this framework.

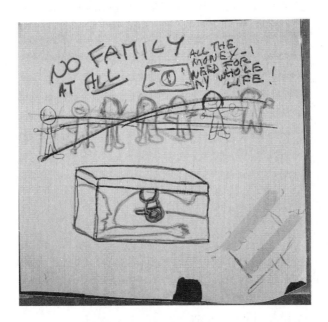

Figure 7.2 What would solve your problems? 'No family at all. All the money I need for my whole life. I am in a box' (seven adolescents in a melded family) (13-year-old girl)

Time limits

The demand for time limited therapy is a reality in the present day world of mental health, particularly for adolescent treatment. It is a painful reality for many therapists who equate brief therapy with bad therapy. However, there are therapists who have found to their surprise, that they were brief therapists before this term was a part of the popular lexicon. The adolescent client pressures the clinician to release him promptly, and the parents want the teen 'fixed' as soon as possible. These pressures can work on the side of success if they are translated into a commitment to accomplish stated goals.

Since the managed care system and government funded programs will pay only for a limited number of visits, it makes sense to become as expert as possible with this approach. Haley (1996) believes that this restriction is a blessing in disguise which has forced clinicians to look at their clients in a new way. For many persons the myth of therapy means

entering into a long-term therapeutic commitment, with tears and guilt the main experience on the way to 'insight'. The push from society has turned this notion around, most clients welcome time-limited treatment. Adolescents are sure that everyone else in the family needs to change, and the parents want relief from their misery as soon as possible.

However, no approach is right for everyone. The efficiency of any form of therapy is dependent on the population which it is designed to serve. Not all consumers of mental health services can benefit from brief, time limited therapy. Hospital, residential, and day treatment settings can use the solution-focused philosophy (deShazer, 1985; O'Hanlon and Weiner-Davis, 1988; Cade and O'Hanlon, 1993), and narrative therapies (White and Epston, 1990), in addition to their psycho/social and educational programs, but the time frame will differ depending on the needs of the client and the structure of the facility. Even in these settings for the more seriously disturbed person, there is pressure to help the client as rapidly as possible.

Philosophy of brief treatment

Clinicians dealing with adolescent youths, find the clients are generally anxious to achieve their goals and leave treatment promptly (Riley and Malchiodi, 1994). They are not interested in looking around, behind, or over the presenting problem. They want the problem addressed and their lives in order (Haley, 1995). This seems perfectly reasonable to many therapists, but not to others. Programs teaching the art of therapy have, until recently, emphasized the uncovering of the unconscious drives and repression (psycho-dynamic, object relations), or systemic interactions that evolve from family of origin which are the cause of present day behavior. The search was for pathology in the client's psyche, and 'insight' was the goal. With the more recent, post-modern theories the central theme is to de-pathologize the clients, and to construct therapy in a collaborative manner. O'Hanlon (1988) and deShazer (1985) are the most recognized proponents of solution focused therapy. White and Epston (1990) are the pioneers of the narrative school of therapy.

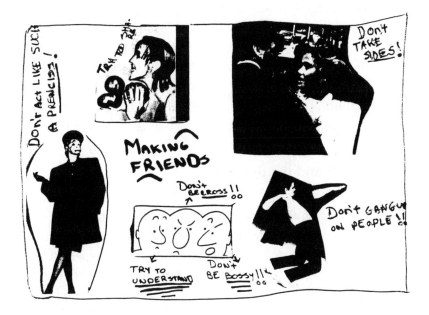

Figure 7.3 15-year-old girl solving social problems. 'Don't act like such a princess. Try to understand. Don't be cross. Don't be bossy. Don't gang upon people'

Case example

It is not too great a challenge to decide which approach is most likely to answer the demands of an angry mother who is fed up with her adolescent child's truancy from school. She wants a quick fix and to leave the clinic as soon as a therapist *makes* her fifteen-year-old son stay in school. In fact, if she doesn't get rapid answers, her kid will have to be expelled from school. If she remains at home to monitor his behavior she will be in jeopardy of losing her job. The parent is desperate. The adolescent is depressed and not easy to reach.

In this case there does not seem to be a plethora of unconscious processes at work, the crisis is in the here and now. The mother is clear that this is an emergency that endangers the family, the child, and threatens their financial stability. In this case, it seems that the therapist should adopt a solution focused approach to be responsive to the client's wishes. Time is limited, soon the school will act. It is of first

importance to devise a way to keep the family from disaster. For the therapist to ignore the crisis and focus on intrapsychic exploration would not make sense, and certainly would not please the client. In a case, such as described above, many therapists work toward pragmatic goals. They do not necessarily call themselves 'solution focused' or 'brief therapists', but the circumstances demand this approach. Perhaps their professional description does not include the term 'brief therapist'.

Belief system and the therapist

What type of therapist 'fits' this mode of therapy? A clinician who is not interested in pathologizing the client; believes that the client's immediate distress must be addressed; does not feel higher in status than his/her clients; and is dedicated to the notion that each person has the strength to achieve their goal. By projecting the attitude of confidence in their clients, the clients in turn are able to activate their coping skills, and with the therapist's help, solve the problem (Selekman, 1993; Cade and O'Hanlon, 1993). Moreover, therapists of this persuasion are attuned to the external environment that impacts their clients. They do not discount that many socio-economic situations create problematic psychological reactions. If these behaviors are seen out of context, they might be interpreted as a 'disorder'. To take a responsible position for instigating change, a therapist can present ideas and engage in certain dialogues, which will be discussed later in this chapter.

Contemporary therapies use an approach that takes the client into full awareness of the process. An open dialogue co-creates a therapeutic relationship that is appealing, particularly to adolescents, and energizes their participation. This cannot be accomplished if the client is seen as 'sick' or a walking DSM IV diagnosis. Selekman (1993) reports; 'In his plea for revamping the DSM-III-R, Wolin (1991) suggests that this volume should contain a listing of client's strengths as long and as technical as the diseases and disorders described within it' (p.21).

Multiple perspectives

The solution oriented therapist must be willing to accept the client's story about the problematic situation that brings him/her to therapy. In adolescent treatment the youth's view is often radically different than the adult's. Hearing this difference provides opportunity for the therapist to negotiate change. There are multiple perspectives to every narrative, and as these alternative stories are brought forth in the therapeutic conversation they alter the view of the problem (Anderson and Goolishian, 1988). If the clinician has the notion that he/she knows better than the client about the client's life, it will be counterproductive to treatment (Wolf, 1991). The contribution the therapist offers is his/her training to recognize when the client has overlooked a successful mode of problem-solving. As strengths are brought to the attention of the client, a new alternative to the problem script can be introduced (White and Epston, 1990).

Assessment-treatment guidelines

Cade and O'Hanlon (1993) offer a frame for an assessment evaluation that is followed by many solution focused, short-term therapists. This protocol does not provide radically new concepts, it is offered as an effective methodology and an approach to treatment; guidelines for the therapist. Some of the basic tenants of assessment have been extrapolated below:

When does the problem occur? Track down the pattern of the behaviors by looking for timing of the occurrence. Does it arise weekly, monthly, daily?

Where does the problem occur? Where does the problem occur and where does it not occur? Specifically identify the place, such as school, office, or home. Difficulties are often related to the environment in which they occur.

What is the performance of the problem? What are the clues to look for in gestures, words, sequence of actions, that would inform us it was happening?

With whom does the problem occur? Who is often around when this occurs? What do they say and do before, during, and after the behaviors

have occurred? This question helps to identify parent–child conflict versus peer-identity insecurity.

What are the exceptions to the rule of the problem? Since most problems do not occur all the time, it is useful to focus on the occasions when there were exceptions to the domination of the problem. Recall what happens when the problem is absent. How did all involved defeat the problem?

How does the problem change and/or restrict the client who is ruled by the problem? How does the problem interfere with activities the client would prefer to be doing? This is particularly important in view of adolescent development. Problems at adolescence often restrict maturation. Ask the Michael White 'Miracle Question' (White and Epston, 1990), 'If everything changed and the problem disappeared, what would you be doing differently?'

What are the client's explanations for the problem and is it demonstrated in the session? Listen to the client's language and speak through the metaphor. Communicate with words that are in harmony with their way of expressing themselves. Learn the adolescent vocabulary. Judgemental language can often impede any progress with teenage clients.

How will we know when the problem is licked? What will be different? How will we notice the difference? What will change in your life? What will take the place of the problem in your life? (pp.57–61).

Clearly these questions are not exploring the issue of blame; who is responsible and who should change; who's childhood or family system was the genesis of the problem. Instead the problem is externalized and presented as separate from the client. The symptom is seen as a piece of behavior that has gotten out of hand which can be mastered and contained by the therapist–client team (White and Epston, 1990). This is not to say that this is always an easy task. However, the chances for cooperation from the family or individual, and particularly an adolescent, are greatly enhanced if the 'problem' is depersonalized and no one is the bad guy. When a therapist takes a positive stance about the capacity and abilities of the client(s), hope is brought into the sessions. Since change is inevitable, it is with confidence that the therapist can share this notion. Most problems are referred to, by the clients, as a condition that has *always* been there. The most effective means of

countering this concept is to explore exceptions and invent transformations (Sluzki, 1992).

Reframing and alternate solutions

The reframe is the most powerful method of moving the repetitive patterning of behaviors to a new interpretation (Fisch *et al.*, 1982). Unwanted problems often start as a single unpleasant incident, one which subsequently is vigilantly guarded against. This fear justifies that extraordinary attention be paid to any signs of a reoccurrence of the difficulty. Since small negative behaviors are interpreted by the family to be generative of the 'problem', the problem grows in strength and becomes a part of the self-image of the problem bearer. When the conflict is seen through a different lens, it loses its familiar hold on the belief system of the client(s). There is no 'truth' concerning behaviors, there is only a constructed meaning which can be deconstructed. This process offers a dynamic opportunity to find new meaning in the actions.

Cade and O'Hanlon (1993) feel that it is important to differentiate two levels when describing reality. *Things and events* are limited to sensory-based observations and descriptions of what we perceive, or remember perceiving, through our various senses: what is happening, or has happened. *Meanings* are interpretations, conclusions, beliefs, and attributions that are derived from, imposed upon, or related to these perceived things and events (p.31). Accepting two views normalizes the contrasting interpretations of reality and adds flexibility to therapeutic thinking. It is important to remember when working with adolescents that their perceptions and their narratives often move between these two realities with the speed of light.

Case example continued

After listening to both mother's and adolescent's narrative of the problem, the mother is introduced to a new concept of reality by learning more about the reasons for her son's truancy. There is a positive reason why her son has stayed away from school. He wants to protect his mother from knowing about his failure in class. He attempts to

safeguard her from the stress he knows his poor performance in school will elicit. His solution is to avoid the problem by staying away from class. When she accepts this information she forms a revised perception of his behavior. The therapist then presents the notion; that since the son's way of solving the problem isn't working they both need to grapple with the monster 'truancy and failure'. A monster that has dominated their relationship. To reinforce a search for strengths, mother is encouraged to remember when her son succeeded in other situations. Through a conversation which confirms his past successes, she gains renewed faith. After she demonstrates her confidence in him, the boy feels less guilty and can talk to her about his distress that 'failing' has taken over his life.

The therapist might commend him for experimenting with the adult skill of dealing with 'failure'. However, it is pointed out, he still has a few years to go before his adult coping skills are capable of taking on such a heavy task. He probably would be less stressed if he delayed 'failing' and tried some measured success. In addition, he might choose to limit the experience of failing to areas of his life that will not affect his mother so adversely. A paradoxical intervention at this point, would recommend that he confine his failing behavior to 'failing' with his girlfriend and at his favorite sport. It is doubtful if he would embrace failing with his peers and conceivably decide to discard failing as a preferred coping mechanism (Fisch, et al., 1982).

Redefinition and positive intent

After provocative behaviors are redefined as the unsuccessful outcome of positive intentions, the behavior is seen as an attempt to solve a problem. Explanations that reveal positive intent can evoke a spirit of cooperation from other persons affected by the conduct (Haley, 1976). The lack of success may be the result of repetitive attempts to solve the problem in the same way (Fisch, et al., 1982). In this case, when the mother found time to consult with the school, she found that his scores on achievement tests were high and she had reason to be proud of his latent abilities. She could then take heart that he was capable of change and could put aside the negative opinion she had of her son. She also

found that he was being peer-pressured into joining a gang. He was avoiding school because he was afraid to refuse the gang invitation and was sure he was going to be beaten by gang members. Academic achievement was not supported by this anti-social group and giving up his options for college was part of his ambivalence. He would rather be playing truant than make up his mind. In therapy, the boy realized that if he made a choice for education, there were ways he could be protected from gang threats. As he illustrated his future through art making, he became aware that he could choose between alternate outcomes for his life script. No historical background was necessary for a positive outcome of this treatment. There was no pathology unearthed, and the therapist's assumption that an answer to their dilemma could be found was fulfilled (Cade and O'Hanlon, 1993).

Helpful techniques

Often the therapist is overwhelmed with the amount of difficulties that the client(s) bring into the initial sessions. It is a challenge not to feel inundated with all the ramifications of the problem-laden situation.

Figure 7.4 Behavioral contract with pre-adolescent boy

Brief therapists think small. They believe that a small successful change will motivate the client(s) to continue the process. The solution oriented therapist resists joining in the client's maelstrom of distress. To accomplish this goal the clinician listens carefully to the client's narrative and then asks him/her to choose a small issue which will be the first goal of therapy. The family may need some assistance with this task, however, they will soon realize that 'improving communications' is much harder to focus on than 'stopping Jr. from mouthing off at his sister'. Small victories can disrupt redundant patterns. Disorganizing a system produces an environment for change.

Selekman (1993), sees the brief therapist as an improvisational artist (p.144). By this he means that playful interpretations, humor, and spontaneity are all essential to the therapeutic process. He feels that therapy can be fun, be creative, and in a non-threatening manner introduce second level change. Since the notion of resistance is not useful, the therapist sees instead that the client is shy, anxious, or has other feelings that must be guarded against the intrusions of a stranger (the therapist). If the session is started with the comment 'What went right this week?', the optimistic view of the situation is projected. It is true that often the answer from an adolescent is 'Nothing', but even that is an opening, there has to be 'something' that was not nothing. An exploration can follow; how the exception to 'nothing' happened, when will the exception happen again, and how would it feel if 'something' took over 'nothing'? I am aware that this sounds like talking nonsense, but when the teenager hears this talk they translate it into the material they were guarding against, and make their own sense of this talk.

Similar to 'nothing' is the answer 'I don't know', probably the most common words uttered by adolescent clients. The best policy is to accept this as their truth, at this time, and speculate how difficult it must be 'not to know'. It makes sense to believe that a teenage youth really does not know how to answer, because her/his sense of her/himself and the world is in flux. He or she has many opinions but none that are absolute. Even, after the defenses go down and the therapist finds that the client 'does know' an answer, it is useful not to consider the first

response as a demonstration of resistance. Attempting to force any issue in therapy is a sure avenue to failure.

Talking to your clients about the therapy as a short-term opportunity to solve problems is also very helpful. The term 'short' is translated by the adolescent client to mean 'not so serious'. With the therapist as a team player rather than a superior wise man or woman, the possibility for a dialogue is greatly enhanced.

Art therapy short-term treatment with adolescents

There are many aspects of art therapy treatment that are in harmony with short-term treatment. The basic tenants are:

1 Art therapy is action oriented; it is controlled by the art maker. The product's meaning, as reported by the client, is respected and taken seriously by the therapist. The process is shared by client and clinician.

2 The therapist can enter into the world view of the client via their imagery. Metaphorical language is derived from the images in the art. Talking through the metaphor is non-threatening and since it is 'adolescent created' the narrative and dialogue in the session is enhanced.

3 A limited issue can be extracted from the larger picture by focusing on a small section of the art therapy created image. This focus becomes translated into a do-able focal point for change. The chosen issue can be cut away from the larger picture and remounted as the immediate goal. Selecting a small part of an image upon which to concentrate, mirrors the approach the therapist wishes to take in solution oriented therapy.

4 The 'truth' of the adolescent (and the parent(s)) is seen as well as heard. In the artwork his/her view is concrete, it is individual. The art is not a pathology, it is an expression. It follows that the art maker is not seen as a container of pathology.

5 The problem is naturally externalized because the art is a product that is external to the client. Viewing the problem from the distance of the artwork, acknowledges that the problem is 'outside' the problem-bearer.

6 The task of finding exception to the recurring patterns of behavior is demonstrated through an art task that provides information. The art illustrates the exception, where and when it occurred. In this manner transformation and change is demonstrated. Clients can visualize and render in an art piece, a time line or pattern of when the 'problem' occurs. They have created the opportunity to observe their own actions.

7 The individual's (or family's) artwork informs the therapist and helps assess the progress of treatment.

8 Art therapists are creative. They are drawn to the profession by their attraction to art as expression. Because of their creativity they are comfortable with an inventive approach to the sessions.

9 Artwork is a pleasurable activity (non-threatening if it is not interpreted by the therapist), and offers the clients a new approach to their problems which suggests new solutions. The atmosphere of 'play' can lighten the sessions for a teenage client.

10 Art therapists are convinced that art therapy shortens treatment, because of the reasons named above. An additional advantage is that the art is a concrete product that can be referred to over time. The richness of meanings seen in the image may be reinterpreted when reviewed with the therapist. Revisiting the art product, discovering significance previously ignored, mirrors the altered perceptions of the client. The revisions perceived in the artwork reflect the change in the client and demonstrate how problems can be transformed (Sluzki, 1992).

Case example continued

Returning to the case described earlier in this chapter the author will project a series of therapy sessions and how the art therapy expressions furthered the treatment goals.

This author has a strong bias about how the art therapist should encourage the client's expressive artwork. Many articles on art therapy will use the term 'directive' to indicate the therapist's request for the client to create a defined art product. I strongly disagree with imposing specific directives. I believe that if the therapist and the client have

formed a working relationship, based on mutual cooperation, the art will naturally become a parallel expression of the issue under discussion. The therapist will ask to 'see' the problem in a drawing, and by exploring the image together, observe its function in maintaining the unwanted behaviors. The artwork is used to illustrate the material discussed in therapy, and through the visual representation a variety of additional pieces of information and undiscovered issues can unfold. The art expression externalizes the problem physically, just as the problem is externalized verbally, and isolated from the person who has been seen as the problem. This methodology will be demonstrated in the following discussions of the case under consideration.

Introducing art therapy to the mother and adolescent

Following the recommended short-term therapy procedure, in the initial session the focus is on a single workable issue. The therapist might say: 'I have listened carefully to your distress about Tommy not going to school, and your fear that his behavior will cause you to lose your job. You seem to have many other stressful circumstances in your life at this time. Since we want to be effective as quickly as possible, would you each, please, pick from this collage box, *one* picture that reflects your view of the *single* most distressing aspect of this problem.' As they are rummaging through the collage box, casually remark: 'Different generations have different thoughts about problems, teenagers sometimes have really unusual solutions to offer.'

By asking the mother and son to choose a single picture of a single issue, an over abundance of material can be controlled. However, in spite of the attempt to limit the field, there is always the possibility that the client will choose a collage representation of an unmanageable issue, e.g., 'poor communication' or 'We never listen to one another'. The issue would be acknowledged by asking: 'Pick one time when you *were* heard, even if it was just for a few minutes.' This shifting of the focus from an unworkable global problem to a specific instance when the comm-unication improved, accomplishes two goals. The first goal directs the conversation away from the familiar negative complaints; the second

moves to a set of circumstances that can be used to illustrate strengths that have been overlooked.

Since each person is asked to project, in visual form, their own view of the problem, their opinion is both seen and heard. If the adolescent does no more than slap down a magazine picture, he or she has entered into a part of the therapeutic process. Silent communication is as powerful as words. Non-verbal communication with an image simultaneously serves the adolescent's refusal to talk and his/her need to control communication. The therapist may then ask the mother and son to explain their image while the other listens. If there is little offered verbally, still there has been a change. The pictures are witness to a message being sent, the challenge is acknowledging the message.

In this illustration, when the issue of communication was too general to be workable, the therapist did not try to redefine the confusion, instead, he/she asked 'when was there an exception to the problem?' This immediately infers that there have been times when they were problem free. To have experienced this problem-free time, indicates that skills exist to make it possible to reduce the crisis.

Demystifying the art in art therapy

Why is this seemingly simple activity of choosing a collage picture effective? From the beginning session it frames the process of using imagery to amplify verbal communication and it demystifies the use of art in art therapy. Clients are afraid of *art*; it reminds them of failures in school to please a teacher who requested a realistic rendition of an object or person. Collage is the least threatening media, one that offers many metaphorical possibilities (Landgarten, 1993). The client can project emotions, bend the meaning of the picture and find in it a personal representation. The act of creating even as simple a collage as the one requested above, forces the client to make choices, fit the choice into the context of the session, and select a single issue from complicated and overlapping problems. The image is unique and unfamiliar as communication, and therefore more likely to be listened to and instigate action. This task demonstrates how the therapist learns to 'think small', to believe that one move will necessarily lead to others,

and trust that patterns in the system that keep an undesirable behavior in place will be disrupted.

Continuing treatment

The sessions following are conducted in the same spirit of curiosity. After being attentive to the client's stories, the therapist asks the mother and son to draw a situation 'when the problem occurs and when it does not occur'. The following session they are requested to depict, 'where the problem occurs'. In every case the therapist encourages the family to look for the time when the unwanted behavior was absent, and who in the system seems to facilitate the patterns of retaining the behavior. The supporting cast can be included in graphic form without naming names or hurting feelings. The drawings convey their message silently and without confrontation.

Without pointing a judgemental finger, the therapist can reframe events in a manner that gives the behavior new meaning. A reframe can be extrapolated from the art; for example, when the mother draws a small child and a happy relationship, naming it 'memories of the past', material has surfaced that can reveal a measure of the conflict. The therapist can muse that perhaps she wishes she still had that sweet youngster, in place of the adolescent boy who is so hard to know. While the mother was unwittingly drawing a desire for her son to stay a little child, the boy draws an image of a man doing chores and watching TV. This rendition could lead to a discussion of how sons with absent fathers tend to take on the head of the household role and distance themselves from their earlier close relationship to mother. The son indicates that he is struggling to individuate; the mother longs for the young child who clung to her and satisfied her desire to be needed. Simple images can open up complicated issues.

The therapist focuses the next session on what service does the problem (truancy) serve? How would a man from outer space know by observation that the problem was happening? Depict that observation through a drawing. Each of the questions that the short-term therapist asks can be addressed through imagery, therefore an entire progression of therapeutic sessions can be laid out and referred to at any time. The

repetitive patterns that sustain the unwanted behavior become apparent by observing the art products. Throughout the therapy the imagery has provided the client and therapist with the advantage of being in an observant position. It is a rare opportunity for anyone to stand outside themselves and be a participant-observer.

A non-judgemental focus

At no time during the course of the therapy does the adolescent feel judged if the externalized behavior is the focus of the therapy, and not himself. What is being discussed is when, where, and how (not why), a set of circumstances arise in the family when the 'problem' is in charge (White and Epston, 1990). By re-evaluating behaviors they are understood in a new light. The motivation is revealed, and the positive functions highlighted. This process contests the notion that unhappiness is permanent; change will lead to a new outcome for the entrenched story of their relationship. The question; 'How would it be if you awoke tomorrow and the problem was gone? Who would know? How would you, your mother, act?' is a fast-forward question that opens

Figure 7.5 'How my mom treats my brother (left). How she treats me!'
Adolescent's reality (13-year-old girl)

up the function of the behavior and an opportunity to explore the problem free relationship. The query is more effective if it is translated into a dyadic drawing constructed by mother and son. Working together to create this piece, they are symbolically creating the reality of a cooperative, problem solving environment. Asking a dyad to actively engage in a non-threatening task together is a way of setting into motion, on a meta-level of awareness, the changes desired in the relationship (Belnick, 1993, pp.23–45).

If the therapist believes that all meaning is a construct, placed in the context of the client's world, s/he can convey this belief to the family or individual. Using the words of the family, their vocabulary, the client(s) comes to appreciate if they construct their realities, they can also deconstruct them. They are aware that this is parallel to control they have over creating a representation of their problem, and the choice of modifying that image. The notion of construction and deconstruction becomes an experience, not an abstract concept. This revelation often leads to a renewed sense of mastery and reinterpretation of the distress that brought them into therapy.

Summary

The principles and values of short-term therapy are precepts that give emphasis to wellness and hope. They are based on the conviction that the client has the ability to find new solutions to old problems. The technique of externalizing the problem and dealing with it as a separate force against which the client can rally is the antithesis of seeking pathology embedded in the personality. Believing that small change in the repetitive patterns can lead to greater change with larger issues is a concept understandable to clients. They regain hope from small victories. The therapist collaborates in that positive outcome and reinforces the client–therapist team attack on the 'problem'.

Art therapy as treatment, offers the client the opportunity to clearly observe the process of change. The action of the client to use media to modify his/her art product, models the notion that change and transformation is possible. The art is tangible and the illustrations created are observable and informative. Client and clinician looking at

the art together, listening to the narrative, create a collaborative relationship in the therapy.

Short-term therapy is not appropriate for clients who are in need of protective therapy to regulate severe mental illness, or patients who need extended help in supportive therapeutic environments, such as day treatment programs. Budman and Gurman (1988) review the conflicting opinions of professionals regarding the conditions under which brief therapy is considered to be effective. They describe brief therapy with personality disordered individuals as a possibility that can be helpful if there is an empathic therapeutic relationship established (pp.214–45). However, the basic beliefs we have discussed in this chapter can be practiced in these settings, particularly the philosophy of not seeing a person as a diagnosis. The problem-solving tenets are always modified for the needs of each population.

The introduction of art therapy shapes the practice of the solution focused treatment. Brief treatment influences the art expression. The use of art therapy in outpatient settings for disturbed youths and residential settings has been addressed in a previous chapter. Imagery is extremely helpful as a monitor of at-risk behaviors and psychological crisis.

Most outpatient clients are stressed by economic responsibilities and societal pressures in addition to the presenting problem. They are eager to solve problems and move on. Even if funding for mental health treatment was not restricted, most clients, particularly families and adolescents, want 'out' of therapy as soon as possible. Ask a teenager! There is a large body of practitioners, some mentioned above, who believe that short-term treatment is the treatment of choice. The philosophy of finding wellness and strength in clients engenders a positive professional environment for the practitioner. They share their optimism and affirmative outlook in treatment and are not unnerved by the changes that have been forced on them by the mental health system.

Social Constructionism
The Narrative Approach and Clinical Art Therapy[1]

This commentary presents a brief summary of some of the concepts of social constructionism and the narrative approach to treatment, and is offered as an overview for art therapists interested in incorporating this post-modern philosophy into their work. In the author's opinion, these concepts are useful for the majority of clients in treatment when the therapy of choice is solution focused. It is particularly relevant for art therapists when mental health services are focused on short-term treatment. When a problem is projected through the use of art expressions the client has the advantage of observing and reinventing a more favorable outcome for their life story. Metaphorical communication and second-level learning can be derived from the art and facilitate co-constructing the path of therapy for both client and therapist. A well-designed synthesis of narration and art expressions often results in an accelerated and successful conclusion of the therapeutic contract.

Social constructionism is defined by Lynn Hoffman (1992) in this manner: 'The social constructionist theorists see ideas, concepts and memories arising from social interchange and mediated through language. All knowledge evolves in the space between people, in the realm of the common world' (p.8). Epston *et al.* (1992) propose: 'the

"story" or "narrative" provides the dominant frame for the live experience and for the organization and patterning of the lived experience. Following this proposal, a story (narrative) can be defined as a unit of meaning that provides a frame for lived experience' (p.97). In addition to these concepts, of how we learn to know the world in which we live, how we construct our 'truths', the therapist accepts that they are in the relationship to learn from the client how *they* perceive the world and to offer observations within these concepts. Therapy becomes an exploration where the goal is to find a new outcome for an old non-productive story, a search that aims for co-constructing a more creative meaning to lived events.

Social constructionist philosophy and narrative view of treatment

When a therapist chooses to adopt a social constructionist philosophy and the narrative form of co-constructed treatment, the clinical interview will be conducted in a manner that promotes conversations that reflect the client's belief system. This philosophy becomes more than a theoretical approach; it is a basic belief system that permeates the therapist's thinking about all relationships. The self emerges from discourse. 'Individual experience cannot be separated from the contexts and conversations that give experience meaning and direction. Personal identity, be it gender, racial, sexual, based on age, or any other factor, is an activity, rather than a thing' (Gergen, 1985).

Congruent with this approach the therapist will expect each member of a family group to possess their own interpretation and experience of the shared events in their lives. Their experiences will be reported as a personal encounter. In response, the therapist takes a stance of curiosity, involved in the process, responsive but non-judgemental in the dialogue (Cecchin, 1987). During the course of understanding the narrative, the therapist reflects on the client's strengths and situations when problem-saturated behaviors or attitudes did *not* dominate the story. The guiding principle behind this approach is the therapist's positive belief that clients have overlooked their innate powers to solve problems. The clinician's role is to create together *with* the clients a new

perspective on their difficulties. As a team they reevaluate how the impact of socio-economic circumstances, as well as the client's or family's personal interpretations, have influenced the continuation of the distressful situation. The narrative approach uses the term 're-authoring' the dominant story. It focuses on finding alternate descriptions of events. The goal is to open up multiple opportunities for re-interpretation and invite the possibility of more satisfactory endings to situations that have been seen as immutable problems (O'Hanlon and Weiner-Davis, 1988).

This approach does not rule out using effective interventions developed under other systems theories, but it does require a radical shift in the position of the therapist. The therapist takes a second-order, observant view which requires him/her to be considered a part of the whole. Lynn Hoffman (1985) states, 'A second-order view means that the therapist include themselves as part of what must change; they do not stand outside [the system]' (p.5).

Inger and Inger (1992) express a similar view:

> As second-order therapists, we work as guests of families in a foreign domain. As guests, we behave in a respectful manner toward our hosts. This attitude of respect requires that we learn their language and meanings. It is, therefore, our job to discover those meanings and try to understand how they operate in the family. Meanings given to experiences depend upon the contexts within which they are experienced. Thus, our work with the family centers around understanding and inclusion [Buber, 1965, p.67] of both their dynamics and their contexts. Inclusion and understanding are processes in which one acknowledges the legitimacy of the position of the 'other' but does not necessarily endorse their position. (p.2)

Constructivism and social constructionism

There exists an on-going misuse of the terms 'constructivism' and 'social constructionism'. Both theories espouse the belief that there is no absolute reality in our world that can be unconditionally known with objective certainty. The constructivist view promotes a vision of the nervous system as a closed mechanism against which events impact. The social constructionism approach to treatment includes the word 'social',

which invites the notion that the world, as we each know it (invent it), is impacted by the social environment of our lives and understood through our use of language. The language is itself has an influence on the interpretations of the events. Only through conversation can we establish a mutual ground for exchanging knowledge and sharing divergent world views. Social constructionism is an open system. Without the inclusion of the impact of the outside (social) world on our constructs of reality, I believe we could not responsibly treat the clinical issues of race, culture, gender, and socio-economic stress. These topics shape our knowing and impact the therapeutic conversation in ways that are unique to each situation.

Fruggeri (1992) sees socially constructed therapy in this manner: 'Psychotherapy emerges here as a communication process in which the different partners construct the reciprocal roles and together construct an interpersonal context within a consensual domain. The definition of knowledge as a definition of discovery is dismissed. The viewing of psychotherapeutic practice dissolves.' In further discussing her entree into the client relationship she reports that she asks the question; 'How do you *see* the situation?' This inquiry implies action and contributes to the recognition that this will be an interview constructed by both parties involved (pp.45–6). *The verb 'see' invites the art therapy contribution to the interview through the concrete expression. Action and recognition are embedded in the art therapy process.*

Hoffman (1993) discusses her move toward accepting this philosophy of practice:

> I began to take more seriously the use of what I call 'associative forms'. If one is trying to break loose from a problem solving approach the content of the interview becomes different as well as the style. The reason for using metaphor is not because they help you in insert suggestions into the unconscious of a client, but because metaphor hardly ever implies that people are doing something wrong. Advice or problem solving almost always does. (pp.113–14)

The use of metaphor is a basic tool in the practice of art therapy.

The narrative approach

Two excerpts from *Narrative Means to Therapeutic Ends* (White and Epston, 1990), give a framework for the narrative belief system:

> A case has been made for the notions that persons are rich in lived experience, that only a fraction of this experience can be storied and expressed at any one time, and that a great deal of lived experience inevitably falls outside the dominant stories about the lives and relationships of persons. Those aspects of lived experiences that fall outside of the dominant story provide a rich and fertile source for the generation, or re-generation, of alternative stories. (p.15)

Later he continues, 'The re-storying of experience necessitates the active involvement of persons in the reorganization of their experiences, in the free recombination of the factors of culture into any and every possible pattern' (p.18).

Looking at the client's problem as external to their person, reinforces the concept that the problem is *not* the client. Seeing the problem as the *problem*, and organizing the individual and family as a team to combat the problem, is the key to depathologizing the diagnostic assessment and therapeutic relationship. In other words, behaviors are not embedded in a personality, the problematic behaviors can be seen distinct from the person performing them.

Moral and ethical responsibility

The question often arises whether it is possible for the therapist to remain neutral and non-judgemental if there are issues of violence or abuse in the narrative presented in therapy. Clearly therapists are obligated to let authorities know when there has been harm or abuse inflicted on another person. The therapist informs the client from the beginning that they do not judge, but they are responsible. The clinician dialogues with the clients regarding his or her ethical stance on the injustice of unbalanced power which, for example, is demonstrated in cases of domestic violence and sexual abuse of children. The more power a person has, the less excuse they have to deny responsibility in abusive situations. However, in the course of treatment the opportunity

to see more than one aspect of the perpetrator's character can be helpful. Recognition of the complexity of a personality does *not* excuse the abuser, and gives some dignity to those persons who cared for him or her in the past or present. An example of this dual approach is presented by Sheinberg (1992) when discussing treatment of families who have experienced incest. Rather than looking at the situation either through the feminist lens of unequal power or the social constructionist perspective, she transforms the impasses into an 'either/or' new order of meaning.

> The position can be summarized as follows: although therapy is nonhierarchical, the therapist is responsible. While I am unequivocal in the belief that people who sexually abuse others are responsible for their actions, I believe unacceptable behavior must be seen as a partial description of the person. I am always alert to other, positive descriptions of the person that can modify and complement my understanding. (p.203)

She goes on to describe:

> In navigating conflicted loyalties [in a family] I have found developing multiple perspectives allows the therapist and the family to acknowledge incest without feeling that their future is necessarily threatened. I conceptualize the abuse as one aspect of the family story, which I name their 'shameful story', suggesting that other aspects of the family may coexist. (p.206)

Sheinberg also involves the family in the process of reporting the abuse to the authorities by having them co-author the letter or phone call to the authorities, which gives them a voice in how the 'shameful story' is presented. I have used this plan for many years and found it often made the difference between a family feeling betrayed by the system or supported through a crisis which allowed them to stay in treatment. This approach can be called an integrated morality in which care and justice operate to protect children and can be woven throughout treatment (p.215).

Art therapy as a social construction

It has become increasing apparent to me that the way clinical art therapy operates depends first, on the attitude and convictions of the therapist, and second, on the impact of the visual product on the dialogue in the session. If the art therapist relinquishes the notion that she or he must set the goals and lead the family or individual toward preselected solutions, their art expressions and their meaning dominate the direction of therapy (Anderson and Goolishian, 1988). The art therapist offers media, the opportunity, and facilitates visual expression; the client chooses the focus, the subject, and the meaning of the art product. Exploration of 'externalized' visual expressions give therapists and clients a common ground on which to establish a mutual exploratory view of each circumstance as it is revealed. As the client(s) and the therapist reflect on the situation, the therapist can offer a variety of alternate meanings which have been revealed but overlooked in the narrative. This does not imply that the therapist's meaning is 'correct', but emphasizes that there are multiple meanings to any event in our lives. The therapist does not relinquish responsibility; on the contrary she or he works conscientiously with the clients as they endeavor to find their solution.

Art therapists have been using the art expressions of families and individuals as illustrations of their stories since the beginning of our profession. The concept of an individually created reality is not a new idea. The difference that I see as important is the adoption of a therapeutic stance that does not search for pathology in the art, does not interpret the content of the product separate from the context of the client feedback, and in particular, does not give the clients or families structured directives based on the art therapist's needs for specific predetermined outcomes. When the therapist allows clients to lead the way, clients will inform the therapist which unique theoretical approach reflects their world view. This approach provides the freedom to re-story their dominant view of the problem-saturated situation through use of the art therapy process, and creatively eliminate or reinterpret the family's perceptions that were previously regarded as immutable difficulties. In this manner, the art creation gives the 'sight'

that is necessary to both the observer and the observer-participant in the therapeutic relationship. The art product is a concept of the art maker and must not be judged. It stands alone in its world. It is not right or wrong; it simply is. If the therapist and family meets the art in this manner the shift in perspective is established. The meaning of the art is shared through social exchange, and the conversation around the art generates a multiplicity of conversations leading to new outcomes for clients (Riley and Malchiodi, 1994).

If we recall one of the favorite concepts used in psychotherapy, we think of how the notion of 'insight' has been a primary requisite for the advance of the client's 'recovery'. How much more positive is the notion that co-constructing an 'out-sight' of the difficulties can be accomplished through viewing an externalized creative product. It is not unusual for the observation and discussion which follows the art therapy process to result in self-discovery (or insight). Rather than waiting for 'insight' to prompt change, the action of reconstructing a solution visually may be the needed catalyst for change. A creative product can facilitate a client-created focus toward a desired outcome by inventing a reality that is more satisfactory to the family or individual. Art therapy makes the evolution of the therapeutic process a visible event shared and respected by the creators and the therapist-observer.

Summary

Combining the philosophy of the narrative-social constructionist view with the practice of art therapy is a position that is inclusive, not exclusive. Recent literature has featured articles that focus on integrating theories: psychoanalytical, systemic, behavioral, and more. Many modes of conducting therapy can be incorporated into art therapy sessions as well; however, client-created art remains the key to the effective co-created outcome of therapy. The social constructionist, narrative methodology is dialogical and focuses on the many aspects of the client's abilities rather than searching for pathology or dysfunction. The therapy does not judge the methods the clients have used to solve their problems. The therapist forms an alliance of equality in which her

or his training as an expert is shared with the clients' expertise in their own lives. The outcome is tailored to the individual client or family and to no other. Art expressions clarify the problems by inviting a narrative, solution focused approach, and makes material visually available as an aid in the process. The art therapist encourages the client to experimentally change the product, which, in turn, metaphorically suggests new resolutions to old scripts.

References

Adler, G. (1982) 'Helplessness in the helper'. In P.C. Giovacchini and L.B. Boyers (eds) *Technical Factors in the Treatment of the Severely Disturbed Patient.* Northvale, NJ: Jason Aronson.

Alexandris, A. and Vaslamatzis, G. (1993) *Countertransference: Theory, techniques, teaching.* London: Karnac Books.

Anderson, H. and Goolishian, H. (1988) 'Human systems as linguistic systems: Evolving ideas about the implications for theory and practice'. *Family Process,* 27, 317–93.

Anderson, H. and Goolishian, H.A. (1992) 'Strategy and intervention versus nonintervention: A matter of theory?' *Journal of Marital and Family Therapy,* 18, 5–15.

Belnick, J. (1993) 'A crisis intervention model for family art therapy'. In D. Linesch (ed) *Art Therapy with Families in Crisis.* New York: Brunner/Mazel.

Berkovitz, I.H. (1972) *Adolescents Grow in Groups.* New York: Brunner/Mazel.

Blau, G.M. and Gullotta, T.P. (1996) *Adolescent Dysfunctional Behavior: Causes, Interventions, and Prevention.* Thousand Oaks: Sage Publications.

Bloch, H.S. (1995) *Adolescent Development, Psychopathology, and Treatment.* New York: International Universities Press.

Blos, P. (1962) *On Adolescence.* New York: The Free Press.

Blos, P. (1979) *The Adolescent Passage.* New York: International Universities Press.

Buber, M. (1965) *Between Man and Man.* New York: Macmillan.

Buck, J.N. (1948) 'The H-T-P test'. *Journal of Clinical Psychology,* 4, 151–59.

Budman, S.H. and Gurman, A.S. (1988) *Theory and Practice of Brief Therapy.* New York: Guilford.

Burns, R.C. and Kaufman, S.H. (1970) *Kinetic Family Drawings (K-F-D): An Introduction to Understanding Children through Kinetic Drawings.* New York: Brunner/Mazel.

Butz, M.R., Chamberlain, L.L. and McCown, W.G. (1997) *Chaos, Complexity, and the Art of Family Therapy.* New York: John Wiley and Sons.

Byng-Hall, J. (1995) *Rewriting Family Scripts: Improvisation and Systems Change.* New York: Guilford Press.

Cade, B. and O'Hanlon, W.H. (1993) *A Brief Guide to Brief Therapy.* New York: W.W.Norton.

Campbell, C. (1990) 'Art therapy with a masochistic adolescent'. *Pratt Institute Creative Arts Therapy Review*, 11, 1–2.

Cecchin, G. (1987) 'Hypothesizing circularity, and neutrality revisited: An invitation to curiosity'. *Family Process*, 26, 4: 405.

Cecchin, G., Lane, G. and Ray, W.A. (1994) *The Cybernetics of Prejudices in the Practice of Psychotherapy*. London: Karnac Books.

Cobb, C.L.H. (1996) 'Adolescent-parent attachment and family problem-solving styles'. *Family Process*, 35, 1: 57–82.

Conger, D. (1989) 'Suicidal youth: The challenge to art therapy'. *American Journal of Art Therapy*, 27, 34–44.

Cox, K. (1990) 'Breaking through: Incident drawings with adolescent substance abusers'. *The Arts in Psychotherapy*, 17: 333–7.

Cyrtryn, I. and McKnew, D.H. (1996) *Growing up Sad*. New York: W.W. Norton.

deShazer, S. (1982) *Brief Family Therapy: An Ecosystemic Approach*. New York: Guilford.

deShazer, S. (1985) *Keys to Solution in Brief Therapy*. New York: W.W. Norton.

DiLeo, J.H. (1974) *Children's Drawings as Diagnostic Aids*. New York: Brunner/Mazel.

Epstein, L. and Feiner, A.H. (1983) *Countertransference*. New York: Jason Aronson.

Epston, D., White, M. and Murray, K. (1992) 'A proposal for re-authoring therapy: Rose's revisioning of her life and a commentary'. In S. McNamme and K. Gergen (eds) *Therapy as a Social construction*. Newbury Park, CA: Sage Publications.

Erikson, E.H. (1968) *Identity, Youth, and Crisis*. New York: Norton.

Fisch, R., Weakland, J. and Segal, L. (1982) *The Tactics of Change: Doing Therapy Briefly*. San Francisco: Jossey-Bass.

Fishman. H.C. (1988) *Treating Troubled Adolescents*. New York: Basic Books.

Friedman, A.S. and Glickman, N.W. (1986) 'Program characteristics for successful treatment of adolescent drug abuse'. *Journal of Nervous and Mental Diseases*, 174, 11: 669–78.

Friedman, S. (ed) (1993) *The New Language of Change: Constructive Collaboration in Psychotherapy*. New York: Guilford.

Fruggeri, L. (1992) 'Therapeutic process as the social construction of change'. In S. McNamee and K. Gergen (eds) *Therapy as Social Construction*. Newbury Park, CA: Sage Publications.

Gergen, K. (1991) *The Saturated Self*. New York: Basic Books.

Gergen, K.J. (1985) 'The social constructionist movement in modern psychology'. *American Psychologist*, 40, 266–75.

Gilligan, C. (1982) *In a Different Voice. Psychological Theory and Women's Development*. Cambridge, MA: Harvard University Press.

Gilligan, C., Rogers, A.G. and Tolman, D.L. (1991) *Women, Girls and Psychotherapy*. New York: The Hayworth Press.

Giovacchini, P.L. (1985) 'Countertransference and the severely disturbed adolescent'. In S.C. Fienstein, M. Sugar *et al.* (eds) *Adolescent Psychiatry: Developmental and Clinical Studies*. Chicago: University of Chicago Press.

Gleick, J. (1987) *Chaos: Making a New Science*. New York: Viking-Penguin.

Goldner, V., Penn, P., Sheinberg, M. and Walker, G. (1990) 'Love and violence: Gender paradoxes in volatile attachments'. *Family Process*, 29, 4: 343–64.

Gullotta, T.P., Noyes, L. and Blau, G.M. (1996) 'School-based Health and Social Service Centers'. In G.M. Blau and T.P. Gullotta (eds) *Adolescent Dysfunctional Behavior*. Thousand Oaks: Sage Publications.

Haley, J. (1976) *Problem Solving Therapy*. San Francisco: Jossey-Boss.

Haley, J. (1980) *Leaving Home: The Therapy of Disturbed Young People*. San Francisco: Jossey-Bass.

Haley, J. (1996) *Learning and Teaching Therapy*. New York: Guilford.

Hardy, K. (1996) 'Breathing room'. *Family Therapy Networker*, 20, 3: 52–61.

Herbst, K. and Paykel, E.S. (1989) *Depression; An Integrative Approach*. Oxford: Heinman Professional Publishing.

Hiscox, A. (1993) 'Clinical art therapy with adolescents of color'. In E. Virshup (ed) *California Art Therapy Trends*. Chicago, IL: Magnolia Street Publishers.

Hoffman, L. (1985) 'Beyond power and control; Toward a "second order" family systems therapy'. *Family Systems Medicine*, 3: 381–96.

Hoffman, L. (1990) 'Constructing realities; An art of lenses'. *Family Process*, 29: 1–29.

Hoffman, L. (1992) 'A reflective stance for family therapists'. In S. McNamee and K. Gergen (eds) *Therapy as a Social Construction*. Newbury Park, CA: Sage Publications.

Hoffman, L. (1993) *Exchanging Voices: A Collaborative Approach to Family Therapy*. London: Karnac Books.

Inger, I.B. and Inger, J. (1992) *Co-constructing Therapeutic Conversations*. London, New York: Karnac Books.

Johnson, D. (1987) 'The role of the creative arts therapies in the diagnosis and treatment of psychological trauma'. *The Arts in Psychotherapy*, 14: 7–13.

Kaslow, N.J. and Racusin, G.R. (1990) 'Depressed children and their families: An integrationist approach'. In. F.W. Kaslow (ed) *Voices in Family Psychology*. Newbury Park: Sage Publications.

Kellogg, R. (1970) *Analyzing Children's Art*. Palo Alto, CA: National Press Books.

Kopelwitz, H.S., Klass, E. and Kafantaris, V. (1993) 'The psychopharmacology of childhood and adolescence'. In H.S. Kopelwitz and E. Klass (eds) *Depression in Children and Adolescents*. Switzerland: Harwood Academic Publishers.

Kottler, J. (1992) *Compassionate Therapy: Working with Difficult Clients*. San Francisco: Jossey Bass.

L'Abate, L. (1986) *Systemic Family Therapy*. New York: Brunner/Mazel.

Landgarten, H. (1981) *Clinical Art Therapy: A Comprehensive Guide*. New York: Brunner/Mazel.

Landgarten, H. (1993) *Magazine Photo Collage: A Multicultural Assessment and Treatment Technique*. New York: Brunner/Mazel.

Larose, M. (1987) 'The use of art therapy with juvenile delinquents to enhance self-image'. *Art Therapy Journal of American Association of Art Therapy*, 4: 99.

Leveton, E. (1984) *Adolescent Crisis*. New York: Springer Publishing Company.

Linesch, D. (1988) *Adolescent Art Therapy*. New York: Brunner/Mazel.

Lowenfeld, V. and Brittain, W. (1982) *Creative and Mental Growth*. 7th. edition. New York: McMillan.

Malchiodi, C. (1990, 1997) *Breaking the Silence: Art Therapy with Children from Violent Homes*. New York: Brunner/Mazel.

Malchiodi, C. (1998) *Understanding Children's Art*. New York: Guilford.

Malmquist, C.P. (1978) *Handbook of Adolescence*. New York: Jason Aronson.

McCown, W.G. and Johnson, J. *et al.* (1993) *Therapy with Treatment Resistant Families*. New York: Hayworth Press.

Minuchin, S. and Fishman, H.C. (1981) *Family Therapy Techniques*. Cambridge, MA: Harvard University Press.

Mirkin, M. and Koman, S. (1985) *Adolescents and Family Therapy*. New York: Gardner Press.

Mishine, J. (1986) *Clinical Work with Adolescents*. New York: The Free Press.

O'Hanlon, W.H. and Weiner-Davis, M. (1988) *In Search of Solutions: A New Direction in Psychotherapy*. New York: W.W.Norton.

Oster, G.D. and Caro, J.E. (1990) *Understanding and Treating Depressed Adolescents and their Families*. New York: John Wiley and Sons.

Oster, G.D. and Gould, P. (1987) *Using Drawings in Assessment and Therapy*. New York: Brunner/Mazel.

Parry-Jones, W.L. (1989) 'Depression in adolescence'. In K. Herbst and E.S. Paykel (eds) *Depression: An Integrated Approach*. Oxford: Heinemann Professional Publishing.

Pipher, M. (1994) *Reviving Ophelia: Saving the Lives of Adolescent Girls*. New York: Ballentine Books.

Raymer, M. and McIntyre, B. (1987) 'An art support group for bereaved children and adolescents'. *Art Therapy, Journal of the American Art Therapy Association*, 4: 27.

Riley, S. (1988) 'Adolescents and family art therapy.' *Journal of American Art Therapy Association*, 5, 2: 43–8.

Riley, S. (1992) 'Art therapy with families who have experienced domestic violence'. In E. Virshup (ed) *California Trends in Art Therapy*. Chicago: Magnolia Street Publisher.

Riley, S. (1993) 'Rethinking outpatient adolescent group art therapy treatment'. In E. Virshup (ed) *California Art Therapy Trends*. Chicago: Magnolia Street Publishers.

Riley, S. (1997a) 'Conflicts in treatment, issues of liberation, connection, and culture: Art therapy for women and their families'. *Art Therapy: Journal of the American Art Therapy Association*, 14, 2: 102–8.

Riley, S. (1997b) 'An art psychotherapy stress reduction group for therapists dealing with a severely abused population'. *The Arts in Psychotherapy, 23*, 5: 407–415.

Riley, S. and Malchiodi, C. (1994) *Integrative Approaches to Family Art Therapy*. Chicago: Magnolia Street Publishers.

Riley, S., Newborn, M., Taksumi, Y. and Walter, J. (1992) 'Art captures the impact of the Los Angeles crisis'. *Art Therapy: Journal of the American Art Therapy Association, 9*, 3: 139–144.

Rinsley, D.B. (1980) *Treatment of the Severely Disturbed Adolescent*. New York: Jason Aronson.

Rutter, M. and Rutter, M. (1993) *Developing Minds: Challenge and Continuity Across the Life Span*. New York: Basic Books.

Sandmier, M. (1996) 'More than love'. *The Family Therapy Networker*, 20–2.

Satir, V. (1967) *Conjoint Family Therapy: A Guide to Theory and Technique*. Palo Alto, CA: Science and Bahavioral Books.

Schneider, S., Ostroff, S. and Legrow, N. (1990) 'Enhancement of body image: A structured art therapy group with adolescents'. *Art Therapy; The Journal of the American Art Therapy Association*, 7: 134–8.

Seibt, T.H. (1996). 'Nontraditional families.' In M. Harway (ed). *Treating the Changing Family*. New York: John Wiley & Sons.

Selekman, M.D. (1993) *Pathways to Change: Brief Therapy Solutions with Difficult Adolescents*. New York: Guilford.

Selvini-Palazzoli, M., Boscolo, L., Checchin, G. and Prata, G. (1978) *Paradox and Counterparadox, a New Model in the Therapy of the Family in Schizophrenic Transaction*. New Jersey: Jason Aronson.

Sgroi, S. (ed) (1988) *Handbook of Clinical Intervention in Child Sexual Abuse*. Lexington, MA: Lexington Books.

Sheinberg, M. (1992) 'Navigating treatment impasses at the disclosure of incest: Combining ideas from feminism and social construction'. *Family Process*, 31: 201–16.

Silver, R.A. (1988) 'Screening children and adolescents for depression through Draw-A-Story'. *American Journal of Art Therapy*, 26: 119–24.

Silver, R.A. (1989) *Stimulus Drawings and Techniques: In Therapy Development and Assessment.* Sarasota, FL: Ablin.

Sims, P.A. and Whynot, C.A. (1997) 'Hearing metaphor: An approach to working with family-generated metaphor'. *Family Process*, 36, 4: 341–56.

Sluzki, C.E. (1992) 'Transformations: A blueprint for narrative changes in therapy'. *Family Process*, 31: 217–30.

Smolowe, J. (1993) 'Choose your Poison.' *Time Magazine*, New York: Time Inc., 142, 4: 56.

Sommers-Flanagan, J. and Sommers-Flanagan, R. (1997) *Tough Kids, Cool Counseling: User-Friendly Approaches with Challenged Youth.* Alexandria, VA: American Counseling Association.

Spietz, A.M. (1990) 'Treating adolescent satanism in art therapy'. *The Arts in Psychotherapy.*

Stierlin, H. (1981) *Separating Parents and Adolescents.* New York: Jason Aronson.

Strand, P.S. (1997) 'Toward a developmentally informed narrative therapy'. *Family Process*, 36, 4: 325–40.

Sugar, M. (1980) *Responding to Adolescent Needs.* New York: SP Medical and Scientific Books.

Toolan, J.M. (1969) 'Depression in children and adolescents'. In G. Caplan and S. Lebovici (eds) *Adolescence: Psychosocial Perspectives.* New York: Basic Books.

True, F. and Kaplan, L. (1993) 'Depression within the family: A systems perspective'. In H.S. Kopelwicz and E. Klass (eds) *Depression in Children and Adolescents.* 45-54. Switzerland: Harwood Academic Publishers.

Watzlawick, P. (1984) *The Invented Reality.* New York: W.W. Norton.

Watzlawick, P., Beavin, J. and Jackson, D.D. (1967) *Pragmatics of Human Communication.* New York: W.W. Norton.

Weeks, G. and L'Abate, L. (1982) *Paradoxical Psychotherapy.* New York: Brunner/Mazel.

White, M. and Epston, D. (1990) *Narrative Means to Therapeutic Ends.* New York: W.W. Norton.

Wilkes, T.C. R., Belsher, G., Rush, A.J. and Frank, E. (1994) *Cognitive Therapy for Depressed Adolescents.* New York: The Guilford Press.

Wolf, A.E. (1991) *Get Out of My Life; But First Could You Drive Me and Cheryl to the Mall?* New York: The Noonday Press.

Wolin, S. (1991) 'The challenge model: How children rise above adversity'. In M.D. Selekman (ed) (1993) *Pathways to Change: Brief Therapy Solutions with Difficult Adolescents.* New York: Guilford.

Wylie, M.S. (1998) 'Public enemies'. In *The Networker: Psychotherapy and Modern Life.* Washington, DC: The Family Therapy Networker. 22, 3: 25–37.

Yalom, I.D. (1995) *The Theory and Practice of Group Psychotherapy.* New York: Basic
 Books.

Further Reading

Allen, J. (1988) 'Serial drawing: A junior approach with children'. In C. Schaefer (ed) *Innovative Interventions in Child and Adolescent Therapy*. New York: John Wiley and Sons.

Amodeo, M. and Drouilhet, A. (1992) 'Substance abusing adolescents'. In J.R. Brandell (ed) *Countertransference in Psychotherapy with Children and Adolescents*. New Jersey: Jason Aronson.

Breunlin, D. and Cade, B. (1981) 'Intervening in family systems with observer messages'. *Journal of Marital and Family Therapy*, 453–60.

Brzezinski, Z. (1993) *Out of Control: Global Turmoil on the Eve of the Twenty-First Century*. New York: Charles Scribner Books.

Dickerson, V. and Zimmerman, J. (1992) 'Families with adolescents: Escaping problem lifestyles'. *Family Process*, 31, 34.

Dickman, S.B., Dunn, J.E. and Wolf, A.W. (1996) 'The use of art therapy as a predictor of relapse in chemical dependency treatment'. *Art Therapy: Journal of the American Art Therapy Association*, 13, 4: 232–7.

Emunah, R. (1990) 'Expression and expansion in adolescence: The significance of creative arts therapy'. *Arts in Psychotherapy*, 17, 2: 101–7.

Feen-Calligan, H. (1995) 'The use of art therapy in treatment programs to promote spiritual recovery from addition'. *Art Therapy: The Journal of the American Art Therapy Association*, 12, 1: 46–50.

Finkelhor, D., Gelles, R., Hotaling G. and Straus M. (eds) (1983) *The Dark Side of Families*. Thousand Oaks: Sage Publications.

Freeman, J., Epston, D. and Lobovits, D. (1997) *Playful Approaches to Serious Problems: Narrative Therapy with Children and their Families*. New York: W.W. Norton.

Gardiner, J. (1995) 'Not asking for the moon, just a bedsit'. *Times Educational Supplement*, October, 20, 4.

Haeseler, M.P. (1996) 'The absent father: Gender identity considerations for art therapists working with adolescent boys'. *Art Therapy: Journal of the American Art Therapy Association*, 13, 4: 275–81.

Haka-Iske, K. (1997) 'Female adolescent sexuality'. *Annals of the New York Academy of Sciences*, 816: 417–21.

Hull, J. (1993) 'A boy and his gun.' *Time Magazine*, New York: Time Inc., 142: 5.

Kelly, F.D. (1997) *The Clinical Interview of the Adolescent: From Assessment and Formulation to Treatment Planning.* Springfield: Charles C. Thomas.

Leader, E. (1991) 'Why adolescent group therapy?' *Journal of Child and Adolescent Group Therapy*, 1, 2: 81–93.

Madanes, C. (1981) *Strategic Family Therapy.* San Francisco: Jossey-Bass.

McNiff, S. (1981) *The Arts and Psychotherapy.* Illinois: Charles C. Thomas Publisher.

Minuchin, S. (1974) *Families and Family Therapy.* Cambridge, MA: Harvard University Press.

Mishne, J. (1997) 'Therapeutic challenges in clinical work with adolescents'. *Clinical Social Work Journal*, 24, 2: 137–52.

Osman, B. (1997) *Learning Disabilities and ADHD: A Family Guide to Living and Learning Together.* New York: John Wiley and Sons.

Pleasant-Metcalf, A.M. and Rosal, M.L. (1997) 'The use of art therapy to improve academic performance'. *Art Therapy: The Journal of the American Art Therapy Association*, 14, 1: 30–6.

Ponton, L.E. (1997) *The Romance of Risk: Why Teenagers Do the Things They Do.* New York: Basic Books.

Pynoos, R. and Eth, S. (1986) 'Witness to violence: The child interview'. *Journal of the American Academy of Child Psychiatry*, 25, 3: 306–19.

Rosal, M.L., McCulloch-Vislisel, S. and Neece, S. (1997) 'Keeping students in school: An art therapy program to benefit ninth-grade students'. *Art Therapy: The Journal of the American Art Therapy Association*, 14, 1: 30–6.

Searles, H.F. (1979) *Countertransference and Related Subjects.* New York: International University Press.

Soo, E. (1986) 'Training and supervision in child and adolescent group psychotherapy'. In A. Riester and I.A. Kraft (eds) *Child Group Psychotherapy: Future Tense.* Connecticut: International Universities Press.

Sugar, M. (1997) 'Adolescents and disaster'. In L. Flarety and H.A. Horowitz (eds) *Annals of the American Society for Adolescent Psychiatry.* New Jersey: The Analytic Press.

Trowell, J. (1996) 'Thoughts on countertransference and observation'. In J. Tsiantis, A. Sandler, D. Anastasopoulos and B. Martindale (eds) *Countertransference in Psychoanalytic Psychotherapy with Children and Adolescents.* Connecticut: International Universities Press.

Walter, J.L. and Peller, J.E. (1992) *Becoming Solution Focused in Brief Therapy.* New York: Brunner/Mazel.

Worden, M. (1991) *Adolescents and their Families.* New York: The Hayworth Press.

Subject Index

abortion, issue of bias 143

acting out, relief of depressive pain 119

action orientation, short-term art therapy 249

ADHD *see* attention deficit hyperactive disorder

adolescence 7, 15, 18–19, 28–9
 see also mid-adolescence; pre-adolescence

adolescent codes, identifying 41–3

adolescents
 art therapy with 38–9, 64–5
 creativity 37–8
 depression 115–52
 developmental process 29–33
 group therapy 66–114
 loss, experience of 47
 of the millennium 28–9
 relationship with therapists 39–41, 53
 residential and therapeutic school settings 153–92
 short-term treatment 249–51
 and their families 193–217
 therapists' problems with 218–36

unpredictability of 13
use of language 57

after-school group program 106–9

agencies
 philosophies for treatment 155
 restrictions, residential and school settings 158, 175–6

alternate solutions 245–6

ambivalence
 in adolescents 139–40, 146
 example of therapist's 96–8

anger, dealing with 59

art expressions
 depressive symptoms 119–20, 121f, 122f, 123f, 125f, 126f
 failure to elicit 222–4
 integrating developmental theories with 27–65
 meta-messages 94–5
 originality of 39
 recognition of cultural differences 13–14

art projects
 group therapy 81, 82
 need for caution 101–2
 residential setting 184–7
 SED program 162, 167–9

art psychotherapy 68

art tasks
 in group therapy 78, 91–3

that act as co-therapists 111–13

art therapy
 with adolescents 38–9, 64–5
 benefits of 68–9
 demystifying the art in 252–3
 for depressed adolescents 143–50
 initiating 81–3, 163, 178
 kinesthetic opportunities 60
 literature 150–1
 perspectives and history 22–3
 short-term treatment 249–51
 as social construction 263–4
 as therapeutic tool 20–1
 training 23
 see also family art therapy

artwork
 assessments of 21–2
 communicating reactions to 59
 confidentiality of 50–1
 dealing with revelations in 232–3
 exceptions to behaviour patterns 250
 insight through 7–8
 messages in 51–2
 mid-adolescence 87–8
 missing messages in 53–4
 value of 200–1

see also collage;
 drawings
assessment treatment
 guidelines 243–5
assessments
 of artwork 21–2
 residential setting
 182–3
 SED program 164
attachments, group
 therapy 77–8, 80
attendance, group
 therapy 67
attention deficit
 hyperactive disorder,
 group therapy 105
authorities, reporting to
 228–30
authority 220–1
avoidance 230–2

behavior, pathologising
 of 173, 189–90
behavior patterns,
 exceptions in artwork
 250
behavioral plans, ADHD
 groups 105
belief systems
 influence of families'
 36
 questioning through
 polarity drawings 50
 and therapists 18, 189,
 242
 transformation of
 adolescents' 165–7
biases, of therapists 140
boxes, for containment of
 feelings 101

brief therapy see
 short-term, solution
 focused therapy

Carlos, case study
 145–50
castle construction,
 pre-adolescent group
 therapy 86–7
caution, group therapy
 93
challenges, for the
 adolescent 72–5
change
 adolescents' potential
 for 143
 evaluating 165–7,
 182–3
chaos theory, and family
 therapy 193–6, 216
character problems
 118–20
clay 58–9
co-therapists, art tasks as
 111–13
cohesion, art therapy
 groups 79–81
collage 35, 53, 61–2,
 118, 252
communication
 metaphorical 43–4
 reactions to artwork 59
 through artwork 21
 through drawings 7, 8,
 53
 through hands 59–60
 see also language;
 messages
confidentiality
 of artwork 50–1
 group therapy 77
constructivism 259–60

containment 101, 107–8
context
 adolescent population
 18–19
 need for awareness of
 28, 33–4
continuation, short-term
 therapy 253–4
control
 experience of, in art
 therapy 69
 issue of 52
corrective drawings 48
Coufal, Rita 106
countertransference
 219–20, 236
creativity
 in adolescents 15,
 37–8
 in therapists 14, 21,
 83, 250
cross-categorical thought
 32
cultural differences
 adolescents and adults
 12, 13
 responses to art therapy
 159–60
culture
 group therapy 85
 issue of 34–7

day treatment
 for depression 135
 group therapy 102–4
decision making, group
 therapy as aid to
 89–90
delinquency, relief of
 depressive pain 119
depression
 adolescent 116–17

after-care 136
art therapy, benefits of
 117–18, 143–50
external stress 128–30
families, impact of
 124–7
gender differences
 130–1
hospitalized adolescent
 girl 122–4
linked to
 misinformation
 131–2
long-term treatment
 136–40
peer group rejection
 132–4
societal pressures
 127–8
summary of treatment
 151–2
therapists' dilemmas
 135–6
Depression in Children and
 Adolescents 124
developmental
 maturation 206–10
developmental patterns
 adolescents 19–20,
 28–9
 gender 35
 incongruities in
 210–12
developmental process
 29–33
developmental theories,
 integrating with art
 expressions 27–65
dilemmas, for the
 adolescent 72–5

discourse, in narrative
 therapy 46–7
distancing 44–7, 202
drawing tests, suspicion
 of pre-planned 22
drawings
 communication
 through 7, 8, 53
 explanatory 118
 polarity approach
 48–50
 resistance to revealing
 contents of 44
 of support by peers 94

emotions, conveyed
 through
 self-expression 8
empathy 27
environmental stressors
 28, 33–4
ethical responsibility
 261–2
ethics, group therapy
 96–8
ethnic groups, growth
 patterns 29
ethnic issues, group
 therapy 85
expectations
 parental 203–4
 therapist/adolescent
 relationship 53
explanatory drawings,
 with depressed
 adolescents 118
exploration, in therapy
 27
externalization, of
 problems 90, 249
face masks 88–9, 162
failure

difficulties for
 therapists 221–2
 example of, art therapy
 101–2
 predictions of 202–3
 to elicit art expressions
 222–4
families
 after-care settings 136
 belief systems,
 influence of 36
 depression 124–7
 developmental
 maturation 206–10
 developmental patterns
 210–12
 parents' expectations
 and fears 203–4
 problematic 214–16
 psycho-educational
 information 204–6
 see also single parent
 families
family art therapy 196–8
 example 198–200
 value of the art product
 200–1
family therapy
 chaos theory 193–6
 facilitating trust 202–3
 and group therapy 94
 residential setting
 188–9
 SED program 170–3
 visual reporting 60
fears, parental 203–4
felt pens 57, 58
flexibility, in therapists
 14, 18
focal issues, group
 therapy 71–5

freedom, art expressions
39
gangs 151
gay adolescents 54
gender
depression 130–1
examining defined
roles 72
illustrations of roles
61–3
individualized
treatments 135
individuation 63
issue of 34–7
perceptions of roles 74
responses to art therapy
159–60
genetics
and depression 124–7
sexual development 29
goals, for group therapy
76–7
group therapy 66–114
after-school group
program 106–9
art tasks as
co-therapists
111–13
confidentiality 77
ethics 96–8
focal issues 71–5
getting started 81–3
goals for 76–7
group cohesion 79–81
group compositions
84–90
meta-messages 94–5
new members and time
frames 90–1
parent support groups
109–11

settings 98–106
shaping groups 77–9
signing in 83–4
techniques for 91–4
theory and practice,
rethinking 70–1
treatment issues 67–9
v individual treatment
70

hands, communication
through 59–60
Hector, case example
96–8
hospitals
group therapy in
99–101
treatment for
depression 135

identity
group therapy 80
search for 31, 41–3, 63
ignorance, therapists'
stance of 92–3, 139
illustrations, male and
female roles 61–3
imagery 39
individualized treatments
135
individuation
current thinking about
68
gender-defined 63
moving out as
metaphor for 197–8
single parent families
212–13
inpatient hospital groups
99–101
insight
psychotherapy 264

through artwork 7
interpersonal boundaries,
testing 13
interpretations, of
artwork 95–6
inventiveness 38

journals 61

kinesthetic opportunities,
in therapy 60

language
barrier to
understanding 56–7
collage as universal
61–2
Lengua, Roberta,
interview with
173–90
lesbian adolescents 54
life line, SED program
167–8
Life Story Lines 164
limited issues, in art
therapy 249, 251–2
literature, art therapy
150–1
long-term projects 169,
184
long-term treatment,
depression 136–40
losses, experienced in
childhood 47
Loth, Aimee, interview
with 156–73

magazines, for collage 35
mask making, SED
program 162
masked depression 119
materials 57–9

art therapy groups 78
difficulties for
 therapists 233–4
meaning, in narrative
 mode 43–4
meaning-making, in
 adolescents 32
meanings 245
media
 for art therapy 57–9
 difficulties for
 therapists 233–4
 importance of 118
 SED program 162–3
mental health services
 170, 187
mental health treatment,
 current 67–8
mental processes, in
 artwork 38–9
message drawings, parent
 support groups 111
messages
 in artwork 51–2
 missing 53–4
 see also meta-messages
meta-messages 94–5,
 204
metaphors
 castle construction
 86–7
 communication 43–4
 moving out 197–8
 short-term art therapy
 249
 volcano construction
 108–9
 zoo construction 107
mid adolescence 87–90
misinformation, and
 depression 131–2

moral responsibility
 261–2
mourning, through art
 messages 52
multiple perspectives
 243, 262
murals, family 198

narcissism 43, 70, 139
narrative therapy
 discourse in 46–7
 philosophy behind
 258–9, 261
narratives
 as an approach to
 treatment 70
 meaning in 43–5
neutrality 261–2
new members, of groups
 90–1
non-judgemental focus
 254–5, 261–2
non-verbal
 communication
 59–60, 74
non-verbal techniques
 7–8
numbers, talking in 54–6

On Adolescence 31
open dialogue 242
optimism, in therapy 248
originality, art
 expressions 39
out-sight 264

paper 57–8
parent education classes
 172–3
parent support groups
 109–11

parent-child
 relationships,
 therapists' difficulties
 227–8
parent-face masks 88–9
parentified children 56
parents, expectations and
 fears 203–4
peer groups
 advice and support
 from 68
 conforming to 43, 53
 preference for 70
 rejection by 132–4
perceptions, of
 adolescence 28
personality
 desire for individual 38
 encountering
 adolescent 41
philosophy, of short-term
 therapy 240–2
physical growth 19, 29
plasticine 58–9
playful atmosphere,
 short-term art therapy
 250
polarity drawings 48–50
positive intent 246–7
poverty 34
pre-adolescence 85–7
predictions, of failure
 202–3
prejudices, in therapists
 140, 224–5
preventative therapy 68
private life, intrusions
 into therapists' 234–6
problem solving,
 mid-adolescence 90

problematic families
214–16
problems
avoiding, in group
therapy 82
examples of therapists'
220–36
externalization of 90,
249
process orientation
residential setting
178–80
SED program 164
psycho-educational
information 204–6
psychological maturation
19
development of
artwork 185
psychotherapy
notion of insight 264
social constructionism
260
see also art
psychotherapy

quality, of art therapy 39

re-authoring 259
reality
example of surprising
95–6
example of working
with 106–7
levels of 245
rebellion 72
redefinition 246–7
reframing 245–6
rehabilitation programs,
group therapy 103–4
relationships

parent-child, dealing
with 227–8
therapist/adolescent
39–41, 53
reluctant clients
dealing with 47–8
example of working
with 134–5
reporting, to authorities
228–30
residential settings
group therapy 102–4
interview with Roberta
Lengua 173–90,
191–2
resistance
to revealing contents of
drawings 44
working with 134–5
responses, to art therapy
in residential setting
176–7
SED program 159–60
roles, male and female
concepts of 74
illustrations of 61–3
rules, group therapy 79

safe space, art therapy
settings 176–7
safety, in group therapy
76–7
school groups 104–6
school settings 158
second-order therapists
259
self-exploration 181–2
self-expression,
conveying emotions
through 8
self-image, parentified
children 56

settings
group therapy 98–9
residential 173–6
SED program 156–8
Severely Emotional
Disturbed (SED)
program 156–73,
192
sexual development,
genetic factors 29
sexuality
dealing with 73–5
difficulties for
therapists 225–7
short-term, solution
focused therapy 20,
237–65
residential setting
185–7
SED program 165,
168–9, 172
signing in 83–4
single parent families
212–14
singularity, art
expressions 39
small, thinking 248, 252
social constructionism
art therapy 263–4
challenge of
communication 57
constructivism and
259–60
defined 257–8
philosophy and
narrative view of
treatment 258–9
therapists' belief system
18
socialization, gender
differences 135

societal pressures, and depression 127–8
society, pathologizing of behaviour 173, 189–90
socio-economic context, importance of 28, 31, 34
socio-economic stressors 124–7
solution focused therapy *see* short-term, solution focused therapy
specificity, in therapy 202
spontaneity, in therapy 248
stress, depression induced by 128–30
subjects, for artwork 50, 81
sublimation 107–8, 150
substance abuse 22, 64, 71
suicide, dealing with threat of 120–2, 124, 230–2
surprise, in artwork 95–6
symbolic meaning, in artwork 21–2, 92

talking numbers 54–6
techniques
 group therapy 91–4
 short-term, solution focused therapy 247–9
theoretical approach
 residential setting 180–2
 SED program 165

theory, rethinking 70–1
therapists
 belief systems 242
 biases and prejudices 140
 creativity and flexibility 14, 18, 21, 83, 250
 not knowing, stance of 92–3, 139
 problems in adolescent treatment 218–36
 qualities, helpful 27–8
 relationship with adolescent 39–41, 53
 role, group art therapy 79
 techniques, helpful 247–9
 treatment of depression 135–6
 uncertainty as trait in 18
therapy
 gender differences 135
 handling proscribed 47–8
 see also art therapy; group therapy
time frames, group therapy 78, 90–1, 92
time limited therapy 239–40
timing, in therapy 46
toilet construction, group therapy 106–7
training, art therapy 23
transparency, difficulties for therapists 221–2
treatment *see* therapy
trust

between therapist and adolescent 44–7
family therapy 202–3
group therapy 76–7
truth, short-term art therapy 249

uncertainty
 in therapists 18
 in therapy 27
unconscious material, bringing to client's attention 233
unpredictability, of adolescents 13

violence 64, 118–20
visual images 39
visual reporting 60
visual thinking 232
volcano construction, group therapy 108–9

zoo construction, group therapy 107–8

Author Index

Adler, G. 222
Alexandris, A. and
 Vaslamatzis, G. 219
Anderson, H. and
 Goolishian, H. 27,
 93, 139, 198, 243,
 263

Belnick, J. 255
Berkovitz, I.H. 70
Blau, G.M. and Gullotta,
 T.P. 29
Bloch, H.S. 29, 68, 71,
 116
Blos, P. 29, 31, 68, 116
Buber, M. 259
Buck, J.N. 21
Budman, S.H. and
 Gurman, A.S. 256
Burns, R.C. and
 Kaufman, S.H. 21
Butz, M.R.,
 Chamberlain, L.L.
 and McCown, W.G.
 194, 215
Byng-Hall, J. 215

Cade, B. and O'Hanlon,
 W.H. 238, 240,
 242, 243, 245, 247
Campbell, C. 151
Carnegie Council on
 Adolescent
 Development 127
Cecchin, G. 79, 258
Cecchin, G., Lane, G. and
 Ray, W.A. 140
Cobb, C.L.H. 47
Conger, D. 151

Cox, K. 71, 151
Cyrtryn, I. and McKnew,
 D.H. 116

deShazer, S. 240
DiLeo, J.H. 21

Epstein, L. and Feiner,
 A.H. 219
Epston, D., White, M.
 and Murray, K. 257
Erkison, E.H. 29

Fisch, R., Weakland, J.
 and Segal, L. 195,
 245, 246
Fishman, H.C. 29
Friedman, A.S. and
 Glickman, N.W. 104,
 151
Fruggeri, L. 260

Gergen, K. 57, 70
Gergen, K.J. 258
Gilligan, C. 135
Gilligan, C., Rogers, A.G.
 and Tolman, D.L. 63,
 130
Giovacchini, P.L. 219
Gleick, J. 194
Goldner, V., Penn, P.,
 Sheinberg, M. and
 Walker, G. 73
Gullotta, T.P., Noyes, L.
 and Blau, G.M. 104

Haley, J. 195, 239, 240,
 246
Hardy, K. 14
Herbst, K. and Paykel,
 E.S. 116
Hiscox, A. 128

Hoffman, L. 57, 257,
 259, 260
Inger, I.B. and Inger, J.
 259
Johnson, D. 94
Kaslow, N.J. and Racusin,
 G.R. 116
Kellogg, R. 21
Kopelwitz, H.S., Klass, E.
 and Kafantaris, V.
 116, 124
Kottler, J. 221, 222

L'Abate, L. 195
Landgarten, H. 62, 150,
 198, 252
Larose, M. 151
Leveton, E. 29
Linesch, D. 70, 151
Lowenfeld, V. and
 Brittain, W. 206

McCown, W.G. and
 Johnson, J. et al. 219
Malchiodi, C. 21, 40,
 50, 82, 151, 206,
 208
Malmquist, C.P. 29, 37,
 116, 118, 119
Minuchin, S. and
 Fishman, H.C. 195
Mirkin, M. and Koman,
 S. 29
Mishine, J. 219

O'Hanlon, W.H. and
 Weiner-Davis, M.
 240, 259
Oster, G.D. and Caro, J.E.
 116, 124
Oster, G.D. and Gould, P.
 21

Parry-Jones, W.L. 117, 119
Pipher, M. 151

Raymer, M. and McIntyre, B. 151
Riley, S. 63, 127, 151, 232
Riley, S. and Malchiodi, C. 57, 60, 210, 240, 264
Rinsley, D.B. 44, 136
Rutter, M. and Rutter, M. 29, 32

Sandmier, M. 127
Satir, V. 195
Schneider, S., Ostroff, S. and Legrow, N. 151
Seibt, T.H. 212
Selekman, M.D. 242, 248
Selvini-Palazzoli, M., Boscolo, L., Checchin, G. and Prata, G. 195
Sgroi, S. 82, 94
Sheinberg, M. 262
Silver, R.A. 21, 103, 151
Sims, P.A. and Whynot, C.A. 43
Sluzki, C.E. 245, 250
Smolowe, J. 83
Sommers-Flanagan, J. and Sommers-Flanagan, R. 14
Spietz, AM. 151
Stierlin, H. 204
Strand, P.S. 31
Sugar, M. 219, 231

Toolan, J.M. 117
True, F. and Kaplan, L. 124

US Bureau of Census 212

Watzlawick, P. 55
Watzlawick, P., Beavin, J. and Jackson, D.D. 204
Weeks, G. and L'Abate, L. 202
White, M. and Epston, D. 71, 215, 240, 243, 244, 254, 261
Wilkes, T.C.R., Belsher, G., Rush, A.J. and Frank, E. 116
Wolf, A.E. 243
Wolin, S. 242
Wylie, M.S. 29

Yalom, I.D. 77, 79